DISCOVERING LOUISIANA

To Norman G. Levine,
Best Wishes
CC Lockwood

DISCOVERING

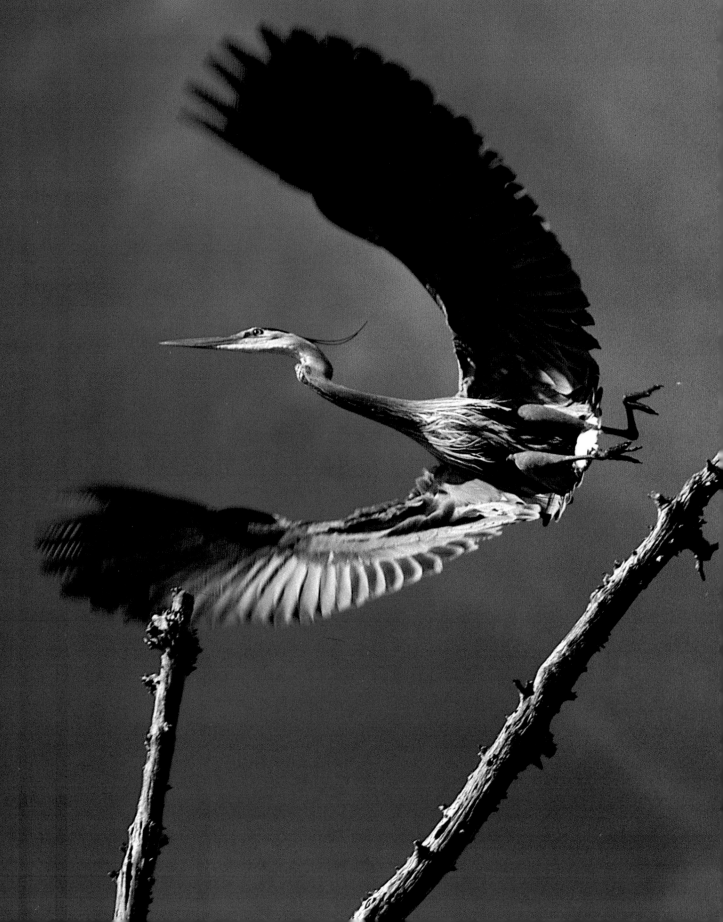

LOUISIANA

Photographs and Text by

C. C. LOCKWOOD

LOUISIANA STATE UNIVERSITY PRESS

BATON ROUGE AND LONDON

Other books by C. C. Lockwood

Atchafalaya: America's Largest River Basin Swamp

The Gulf Coast: Where Land Meets Sea

For Amelia Lockwood,
a teacher, my grandmother,
who taught me so much

Copyright © 1986 by C. C. Lockwood
All rights reserved
Manufactured in Japan

Designer: Albert Crochet
Typeface: Linotron Palatino
Typesetter: Moran Colorgraphic
Printer and binder: Dai Nippon Printing Company, Ltd.

LIBRARY OF CONGRESS CATALOGING-IN-PUBLICATION DATA

Lockwood, C. C., 1949–
 Discovering Louisiana.

 Includes index.
 1. Louisiana—Description and travel—1981– —
Views. 2. Natural history—Louisiana—Pictorial works.
I. Title.
F370.L82 1986 917.63'0463 86-7509
ISBN 0-8071-1335-2

Contents

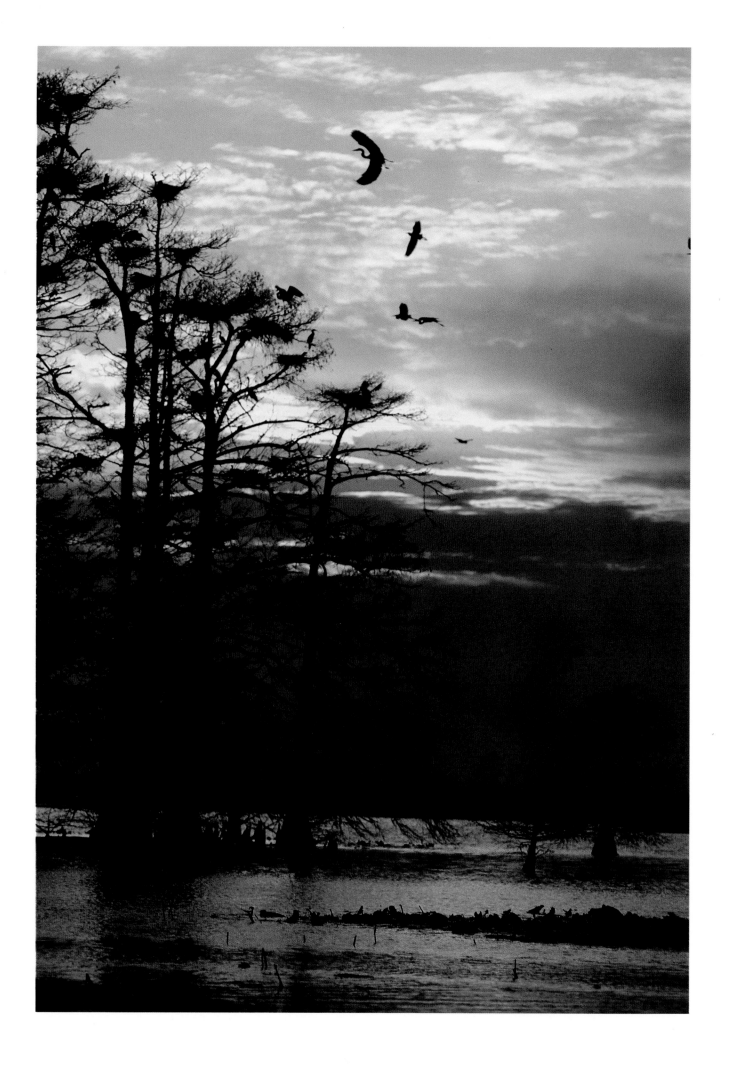

Acknowledgments

Over the last two years, I received assistance, information, and access to property from hundreds of people and I owe them all my gratitude. First of all, I'd like to thank my staff, Jane Switzer, Anne Earnest, and especially Kathy Jarecki-Stratman. Kathy Rhorer Wascom helped by doing research, and Al McDuff's many suggestions on my rough drafts were invaluable.

Some of the many others who gave me help are: Buddy Abraham, Nancy Albritton, Whitney Autin, Ray Aycock, Wylie Barrow, Wayne Bettoney, Melanie Blanchard, Bobby Brown, Merril Butler, Dr. Paul Burns, Nigel Calder, Desmond Clapp, Phil Cohagen, Paul D. Coreil, Nancy Craig, Lionel Currier, Glen Daigre, Skipper Dixon, Jim Dowling, Pam Drewry, Dr. Peter Fogg, Dr. Stephen W. Forsythe, George Foster, Dr. J. Robert Fowler, Terri Frisbie, Ken Guidry, Russel Hayes, Robert Helm, Sam Henson, Joe Herring, Tom Hess, Diane Hewitt, Gloria Holmes, Oliver Houck, Richard and Jessie Johnson, Bert Jones, Kenwood Kennon, Dr. Richard Kesel, Chuck Killebrew, Joseph L. Killeen, Jr., Dr. Fred Kniffen, Gary Lester, Joel Lindsey, Eleanor Lowry, Pat Mabry, Emile Marchive, Dale Mathews, Ed and Annie Miller, Dr. Bob Miller, Bob Misso, Robert Murry, Dr. Milton Newton, John O'Neill, Annette Parker, Dr. Edward Pendleton, Doug Pratt, Clive Pugh, Van Remsen, Dr. Douglas Rossman, Gretchen Rothschild, Myra Seab, Keith Sliman, Ladimore Smith, Dave Soileau, Dr. Robert Stewart, Bob Strader, Herman Taylor, Bob Thomas, Eugene Turner, Dr. Lowell Urbatsch, Paul Wagner, Roger Ward, Susan Waters, Roy Webb, Prep Welch, Talbert Williams, Paul Yakupzack, and Kip Yearwood.

I would like to give special thanks to *Louisiana Life*, for some of the photographs included here were done on assignment for them.

Government agencies and other organizations were also helpful: Briarwood Nature Preserve, Coastal Management Section of Louisiana Department of Natural Resources, Kisatchie National Forest, Louisiana Department of Culture, Recreation and Tourism, Louisiana Department of Wildlife and Fisheries, Natural Heritage Program of The Nature Conservancy, United States Fish and Wildlife Service.

And finally I would like to thank the staff of Louisiana State University Press, especially Barbara O'Neil Phillips, my editor, designer Al Crochet, Les Phillabaum, and Beverly Jarrett.

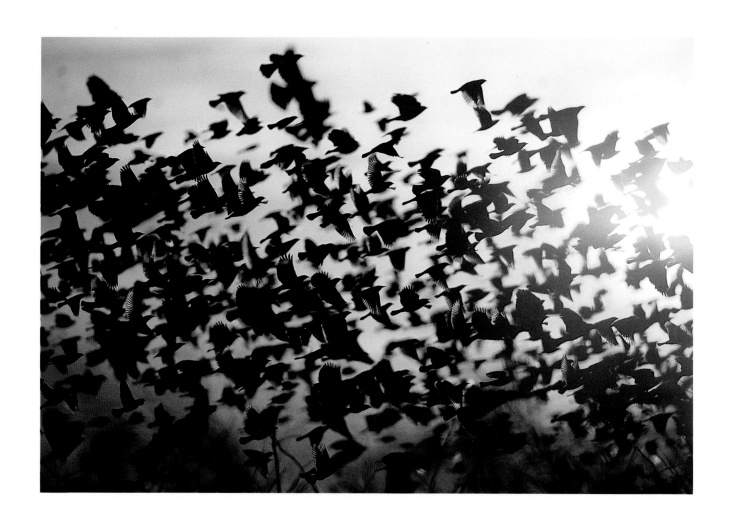

DISCOVERING LOUISIANA

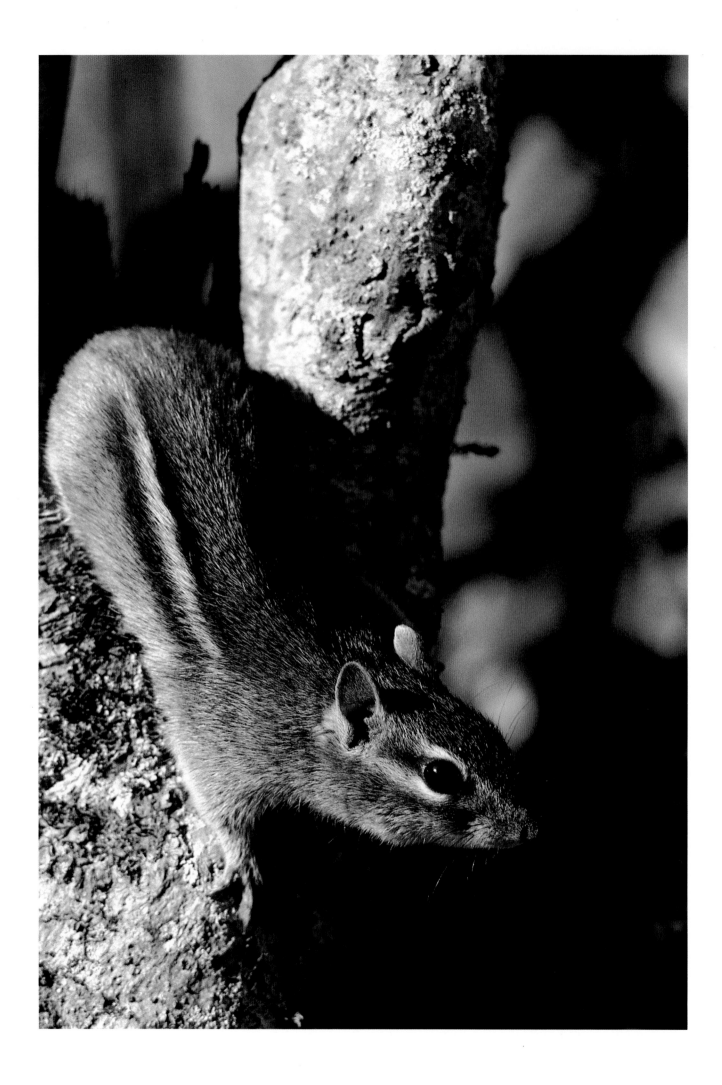

Introduction

I discovered Louisiana. Let me qualify that, for I did not sail the Gulf of Mexico in 1528 or venture down the Mississippi River in 1682. Those adventures go to Piñeda, Narváez, de Soto, La Salle, and Iberville. What I did discover is the natural treasures of Louisiana—colorful flowers, diverse wildlife, and varied landforms.

The real discovery was finding more than I expected to find, and I know exactly why I found more. Prejudice. I was a seasoned traveler in south Louisiana, brother to the swamps and marshes. I had never taken the time to look at the rest of our state except passing quickly by on a main highway.

I fended off questions from out-of-staters about the myths of Louisiana, not realizing that with my books, lectures, and workshops, I probably contributed as much as anybody to the image that we take pirogues to work, live in houses on stilts, and have alligators in the backyard.

When I started this project, it was entitled *Louisiana Naturally*, and I wasn't planning on changing much of our swamp image. Once I got going, however, things were different. I waded down crystal-clear creeks, climbed steep and crumbling bluffs, sat on big rocks, and smelled the piney woods. When I sat high in a white oak that bent over Kisatchie falls, I said to myself, "I am discovering a Louisiana that I never knew was here."

Take the eastern chipmunk, for instance. The eleven-inch rodent is not hunted, you can't catch it in a crawfish trap, I don't know anyone who eats it, it's not an endangered species, and you don't see it in Louisiana unless you go looking. Nobody talks about it. So why is it important? It defines a habitat found nowhere else in the state.

Although common in suitable habitats throughout the eastern United States, the chipmunk is unique to the Tunica Hills in Louisiana. The layman couldn't tell much of a difference, but the steep ravines of Tunica harbor a cool and more diversified hardwood forest that is more typical of the eastern United States . . . thus the eastern chipmunk.

I like to observe this speedy little creature and have done so many times in West Feliciana Parish. The best way to see one is to sit quietly by a stream and wait. If you're lucky, a chipmunk will scurry out of his burrow in search of nuts to store in his pantry. One day near Bains, Louisiana, I watched one carry acorns into its den three times. I read that they are very protective of their food caches, which may be a separate room from their sleeping chamber. Like

most burrowing animals, chipmunks usually have two or more entrances to their dens.

On another occasion I watched the small rodent chew on a pecan until he finally got to the meat, then he packed every last tidbit into his mouth until his cheek pouches were full. The little fellow looked like he had the mumps. Then he ran off to empty his pouches and eat the pecans later.

On the other end of the spectrum is the nation's largest baldcypress tree, situated on the banks of the Mississippi River. At two hundred tons, it dwarfs the four-ounce chipmunk. I didn't discover this mammoth tree. Desmond Clapp, an area forester for Georgia Pacific, found it in 1981. But I felt like a pioneer looking at that giant, fifty-three feet in circumference. Desmond, whose hobby is finding state and national champion trees, claims there are bigger ones on back in the same woods. He said he would save those until some other state beats his record, then he'll find another and reclaim his title. Louisiana has five other national champion tree species (see Appendix B for details).

For aromatic as well as visual delights, the piney woods is the place to be. During the spring, in the Evangeline unit of Kisatchie National Forest, the dogwood with its showy white flowers contrasts beautifully with the reddish brown, to sometimes charred black, bark of the loblolly pine. By the time the dogwoods lose their flowers, the wild azalea has blossomed. Its fragrance mixed with the pine tree's is my favorite. That air is a perfect sleeping potion on a cool spring night.

Along with the piney woods, clear creeks, rapids, and rolling hills, north Louisiana also has a few swamps. I paddled my canoe down Bodcau Bayou one fall day and noticed that the rusty red of the cypress leaves was much more vibrant than those in the Atchafalaya. It is a swamp with clear waters, but has the same vegetation that we find in other swamps throughout our state.

While discovering Louisiana, I had a great time, and in the following text and photographs, I trust you will learn a little more about the natural history and geography of Louisiana.

In reading the text, please note that some parts are excerpts from my journal, which records my travels over the years. During the last three years I jumped around, all over the state, attempting to be in each region in as many seasons as I could, since my original intent was to present the book divided by seasons. However, upon "discovering" Louisiana's varied habitats, I decided to explore each unique area individually rather than lump them all together in order of the seasons.

Please enjoy and go out and discover a little of Louisiana yourself.

Generalized Land Use Map of Louisiana
Based Upon United States Geological Survey Land Use Maps

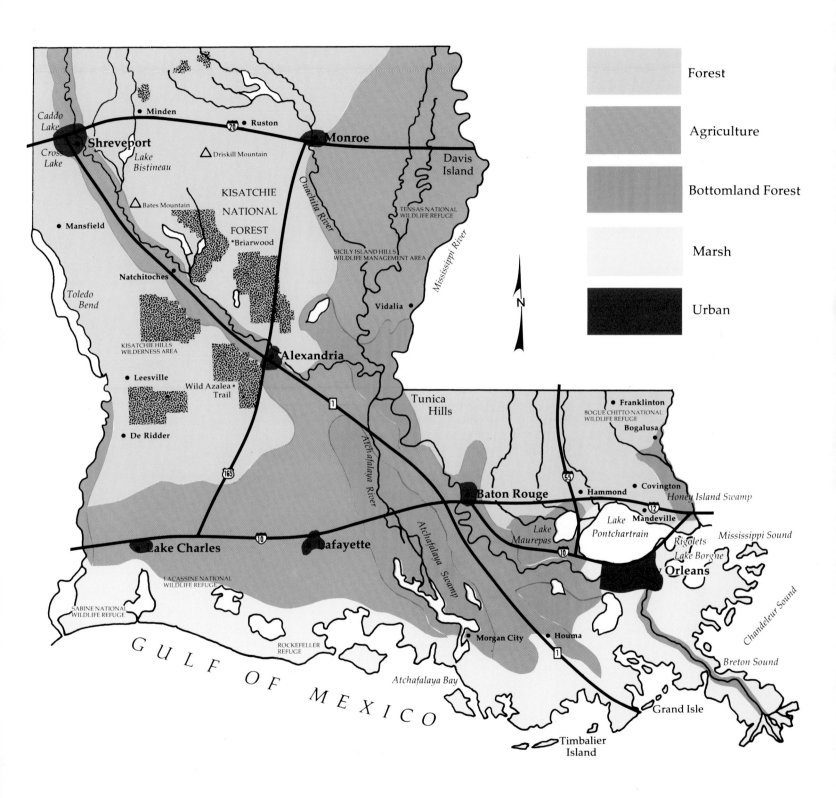

Forest

Agriculture

Bottomland Forest

Marsh

Urban

Caddo Lake

Cross Lake

Shreveport

Minden

Ruston

Monroe

Davis Island

Lake Bistineau

Driskill Mountain

Ouachita River

TENSAS NATIONAL WILDLIFE REFUGE

Mansfield

Bates Mountain

KISATCHIE NATIONAL FOREST

*Briarwood

SICILY ISLAND HILLS WILDLIFE MANAGEMENT AREA

Mississippi River

Toledo Bend

Natchitoches

Vidalia

KISATCHIE HILLS WILDERNESS AREA

Alexandria

Leesville

Wild Azalea Trail

Tunica Hills

Franklinton

BOGUE CHITTO NATIONAL WILDLIFE REFUGE

Bogalusa

De Ridder

165

1

Atchafalaya River

Baton Rouge

Hammond

Covington

Honey Island Swamp

Lake Charles

10

Lafayette

Atchafalaya Swamp

Lake Maurepas

Lake Pontchartrain

Mandeville

Rigolets

Lake Borgne

Mississippi Sound

10

New Orleans

LACASSINE NATIONAL WILDLIFE REFUGE

SABINE NATIONAL WILDLIFE REFUGE

ROCKEFELLER REFUGE

Morgan City

Houma

Chandeleur Sound

Breton Sound

G U L F O F M E X I C O

Atchafalaya Bay

1

Grand Isle

Timbalier Island

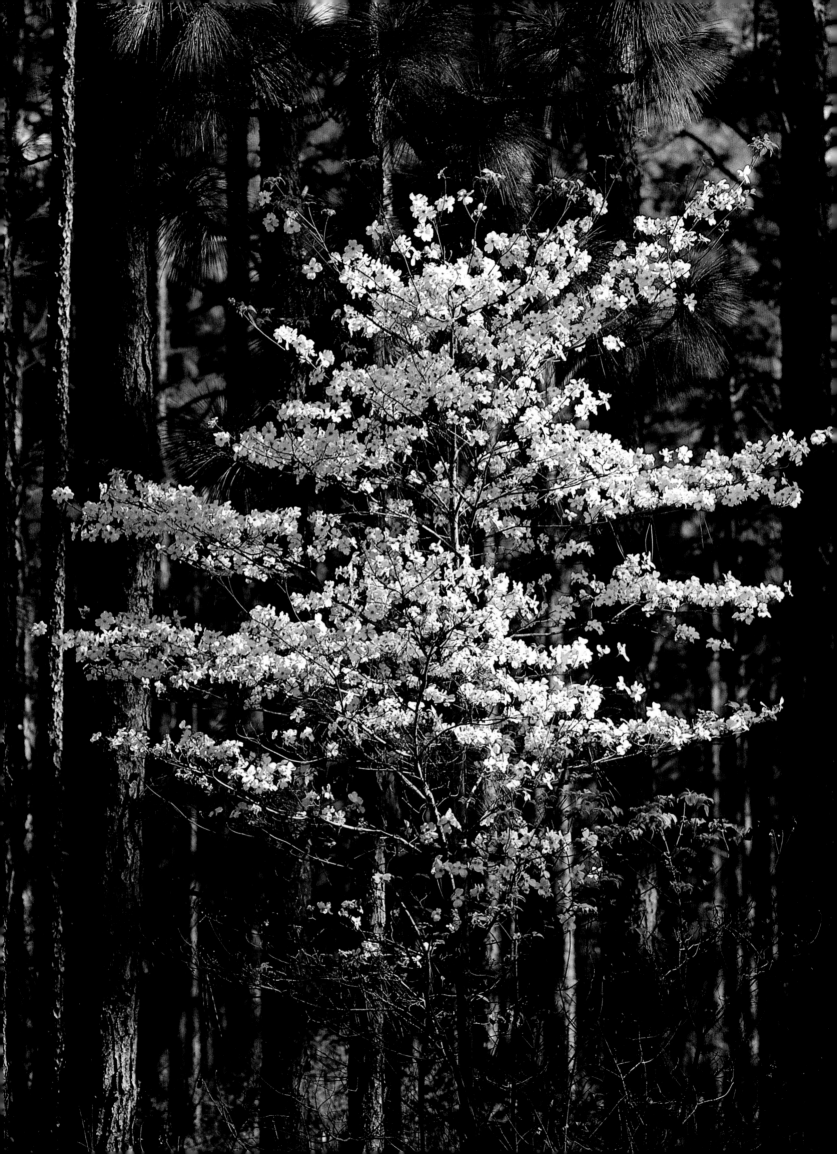

1

Hills and Piney Woods

Driskill Mountain at 535 feet above sea level is the third-lowest highest point in the United States. Confusing? What this means is that Louisiana's summit is taller than the highest point in two other states. Florida's is 345 feet and Delaware's is 442 feet.

Coloradans may have something to be proud of, having the third-highest high point, but can you be proud of having the third lowest? First is always best, even if it is first of the lowest. So maybe Louisiana should shave 191 feet off Driskill Mountain to beat out Florida. It would certainly be easier than adding 19,786 feet of dirt and rocks to edge out North America's high point at the top of Denali in Alaska at 20,320 feet.

Even our neighbors dwarf us. Mississippi's pinnacle is 806 feet, Arkansas' Magazine Mountain reaches 2,753 feet, and Texas tops us all, as usual, with Guadalupe Peak rising to 8,751 feet above sea level.

What happened to Louisiana? Nothing to be ashamed of; forget the highs and lows. We should be proud of our geographic location at the mouth of the Mississippi River, which makes us a flood-plain state full of fertile alluvial soil. There are no mountains, but we do have a few hills that were built with sediments and by the advancing and retreating sea associated with the various ice ages thousands of years ago.

Driskill Mountain is part of the Nacogdoches Wold, which was effected by the Sabine uplift. That simply means the earth's crust pushed up a bed of domed rock. The weathering effect of rain, wind, and streams wore down the soft parts over the millennia. Driskill, with its ironstone cap, remained a pinnacle in Louisiana.

From the outset, I knew I would have to attempt this towering summit, for how can you cover the natural history of a state without standing on its rooftop? I knew it would take a plan, a good plan, to successfully complete this assault, so I did my research.

Checking the records and the literature as well as contacting my mountaineering friends proved not much help. I learned not only that a 1973 Baton Rouge Sierra Club expedition failed to reach the top but also that no location was known for a base camp and Sherpas are not to be found anywhere in Bienville Parish. Lacking information, Sherpa support, funding, or even a donated ice ax from a climbing-gear manufacturing firm, I ventured down Highway 507 to the foothills of Driskill Mountain.

I discovered that there were roadways that actually circled my objective, and I traveled them twice trying

The flowering dogwood, Cornus florida, *with its showy white flowers, is one of the most noticeable trees in the piney-woods understory.*

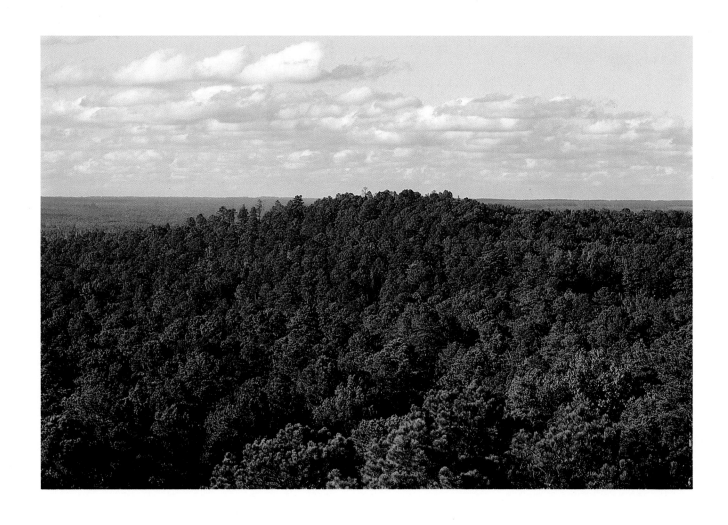

Driskill Mountain, at 535 feet above sea level, is Louisiana's highest point (above). *I enjoyed climbing it, even though I found someone else had beat me to the top by one day* (top right). *The view from Longleaf Vista* (bottom right) *shows one of Louisiana's hilliest regions.*

to determine the safest and easiest route to the summit. You see, I wasn't interested in making the first ascent of the north face, the hard technical route, but in getting to the apex with my camera gear and note pad. Besides, I had yet to hear of a successful attempt at reaching Louisiana's rooftop.

Still unable to find a route, I climbed the nearby Gentry Hill Fire Tower for a better view. To the west I could see Jordan Mountain jutting out of pine woods, 492 feet tall. To the south, row-planted pines showed disturbing uniformity among the swatches of clear-cuts. Eastward lay the much more productive Dugdemona River bottoms and the Jackson Bienville Wildlife Management Area. And to the north, the mountain I was going to conquer. From here it looked as if a gully up the south wall would be my best ascent.

Back at my selected base camp, I began to load my pack. On this October 7 day, fall (much less winter) had yet to set in. But I packed a sweater, because temperature drops 3.3 degrees for every 1,000 feet of elevation gained. Better safe than sorry. I added cameras, tripod, peanut butter and jelly sandwich, water, and compass. With oxygen, ropes, mountain tents, and survival beepers unavailable in this territory, and since I desired a lighter load anyway, I opted to leave a note on my jeep directing searchers to my route. Of course, I also left my will and listed next of kin.

To my surprise, the climb went easily. Only once

did I backtrack to find another route. Stumbling over ironstone and young pines, I was looking for the tallest pebble on the flat-topped summit when I sighted a flag. Cut from a bed sheet, artfully drawn in blue ink and skillfully tied to a small sapling, the banner read "Mt. Driscoll, we did it, us. 10-6-84." Well, one consolation—they misspelled Driskill, even if they did beat me to the top. Calling Driskill a mountain may be a bit facetious, but I'd say any state's high point should be treated properly.

I topped Driskill once more, but this time from the front seat of Bert Jones's 1939 J-3 Piper Cub. Actually, it wasn't much different from going up on foot.

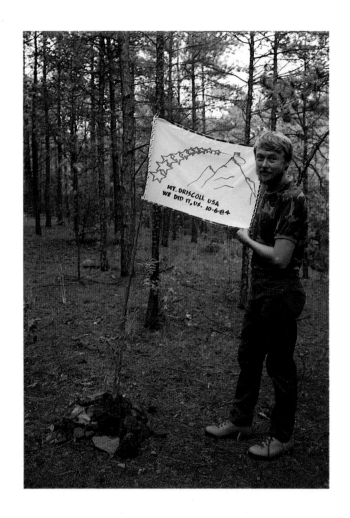

Pilot Kip Yearwood's legs were my armrest as I straddled a stick and gazed at the simple dashboard with only three gauges. Feeling like a horse with Kip as the jockey, I noticed that none of the three was a gas gauge as we putted over hill and dale at forty miles an hour. I asked (yelled) over the hum of the eighty-five-horsepower engine and the open window how Kip could tell how much gas was left.

Kip replied, "See that wire sticking out of the gas cap up front? It's connected to a cork, so as we run out of gas the cork sinks and lowers the wire. Fool-proof gauge!"

It was a hazy morning and the valleys were filled with fog. At our low flight level, with the rising sun pushing through, I imagined that we were in a miniature version of the Smoky Mountains. Finally Dris-

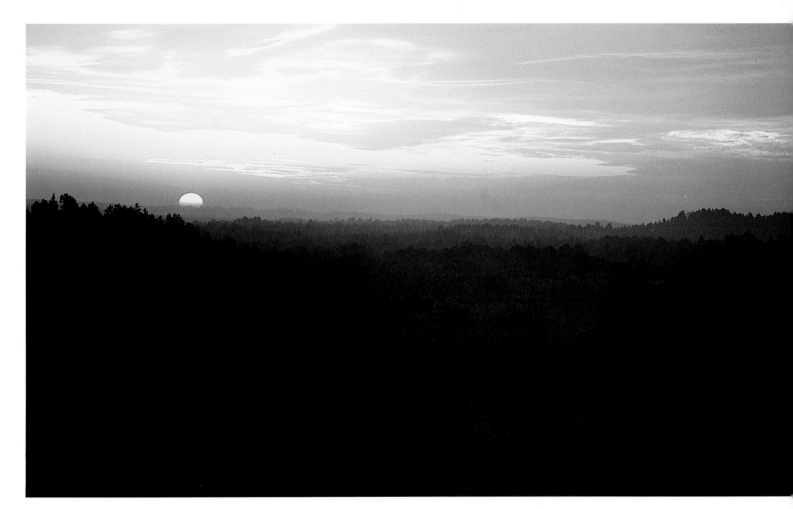

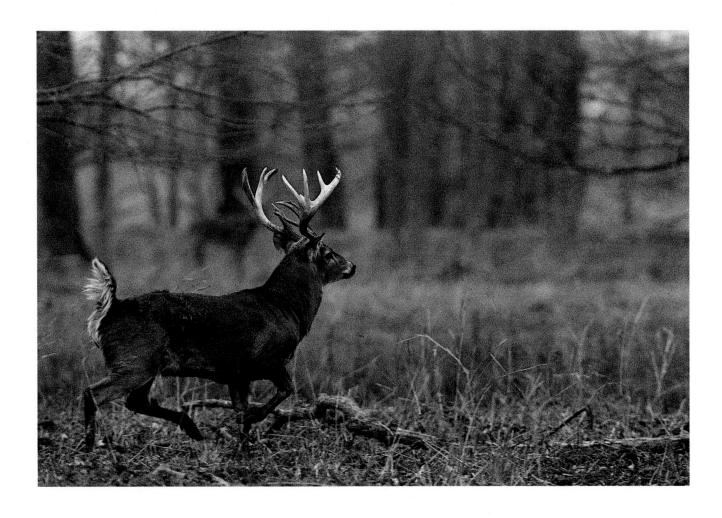

kill loomed ahead just barely showing its might over nearby Jordan Mountain and Gentry Hill.

Kip and I continued our journey for two hours, seeing most of the sand hills of Bienville Parish, and on our return we passed two white-tailed deer. We circled and saw that one was a six-point and the other a spike. After landing in Ruston, Kip promised to take me over Bayou L'Outre later in the year.

Hills and terraces cover nearly half of Louisiana. What geologists call hills in our state were formed by the Nacogdoches and Kisatchie wolds and the Sabine uplift. These are located west of the Ouachita River and north of the line that runs between De Ridder and Harrisonburg. East of the Ouachita River, we have two areas of high ground called the Bastrop Hills and the Macon Ridge, site of the archaeologically significant Poverty Point.

The hill country, which includes the Tunica Hills in West Feliciana Parish, is called terraces, even though some are just as steep as Kisatchie.

The Tunica Hills are a pleasant change from the miles of bottomland to the west along the Mississippi River. The loess soils of this region are very good for cotton agriculture, and that crop was prevalent. But due to the steepness of the area, erosion was commonplace. Now many of the former cotton plantations remain cattle pastures or have returned to forest such as they were.

Loess soils originated in the Pleistocene epoch.

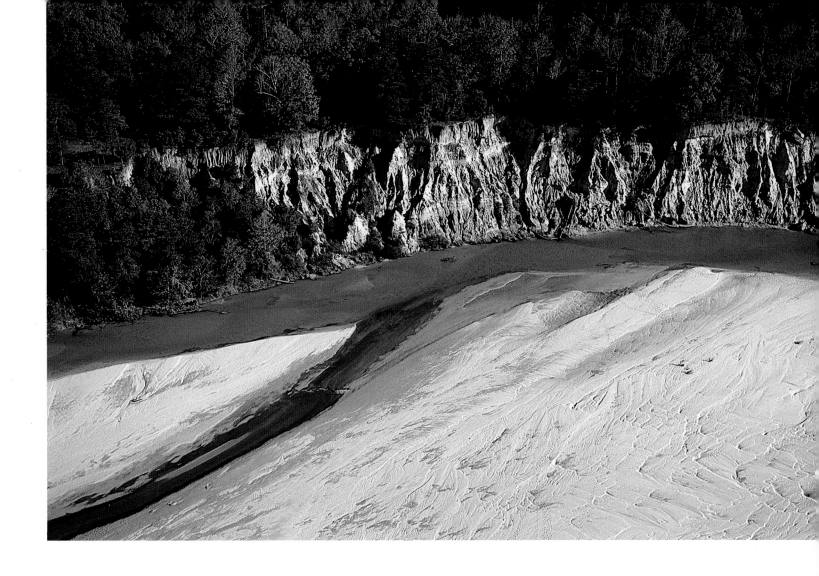

Glaciers ground up fresh raw sediment, and the Mississippi carried it to Louisiana. Wind then blew the silt-size particles to the Tunica Hills. The same process is going on today in Alaska. Unweathered loess soils are unmistakable: they erode to a vertical face rather than a slope. This characteristic is readily seen on a drive along the old Tunica Trace from Pletenberg to Tunica. Walls of silt, thirty-five feet high in places, give one the feeling of driving through a tunnel. Late spring is particularly inviting—the oak leaf hydrangea displays its showy cream-white flowers on these same walls of silt. Can the walls fall? Yes, and it's called spalling off when vertical slabs of loess soil fall away.

I saw this on a larger scale on Little Bayou Sara. I was wading downstream, and the shallow water kept me cool as I approached Ellersie Bluff. The Feliciana rivers and bayous have bottoms of a light brown sand interspersed with gravel deposits. The eroding loess soils are carried quickly downstream to the Mississippi River.

The bluff was immense, much larger than I had expected. Some of the jagged vertical ridges resembled in miniature the towering buttes in the deserts of the Southwest. It was a landscape just as special as the grand panorama at Polychrome Pass in Denali National Park, Alaska. The bluff, though, was on the cutbank and Little Bayou Sara was cutting into the steep hillside. Huge hunks of spallings were piled

(top left) *Alert to the photographer, a white-tailed buck bounds away.*

(bottom left) *Winter huckleberry,* Vaccinium arboreum, *is preferred by deer browsing in the piney woods. It also produces a tasty fruit.*

(above) *As Bayou Sara cuts through the Tunica Hills the loess soils leave a vertical face. Marchive Bluff is one of the most spectacular.*

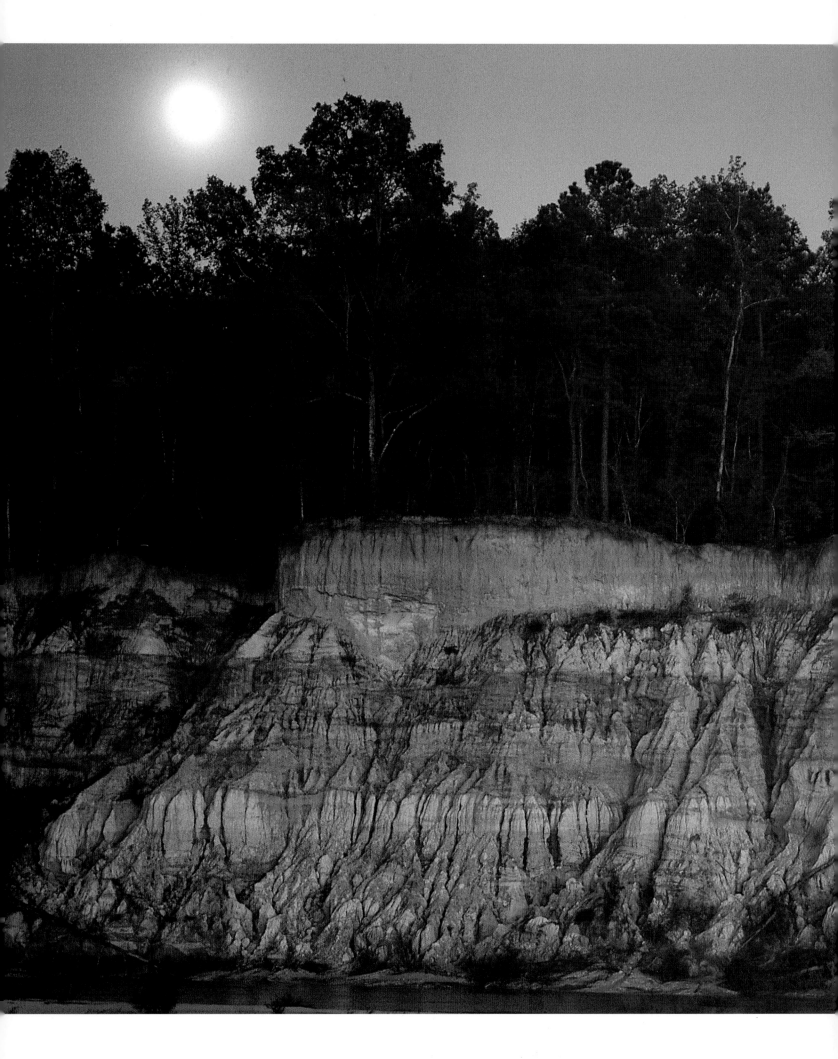

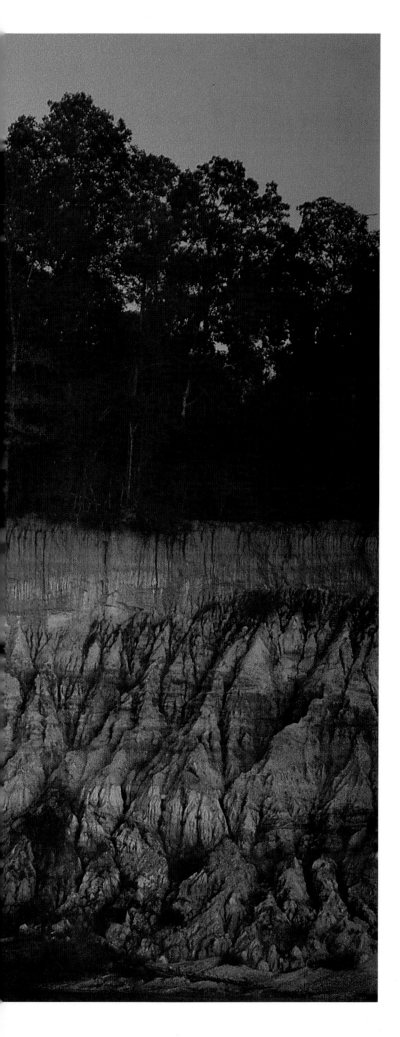

half as high as the bluff, and near the bottom a plume of clay made a turbid streak in the otherwise clear waters of the stream.

Another impressive bluff on Bayou Sara was a few miles away. It faces the setting sun, and I waited one day to catch the evening glow on the orange soils devoid of vegetation. A few minutes after the sun set, a shimmering white full moon rose above the pines, giving me a sense of peacefulness and beauty that only nature can provide.

Later, when talking to Emile Marchive, the owner of this bluff, I learned that he has lost one hundred feet of land in thirty years due to spalling off. Entire eighty-foot pine trees tumble down with the silt.

Continuing my Bayou Sara travels, I entered a small tributary, a stream. It was clear and sandy, just like the bayou, as it meandered up a ravine between the hills. Green mosses and ferns dressed its banks. The American beech trees are fairly large here and were dropping their fall mast. A rustle in the branches above, and I saw a cat squirrel already cutting those tiny seeds.

After a while the stream forked, and I took the left fork. I glanced up to see puffy white clouds drifting across clear blue skies and decided to lie down beside the stream to watch the cloud parade go by the leaves that I hoped would turn gold for my cameras in December. The creek bank was about eighteen inches high. I propped my tripod from the sand of the creek to the bank and did the same with my legs. It only took a few clouds to put me into a catnap.

Plod, crack, crunch! I awakened, but not with an abrupt spring to my feet. From experience, I slowly opened my eyes and looked left first, then right. An armadillo stumbled down the opposite bank ten feet away and ambled into the water. In the middle of the creek it stood to sniff the air, and I could see it was a male. Then he continued toward my side of the

The many moods of Marchive Bluff include the harvest moonrise (left).

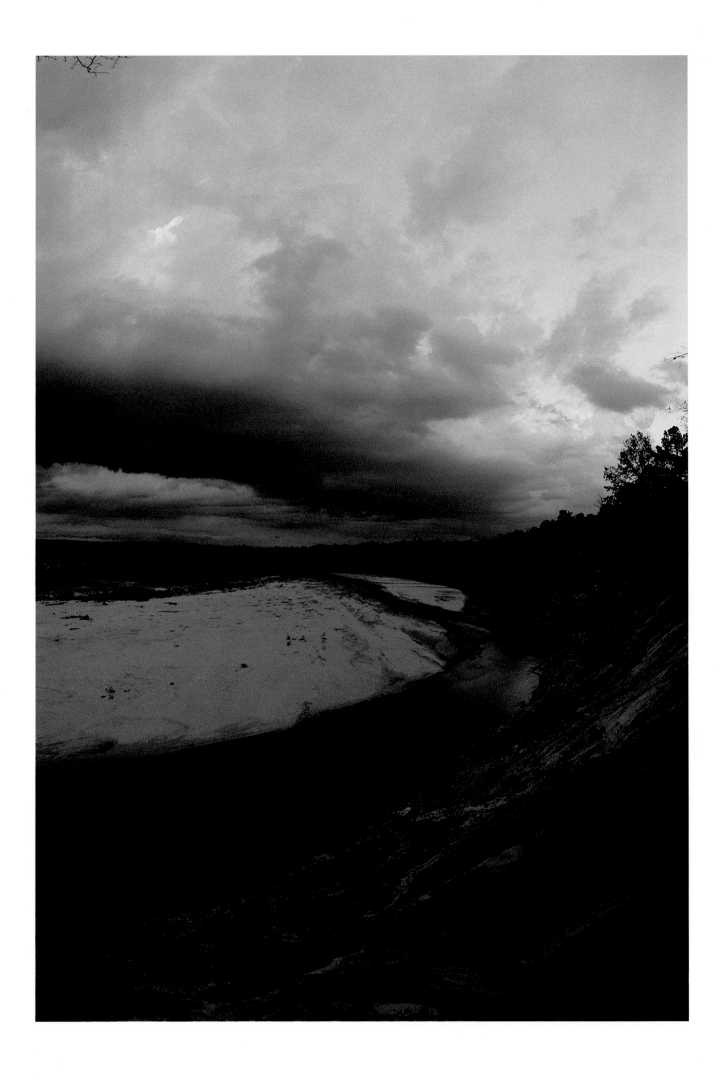

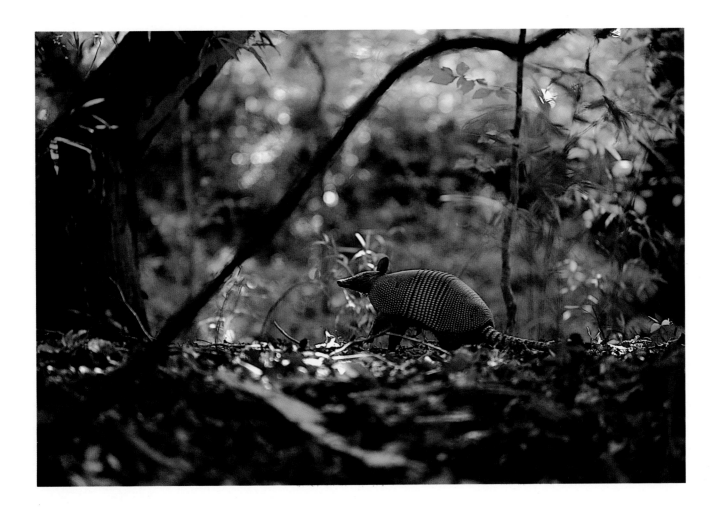

stream. Remarkably, he turned toward me and walked under the tripod, then under my legs, and a short distance away he started up the hill. All this time I was slowly pulling my camera into position so I could prepare for the picture. I snapped and the shutter gave a loud *kurwank*. No reaction from the dilla. He continued on up the hill while I rose slowly to follow so I could get a better picture.

Through the beech and magnolia forest, up hill and down glen, I followed the foraging armadillo for two hours. Every once in a while, his nose poking in the leaves and roots would detect something, possibly a big grub or a juicy tuber, and his feet would go to work like a D-9 backhoe. Occasionally he would use those three white claws to turn over a log. If it had termites, he would eat a few and then move on. Perhaps he left some so that there would be more next time. But more likely it was because prey species such as the armadillo always eat on the run. And on the run he was. Rarely pausing, he was creating a tough photographic situation in the low light of the understory. A click here and a click there and I knew I was getting a blur. Persistence paid off—I caught the nine-banded creature balanced on three legs sniffing the air with the beautiful glow of the lime green forest in the background.

Occasionally I would circle in front of the animal and let him pass. I soon learned that the vibrations of my footsteps alerted him more than anything else to

(left) *Marchive Bluff in a quick-brewing thunderstorm*

(above) *While searching a Tunica Hills forest for food, an armadillo,* Dasypus novemcinctus, *pauses to survey his surroundings for danger.*

(overleaf) *A small stream cuts through the beech-oak-magnolia forest of the Tunica Hills.*

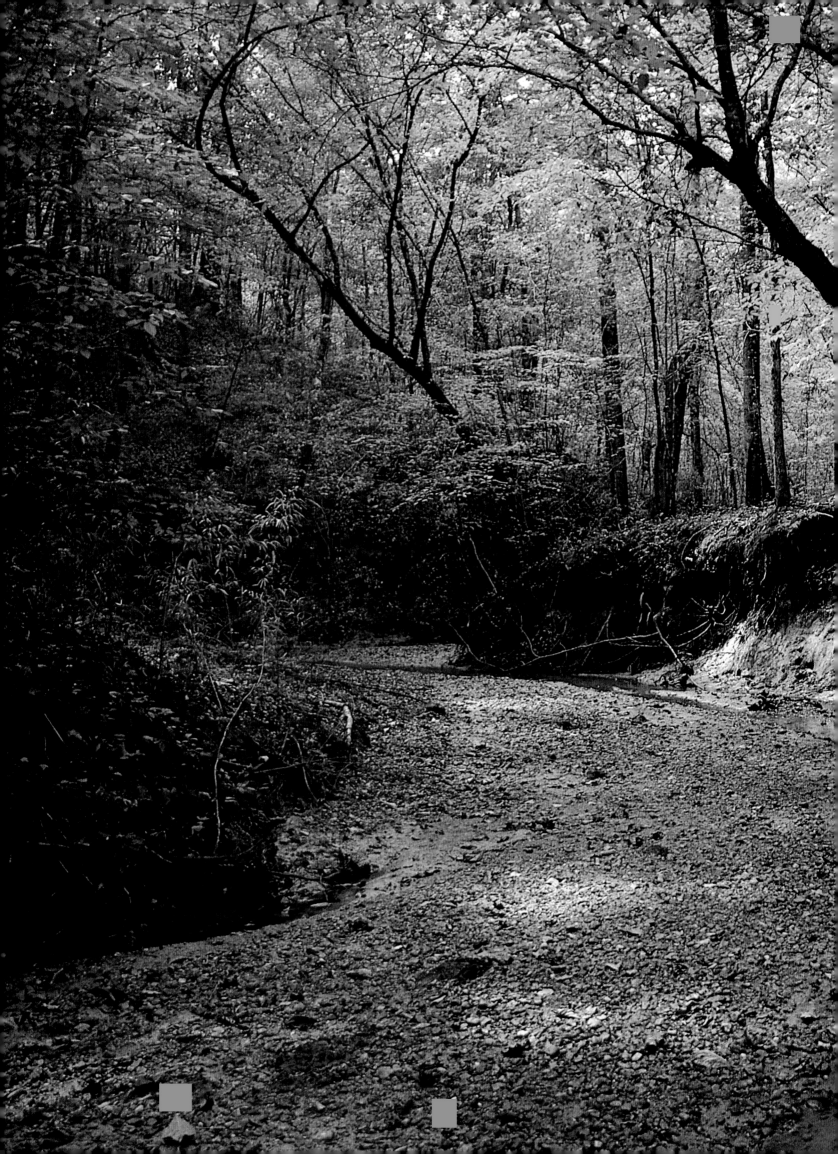

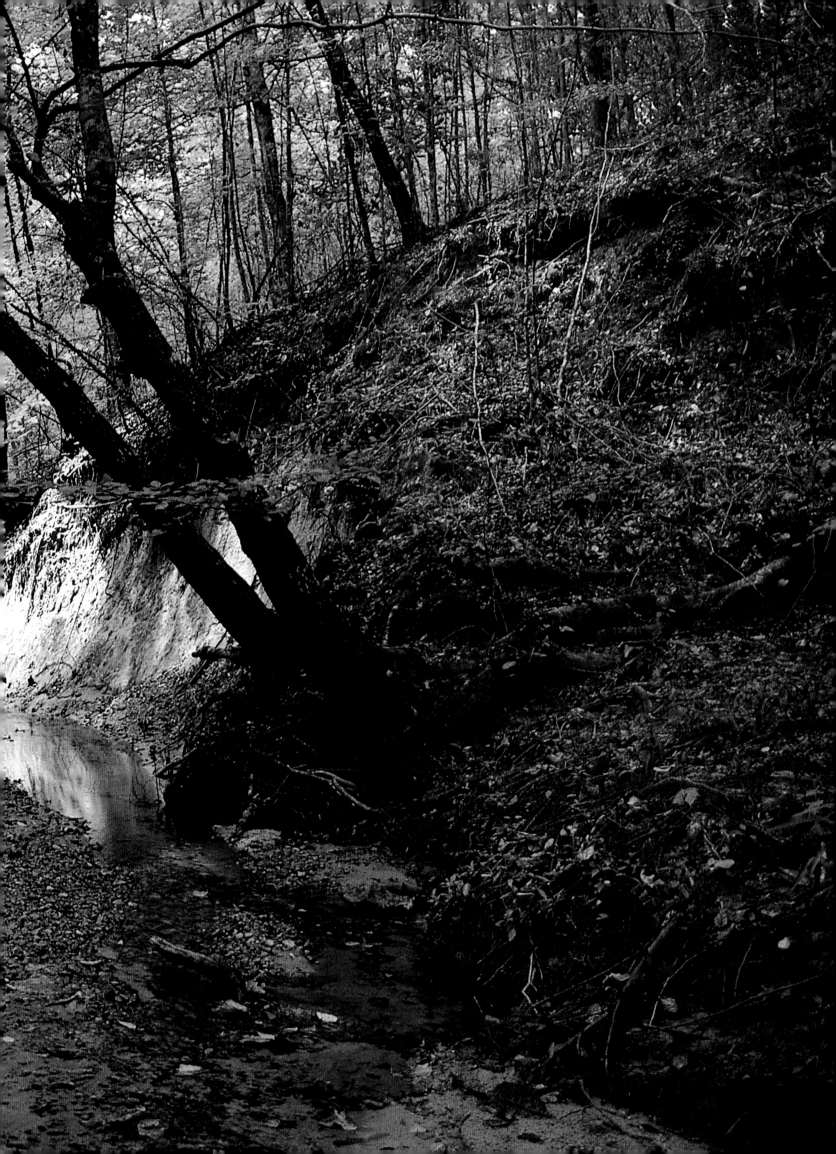

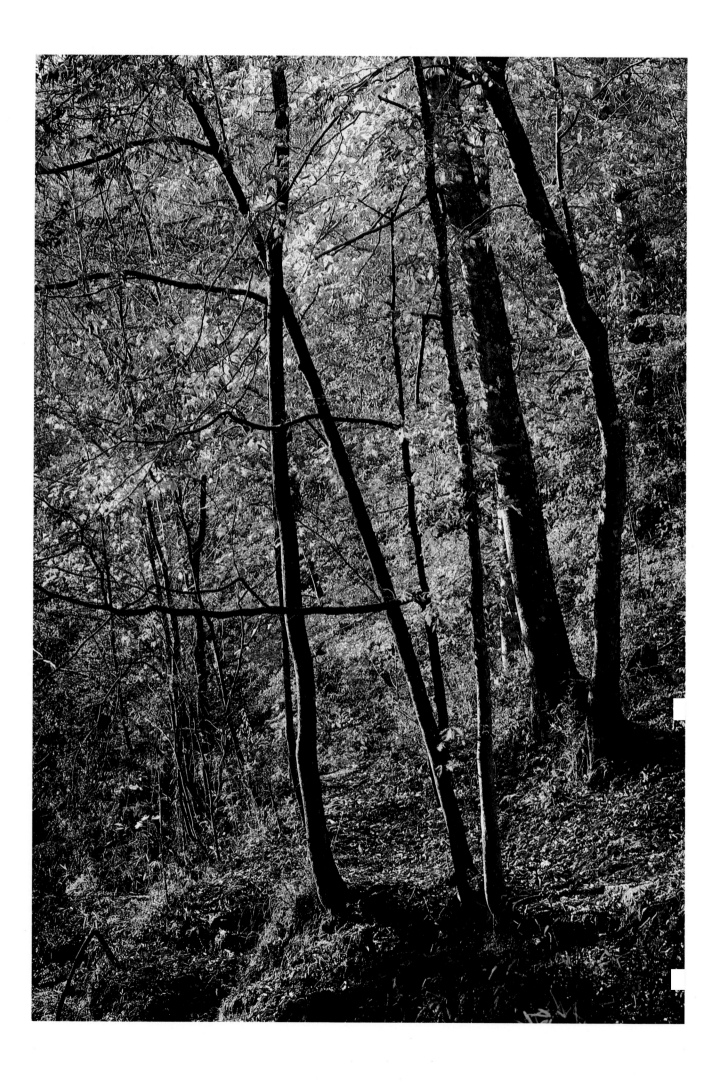

my presence. After throwing a big stick within two feet of the armadillo, I discovered that my vibrations must have been different from those of the stick landing—the creature did not even flinch when something as common as a fallen branch landed near him.

Soon he must have fed enough because he ventured into a hole beside the stream. I tiptoed away. Titmice and cardinals were singing in the branches above.

I've walked these same woods dreaming of the fall colors you see in Tennessee, Vermont, and New Hampshire. With our climate we'll never match them, but two days before Christmas one year we came close. On one of those unnamed creeks in the Tunica Hills, I finally got a photograph that said "fall." The beech and oaks were shimmering gold and orange in the low arc of the winter sun as it was setting.

It was one of those special days with the air crisp and sweet, but not yet cold. After my photograph I didn't want to leave. I sat still, watching and listening. I found it immensely more interesting than the Sunday football game or anything else I could be doing at home.

Twilight turned to dark and the golden hues of fall faded to gray. I put my pack together to leave. The evening chill set in and my eyes adjusted to the trail as I reveled in the courtship calls of the barred owl. Homeward bound.

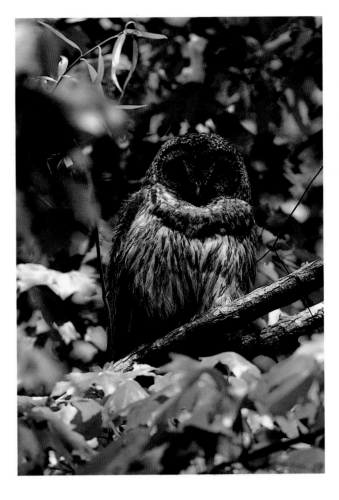

(far left) *A splash of fall colors dresses the beech and oaks near Thompson's Creek.*

(above) *A barred owl,* Strix varia, *sleeps the afternoon away.*

(left) *The steep and shady community of the Tunica Hills mimics a diverse eastern forest. A Christmas fern,* Polystichum acrostichoides, *is part of the scene.*

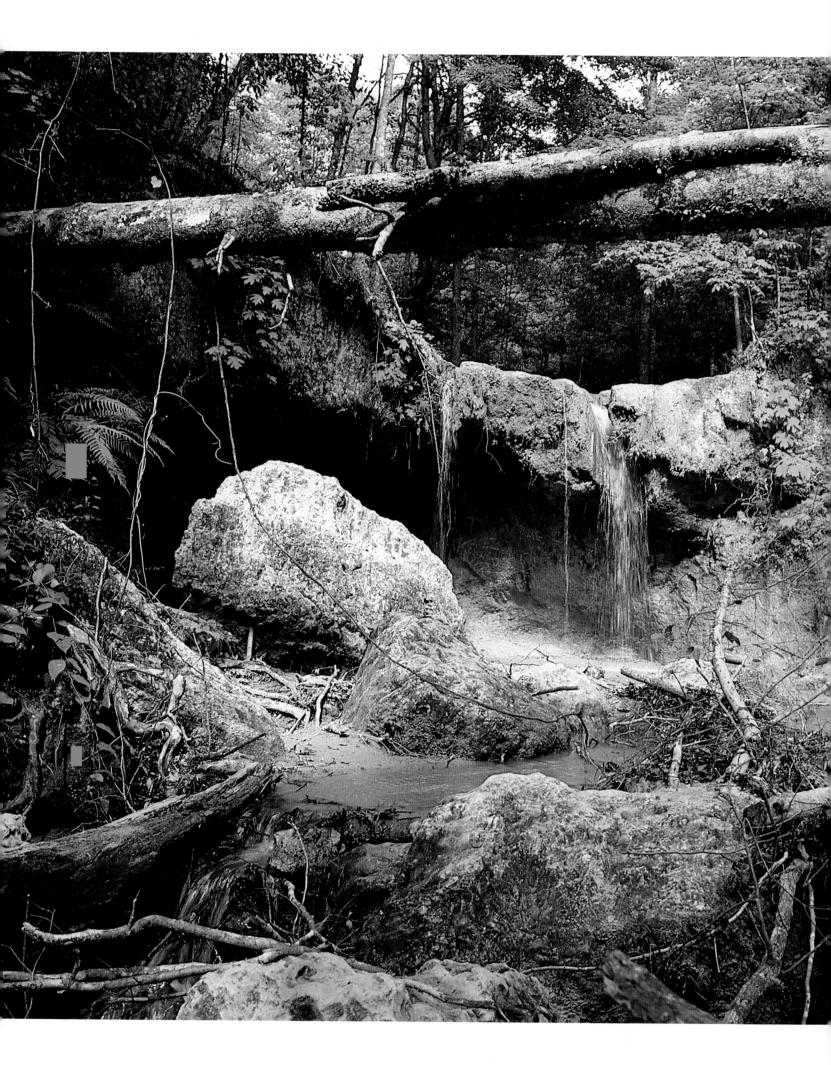

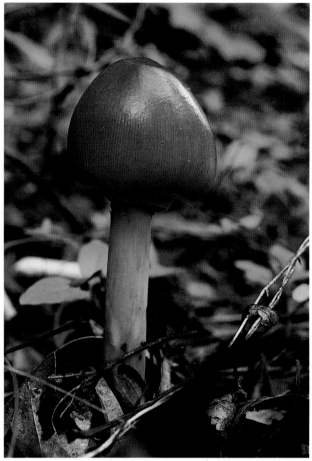

The Tunica Hills also boast some waterfalls. Clark Creek Natural Area has a series of seven falls on two branches of Clark Creek. Some of these falls tumble down hardened silt more than twenty feet. Large boulders, many weighing tons, litter the creek below each fall. The sandy creek with intermittent patches of gravel usually runs two to three inches deep. A trail along the creek and to the falls has been provided by The Nature Conservancy, and timbered steps help you along on the steeper hills.

The problem with these waterfalls, though, is that they are just over two miles out of Louisiana in Mississippi, and I wanted to find something just as big within Louisiana. My search led me to Grant Parish, just north of Pollock, to a place called Little Falls. I was told, always by witnesses who had seen the falls twenty years ago, that they were at least ten feet high and always flowing. All the directions were approximate and all just a little bit different.

(left) *One of the seven falls on Clark Creek, which tumbles down 100 feet out of the Tunica Hills into the Mississippi River*

(above) *A wet October brought out this mushroom,* Amanita umbonata, *and many more as well. Deer and other animals take advantage of this unusual fall food supply.*

(right) *White-tailed fawn,* Odocoileus virginianus. *Born with no scent and with spots for camouflage, the fawn can lie hidden in the grass while a coyote snoops only a few feet away.*

As the fawn grows up she will switch from the doe's milk to tasty treats like the fruit of the flowering dogwood (above).

On an early September morning, I hiked into the hills on the west bank of the Little River. Up and down I trekked, looking for, finding, and following small creeks as I searched for the falls. The day was passing quickly, and though I had not found the falls, I was enjoying the terrain of oak and pine hills rising from oak and cypress bottoms.

The white and overcup oaks had already dropped their acorns, and I saw the signs of many hogs and deer that had been feeding under the big trees. One baldcypress, twice as wide as I, had a grotesque formation—kneelike structures were attached to the trunk. Probably it grew that way during high water.

Quietly backtracking my morning steps as the woods began to fade into twilight, I caught a glimpse of a chase. Across a hill and into a ravine a fox chased a cottontail rabbit. The rabbit zigzagged for its life, with the agile gray fox in hot pursuit. Although seeing only a flash of this race, I'd bet on the rabbit. The spry fox can turn very quickly and even climb trees, but this rabbit looked healthy enough to outlast the tiring predator.

The crepuscular creatures were stirring, and I was hungry. I estimated that I was about four miles from my jeep, without a compass, and all these hills looked the same. I was not lost but turned around again, and I spent the next two hours trudging through the thickets with my tripod catching on smilax vines every ten minutes and abruptly bringing me

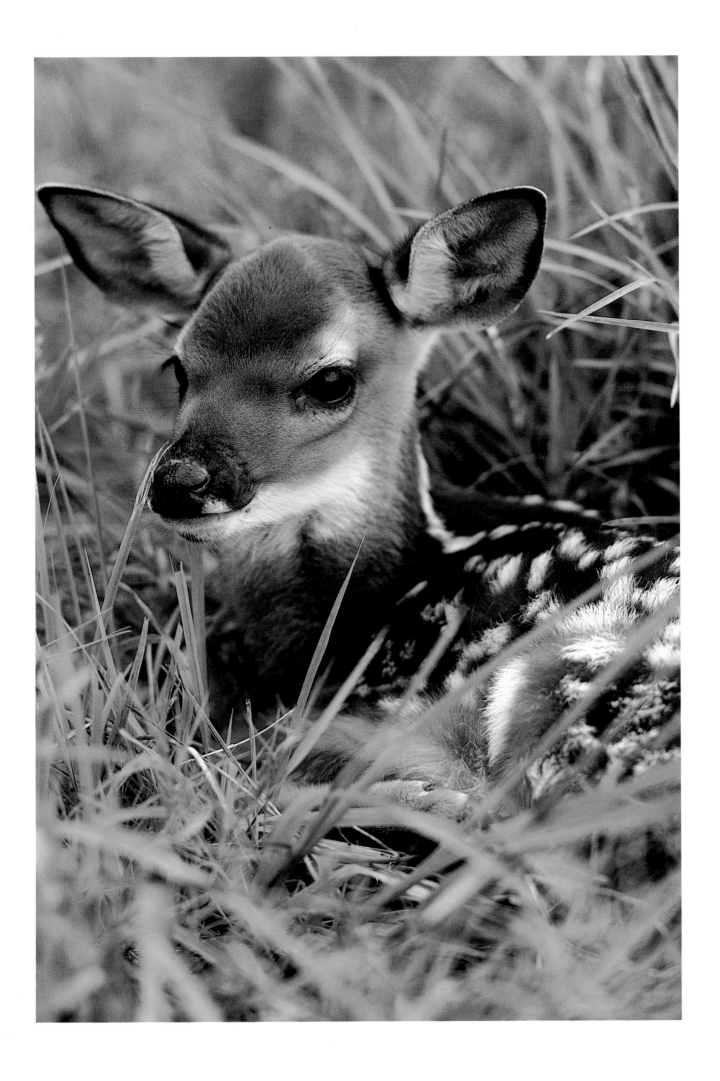

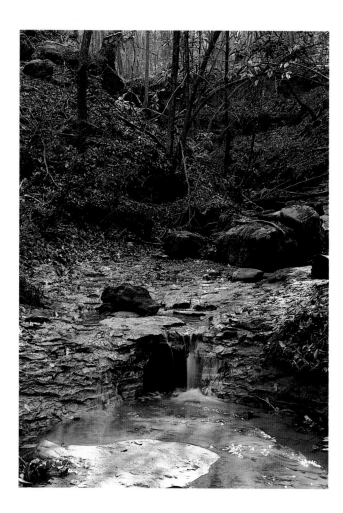

A spring-fed creek in the Sicily Island Hills offers some surprising Louisiana terrain—rocks, rapids, and a twenty-foot waterfall (above and right).

to a halt. Now I know why my dendrology professor called this plant "blasphemy vine."

Just as I had begun to think that I would have to settle for the rapids in Bayou Kisatchie, my search for a waterfall was given a big boost by Annette Parker, the botanist for The Nature Conservancy's Natural Heritage Program. Its staff had just visited the Sicily Island Hills Wildlife Management Area to look for rare plants. In addition to finding plants, they spied a twenty-foot waterfall. Annette's directions were much better than all those I had received in my hunt for Little Falls.

Sicily Island Hills, almost a perfect circle with a diameter of six miles, were sliced away from the chalk hills to the west by the Ouachita River. I could see by the tightly woven contours of the sectional chart that these oak and beech hills would be steep.

Arriving at the end of the jeep trail, I began walking and immediately discovered a fifty-foot descending slope. At the bottom the ground was already moist, almost soggy. Seeps or springs were the source of these falls. As the ground grew wetter, a depression was formed—the headwaters of the creek. After about half a mile, a true small stream had formed and I could hear the tumbling water just ahead. I moved on quickly. As I stood at the brink I was impressed. Can you compare this to the massive falls in Yosemite National Park? No way. I'm talking about Louisiana here—swamplands, marshlands, alligators in your backyard . . . and this beautiful little glade, horseshoe-shaped and adorned with ferns and mosses. At the base of the toppling waters rested a massive stone with sharp edges, leading me to imagine some geological feat that ripped it from the walls above.

For another mile the stream dropped over smaller falls, more like rapids, as it curved back and forth between points of each hill. As this February day came to a close, I noticed that the beech trees still had their leaves, all brown, dried, and curled. Louisiana blinks and misses the winter.

To experience fall, I recommend that you head toward Shreveport. Here you see north Louisiana's fall colors in a panoramic view, one of the few available in the state without climbing a fire tower or a tall tree. The panorama was from Bates Mountain, 330 feet above sea level. Normally you'd have to be up a tree to see from any of north Louisiana's hills, but Bates was clear-cut in 1981 and there is an unobstructed view twenty-four miles northwest to Shreveport and twenty miles west to the paper mill at Mansfield. That's a substantial distance for Louisiana, and it only happens when a front brings clear cold air, a perfect time to camp here and view the sunset, full-moon rise, and sunrise.

After setting up camp, I started piddling around with some of the old logs the timbermen had left and found a scorpion, *Centruroides vittatus*. The striped scorpion is the only scorpion species in Louisiana west of the Mississippi River and ranges from Allen Parish north to the Arkansas line. East of the Missis-

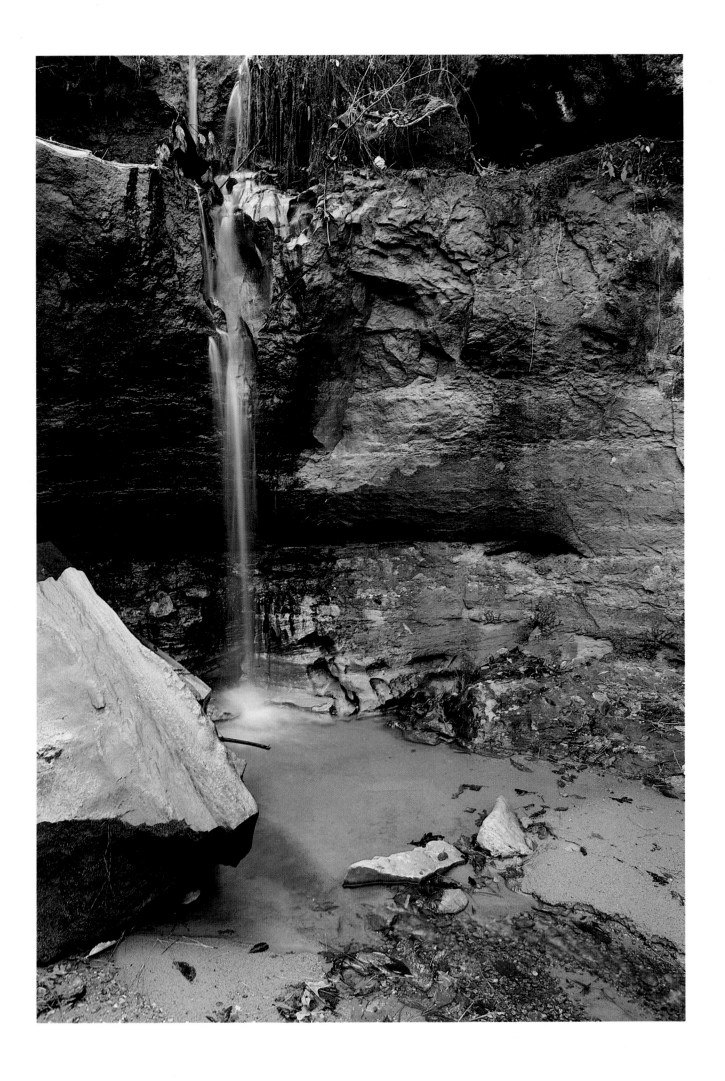

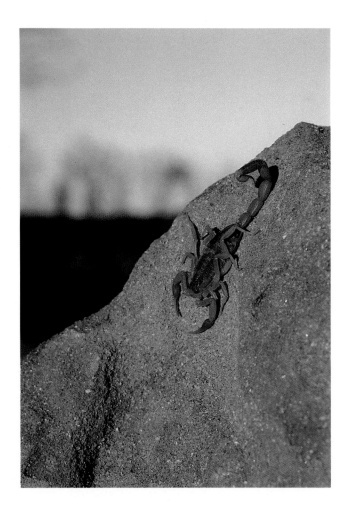

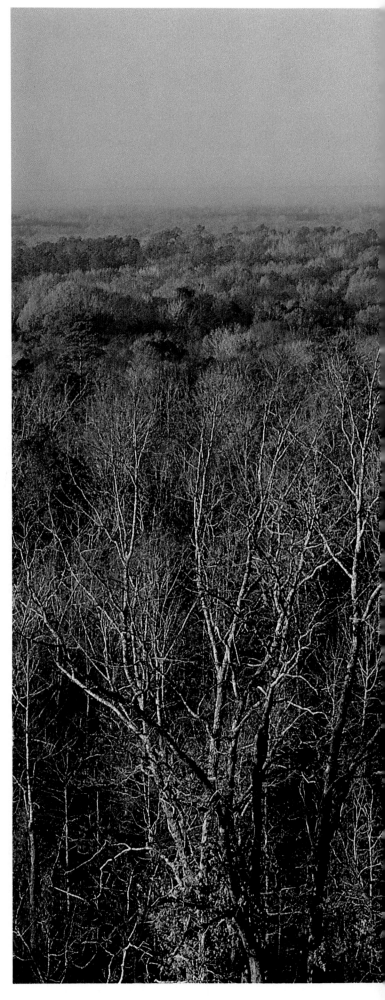

sippi is another species common in the Tunica Hills. I say common, but you have to turn logs and even peel off the bark to find these species.

A few rays of the afternoon sun warmed him or her up enough to crawl around the stump and a rock or two before going under again. I carefully avoided its painful stinger and got some close-up photographs. This scorpion's sting is not deadly to a non-allergic person. It would feel like a hard beesting. Out west they say it's a different story. One of the smaller scorpions there can put a man into blind staggers and is occasionally fatal. But just as with any wild creature, you have to be mighty unlucky or careless to be hurt by them. They never see us as food or prey, for we are too big and, I suppose, not very tasty. They only hurt us to defend themselves.

(above) *The striped scorpion,* Centruroides vittatus, *is one of the two species in Louisiana.*

(right) *The view from Bates Mountain of a diversified forest, which is much more productive for wildlife and recreation than are even-age pine plantations. The orange leaves are oak and beech trees; the green, pine trees; and the bare branches are hickory.*

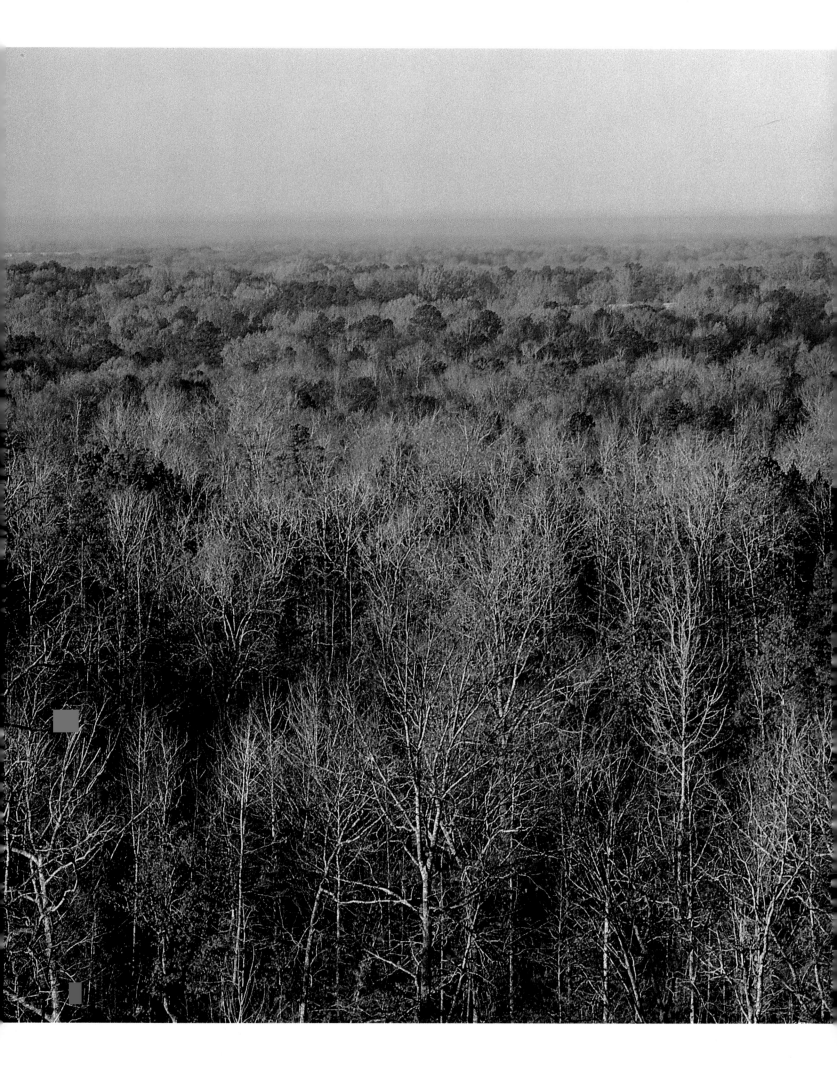

25

Letting the scorpion go its own way, I retreated to the top of Bates Mountain to start my cooking fire and await the Lord's light show. A few woodpeckers flew by in their undulating pattern as robins poured in to roost in the shrubby new growth of pines, oak, and hickory. Unlike more northern states, where people look for robins as the first sign of spring, Louisiana gets them all winter long and sometimes in flocks of thousands.

The sun set over the rolling hills as my sapling grill sizzled. I felt peace and awe. Clear cold air, a high-pressure glow with the scent of firewood and fresh food, and soon the full moon to dim the lights of Orion and Sirius, the winter sky's brightest star. What more could a man want? I ask you.

I awoke to the chirping of the robins more than thirty minutes before the sun rose. My coals were still glowing, and soon I had a fire heating my morning tea. The setting moon and the pink glow of a new day were dressing opposite sides of the sky. The glow turned out to be much more impressive than the sunrise, for as the sun peeked over the pines the skies were too clear to give it any color. But I enjoy the awakening of a new day as the stirrings of the diurnal wildlife replace those of the nocturnal. Sitting still at the apex of Bates Mountain, I caught a glimpse of a coyote way below, loping through the sapling loblolly pines, probably on the way to his den.

Many years ago the loping belonged to the red

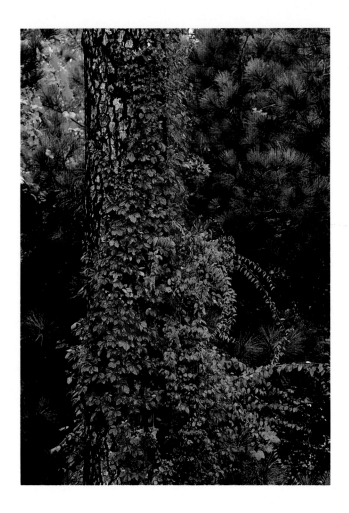

(above) *Loblolly bark*

(left) *A loblolly pine,* Pinus taeda, *near Ruston is covered by the fall colors of Virginia creeper,* Parthenocissus quinquefolia.

Although the use of fire is a necessary management tool in pine forestry (bottom right), *if used to make a monoculture it can contribute to the spread of the southern pine beetle* (top right).

wolf, now extirpated from all of Louisiana except Cameron Parish and more than likely hybridized out of existence there by dogs and coyotes. Historically, our nation had three doglike predators. The red wolf had its niche in the dense hardwood bottomland forest of the Southeast. The timber wolf roamed the Great Plains, the northern United States, Canada, and Alaska; the coyote's home was the open and arid Southwest.

Fearing the two bigger wolves, man began eradicating them with guns, poisons, and traps while changing the animals' habitat. With the competition gone and the forest opened up, the wily coyote moved into most of the rest of the United States. He arrived in Louisiana in the late 1940s and now ranges over almost the entire state.

Exchanging my binoculars for my camera, I prepared for my shot as the morning sun steadily put more light on my western panorama. From my pinnacle, I framed the rolling hills in the foreground. The bare sticks of the hickory branches showed that winter might be on the way. Beyond was the checkerboard pattern of a diversified forest. The yellow and brown of the oaks and beech contrasted with the ever-present green of the loblolly pine, except for a few patches where the southern pine beetle had struck, turning the pines to a rusty brown and killing them in a matter of days.

Diversified is the key word here. Nature evolves to-

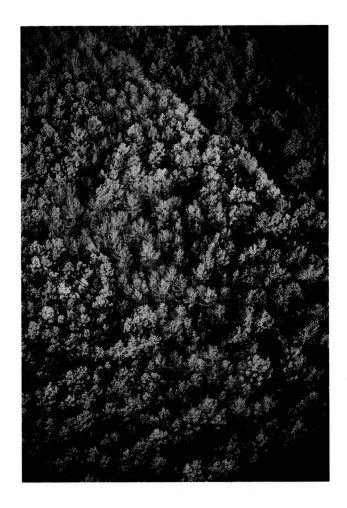

ward diversity and that's just what Skipper Dixon wanted his property to become. From the top of Bates Mountain, I was looking at the Dixon land of hills and valleys with small creeks draining into Loggy Bayou.

Historically, north Louisiana had pine on the ridgetops, pine and oak on the hillsides, and oaks turning to cypress as you went from the dried to wetter bottoms. Finally, all the smaller bottoms led into the Red River flood plain, which at one time contained 500,000 acres of hardwood bottomlands, but now is exclusively used for agriculture.

This diverse mix is in jeopardy and the situation gets worse daily. In the last thirty years, man has developed mechanized equipment so powerful that he can completely control the environment and easily make even-age, monocultural pine plantations. Why does he do it? Because it is the highest and best use economically of the north Louisiana hills . . . to the stockholders. Not to Skipper Dixon, not to me, and I'd guess not to the general public of Louisiana. We'd better call it the top-dollar use to the stockholder and hold the highest and best use for later.

Skipper gets the benefits of recreation and aesthetic satisfaction by keeping his forest diverse, and many other landowners are currently doing the same. However, he is worried that his children or his grandchildren may not feel the same way. He told me, "Any land in private ownership is doomed to

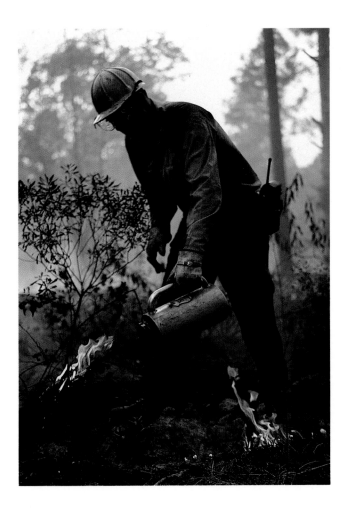

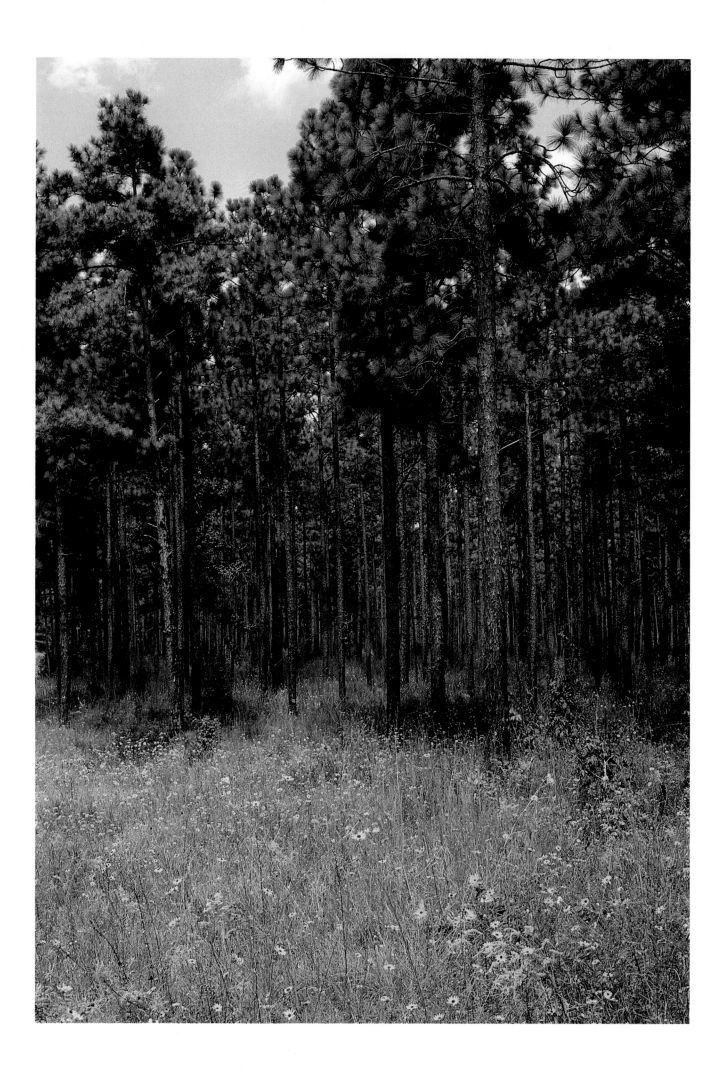

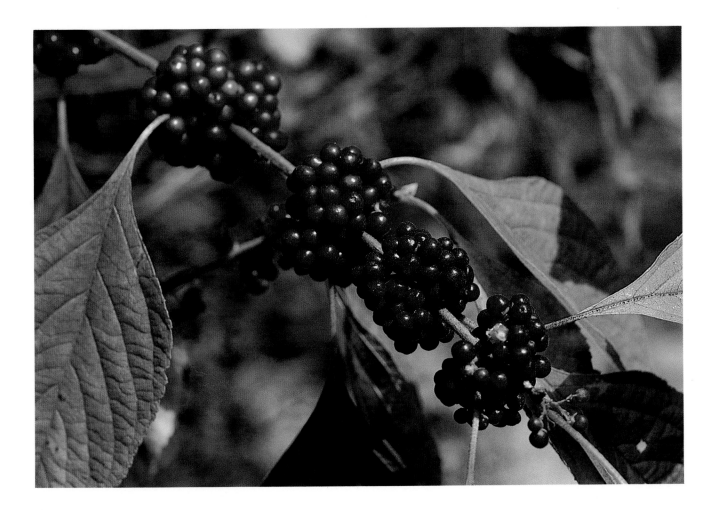

commercial exploitation at some point in time."

Skipper's axiom gives me a chill of fear, because of the 10,000,000 acres of north Louisiana forest left, 90 percent are privately owned. That leaves 300,000 acres of state wildlife management areas and 700,000 acres of federal lands. The majority of this acreage is in Kisatchie National Forest.

Those 9,000,000 privately held acres (mostly corporate lumber land) are on a breakneck course to even-age pine plantations. The like-aged trees are more susceptible to the southern pine beetle. The monoculture is far less appealing to wildlife, and the clear-cuts cause erosion and add to our already overly turbid bayous and rivers.

Our last stronghold may be in Kisatchie. Our state's only national forest contains 600,000 acres scattered throughout central and north Louisiana and divided into six districts. It is fairly accessible for Louisianans in the square formed by Lake Charles, Shreveport, Monroe, and Baton Rouge. Our national forests are dedicated to use by and for the American people, who own them. In the past, those in control of our national forest tended to go toward even-age pine plantations, but now I think the officials are beginning to realize that people want the higher and better use of diversified forest, which will still produce plenty of timber and also provide multifaceted recreation.

Caroline Dorman, writer, artist, forester, teacher,

(left) *Standing in rows like toy soldiers and decorated by sunflowers, the longleaf pine,* Pinus palustris, *in monoculture in Kisatchie National Forest is less than the best use for this land.*
(above) *French mulberry,* Callicarpa americana, *is a common understory plant in the piney woods.*

A seasonal creek on the Longleaf Vista Trail is bone dry in September (above). Castor Creek Scenic Area on the Wild Azalea Trail has a few giant pines like this loblolly (right).

and botanist, was the spiritual founder of Kisatchie National Forest and she almost succeeded in preserving a tract of virgin longleaf pine. Her failure, which is a sad tale, was told to me by Richard and Jessie Johnson. They are friends of the late Miss Carrie, as Dorman was affectionately called, and are curators of Briarwood, Miss Carrie's home.

Jessie told me, "Miss Carrie loved the longleaf pine, the virgin giants," and she showed me a picture of the Kisatchie founder resting against "Ole Grandad," one of the few trees left from the primeval forest.

"Carrie talked to legislators, forestry community members and lumber barons from 1920 until 1927 trying to get a tract of virgin longleaf pine preserved along Bayou Kisatchie. These giants were five feet across and went right up to the creek bank where Odom Falls are today. A magnificent piece of ancient forest. But throughout the South, lumbermen had found the southern pine and were mowing them down like wheat.

"The men she talked to," Jessie continued, "agreed with her and promised to help as seven years dragged by. Then, success! The government designated $80 per acre for this timber as a fair price. Then the local forester, perhaps thinking he would save the government some money, offered the owner of this tract, Spencer-Crowell, $12 per acre. Mr. Crowell must have laughed as he cut the trees.

"Miss Carrie got there in time to see the logging engines puffing across lovely Odom's Falls."

I almost cried when I heard that story. What a treat it would have been to be able to walk in a mature forest.

Our ancestors did us wrong by not leaving any virgin forest in Louisiana. Certainly they could have left us a few acres of longleaf pine, bottomland oaks, or baldcypress swamp. I guess it was just the attitude back then that the supply of natural resources was endless.

Richard Johnson related a story to me that confirms that attitude. Richard said, "It was my grandfather who was involved in some of the first products to be shipped out of the Saline, Louisiana, area on the new railroad. They were pigeons and ducks."

The pigeons he spoke of are passenger pigeons that flew in flocks of ten million in the 1800s. He continued, "Grandad and the hunting group would go into a known pigeon roost and brace 10-gauge shotguns pointed into the branches. They cut their shells partially in two so they would scatter more. Then they would wait for the pigeons to return and when the trees were full they would all pull the triggers at once. Then they would run like hell to get out of the way of the falling birds, feathers, blood, droppings, and branches. When the smoke cleared they would return, pack the pigeons in salt and put them on the train to Kansas City." After a short period of filling people's bellies in restaurants, passenger pigeons became extinct in 1914.

Richard and Jessie Johnson are much different

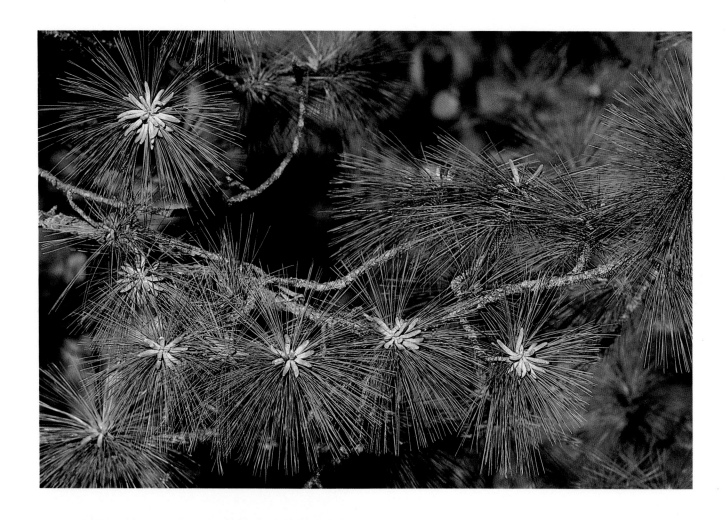

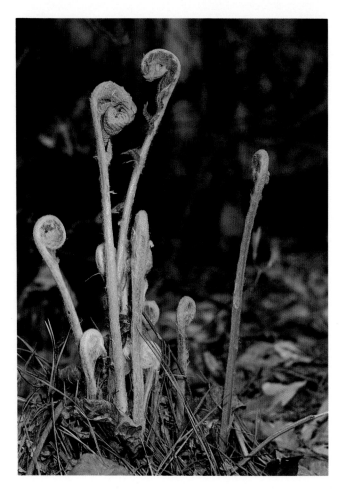

from their ancestor. They take care of Briarwood, a haven for native plants and home for much wildlife, the same way Caroline Dorman would have. People can tour the Briarwood hiking trails, as well as the Dorman cottage, in the spring and fall.

I spent quite a bit of time on Briarwood's eighty acres, happily walking its trails and photographing its flowers. Something's blooming almost all the time. One of the more aromatic was the sweet shrub, plain to look at but one of the most fragrant flowers I've ever smelled. Toward the opposite end of the spectrum was the star anise, a shrub with a beautiful red flower that smelled like a wet dog. Both beautiful and fragrant is the wild azalea. Others among the hundreds that caught my eye were the blazing red cross-shape of the fire pink, a delicate ground cover called green and gold, and most of the Louisiana native orchids.

Richard and Jessie have a story or unique information about most of the plants on the preserve. On showing me a cinnamon fern, Richard told me of its medicinal uses. He said that early Louisianians mixed the spores with soot and spider webs to stop bleeding. Not many people use this anymore, but plants and animals are the basis of most of our drugs, medicines, and vitamins, as well as many other products. And did you know that one North American species is wiped from the face of the earth every day? How many wonder drugs have we missed? How much

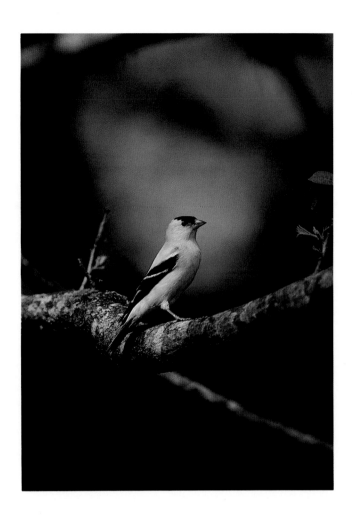

wonder of the world have we missed?

That's why it was an important step when the federal government finally began buying up Kisatchie in the 1930s. It wasn't much of a forest, but rather an eroded mess of squandered land that the lumber barons cut and then abandoned. By the 1970s, with most of our lands in second-growth forest, it produced an average annual yield of 153 million board feet. That's enough to build 15,300 average houses. Kisatchie has an estimated 4 billion board feet of merchantable timber on the commercial forest land.

But Kisatchie's not just a timber farm. It's designated by Congress as a multi-use area for recreation, soil conservation, clean water, research, lumber, and many other activities.

One of my favorite areas is the Kisatchie Hills Wilderness Area, located thirty miles south of Natchitoches. These 8,700 acres are dedicated to natural forest: no harvesting, no grazing, no motorized vehicles are allowed. On the Longleaf Vista Trail, you can take an hour hike and see the fringes of the Red Dirt Wilderness area, as it is sometimes called. The short hike takes you over two buttes with steep rocky sides and gives you a view of the rolling hills of the Kisatchie Wold. If you're up for hiking in the rain, a dry creek bed turns into a small waterfall, and in the spring the wild azaleas and dogwoods are beautiful.

For a more serious wilderness experience, you can venture on into the hills and probably never see an-

A close-up view of the piney woods reveals an emerging cinnamon fern, Osmunda cinnamomea *(bottom left),* the flowers of longleaf pine *(top left),* an American goldfinch, Carduelis tristis *(above),* and the deep red of the fire pink, Silene virginica *(right).*

(overleaf) *One of two buttes along the Longleaf Vista Trail. There is a world of difference between this and the marshes of south Louisiana.*

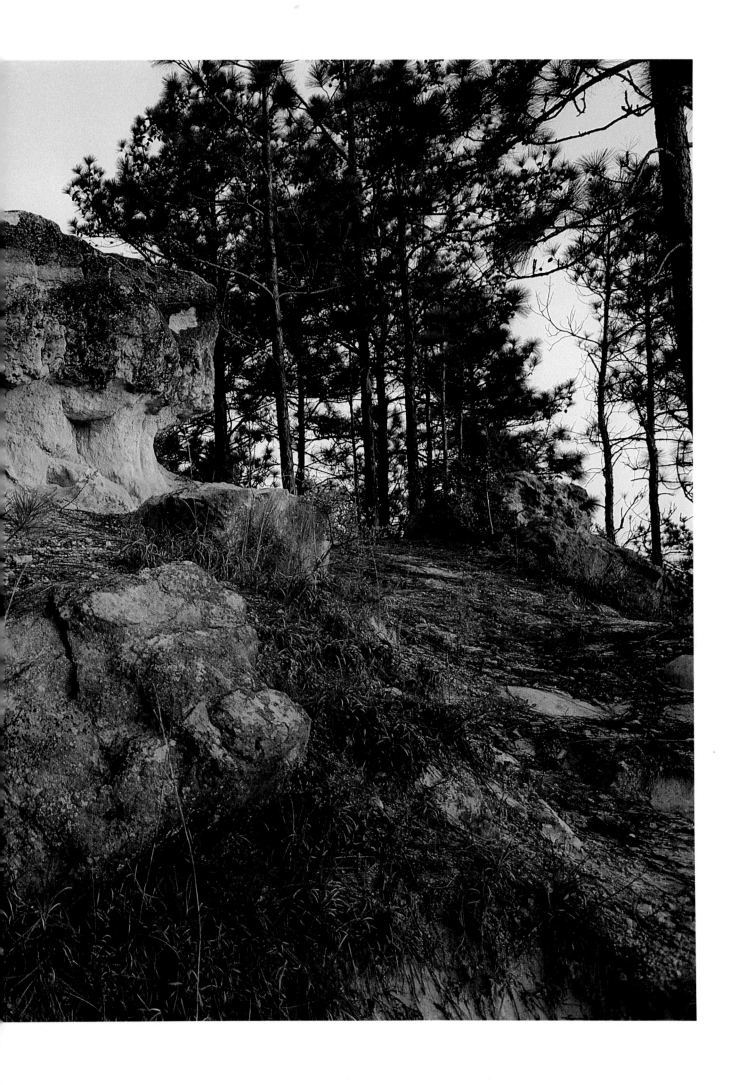

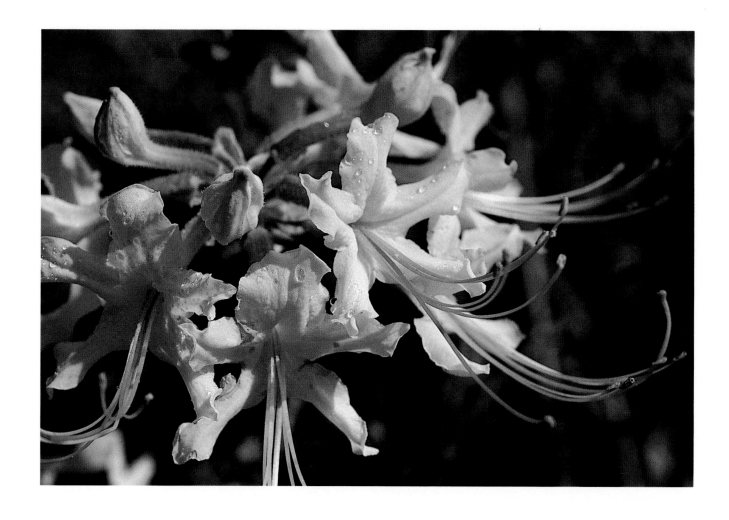

Flowering plants such as the wild azalea, Rhododendron canescens (above), *the green and gold,* Chrysogonum virginianum (top right), *and the Indian pipe,* Monotropa uniflora (bottom right), *dress up the hill country. The Indian pipe is a perennial herb that lacks chlorophyll, so it never has any green.*

other soul as long as you hike. I'm just wishing I could live for sixty more years so I could see Red Dirt when the longleaf pine become giants like those described by Caroline Dorman when she roamed the banks of Bayou Kisatchie.

Another great hiking spot is the Wild Azalea Trail in the Evangeline Ranger District. This scenic, thirty-one-mile trail is particularly beautiful in the springtime when the azaleas are in full bloom, but it is interesting any time of the year. For the botanist or forest ecologist, it offers a diverse range of habitats, including mixed pine hardwood, pure-pine plantations, upland hardwoods, bottomland hardwoods, bogs, and clear-cut areas.

The trail goes from Highway 165, seven miles south of Alexandria, to Valentine Lake Recreation Area. But there are a few forest roads crossing the trail, so you can take a shorter hike. One of my hikes there was with The Backpacker, a Baton Rouge outdoor shop. The group of nineteen was led by Jeff Masters and Jill Robbins, veteran Wild Azalea trekkers. I joined the group to photograph Kisatchie recreation for the magazine *Louisiana Life*.

It was a great fall day and the hikers were all smiles as we began to follow the yellow blazes that accurately mark the trail. It was a good group and included a big fellow from Baker and his wife. Rambo-like, and just as prepared, he toted an eighty-pound-plus pack. He carried not only his gear and

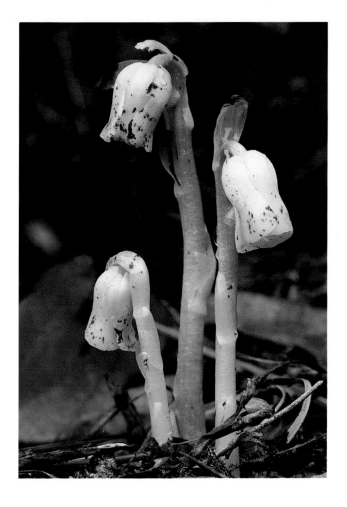

most of his wife's gear but also first-aid and survival items to last our group a week if we had gotten lost. His wife carried some gear plus twenty pounds of rocks. It was her first backpacking trip, and they both wanted her to get used to carrying a pack, but still be able to jettison some if need be.

We hiked about nine miles of our twelve-mile hike the first day. To be by water, we had to camp near quite a few other people—a group of scouts from Alexandria and an ecology class from Lafayette. We went upstream far enough to be almost out of earshot of the scouts. It was strange to meet so many people after having the hiking to ourselves all day.

The creeks were the most impressive to me. We crossed four. All were crystal clear and sandy—much different from those in the bayoulands.

I later visited the national forest creeks again, this time in search of *Margaritifera hembeli*. *Margaritifera* is an animal known to exist only in a few of Kisatchie's smaller creeks. Its entire range is less than two square miles. I found this rare mussel with the help of Nancy Craig and Gary Lester of The Nature Conservancy's Natural Heritage Program. It's their job to catalog all the unique areas and the rare plants and animals within Louisiana. Then when monies become available for private, state, or federal parks and refuges, we will know what the most crucial areas are.

Margaritifera is a freshwater mussel about four

inches long, black, with ridges showing its age. Quite plain, it stands upright in the sandy bottom of a shallow creek. Its slimy foot anchors it while it siphons nutrients from the creek. We saw three colonies of ten to fifty mussels, and that may have been 2 percent of the world's population of *Margaritifera*.

This mussel is under consideration for addition to the federal endangered species list, but one Kisatchie creature that is so classified is the red-cockaded woodpecker. Unlike other woodpeckers, it nests only in live trees, particularly in old longleaf pines that have red-heart disease. The core of the tree is easier for the woodpecker to drill into. It's quite a task, though, in spite of the disease. Sometimes it takes three or four months for the eight-inch bird to make a nest hole.

These hammerheads live in colonies. Young from a couple of years back often help with the nesting activities. Watching a nest one day in the Vernon Ranger District of Kisatchie, near Leesville, I saw the endless supply of spiders, caterpillars, and grasshoppers that the parents and last year's siblings brought to the sticky nest-hole. The red-cockaded drills sap wells above the nest hole, letting the pitch drip down. This discourages tree-climbing snakes from eating the eggs.

The bird is endangered because of habitat loss. Modern forestry practices cause the trees to be cut down before they become old enough to get red-

(above) Margaritifera hembeli, *a mussel known to exist in only a few small creeks in Kisatchie National Forest, is one of Louisiana's rarest animals.*

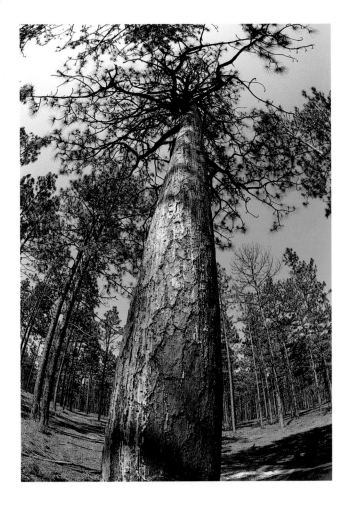 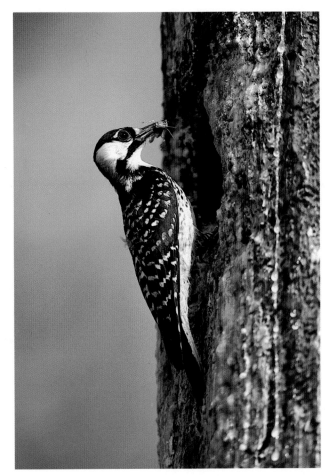

heart disease, thus knocking out another niche in Louisiana's natural habitat. Now that man has realized some of his mistakes, some areas that house red-cockaded-woodpecker colonies are cut around. Biologists in Kisatchie mark trees with three blue stripes to indicate a nest tree.

This is a start. I'd like to see a patch of never-cut forest in every parish, not only for the red-cockaded woodpecker, but for our schoolchildren to see what a primeval forest looked like when the Indians first walked Louisiana.

Louisiana is the "Sportsman's Paradise" because it has diverse habitats. The hills and terraces are the epitome of diversity. Location, soils, steepness, climate, and even a few feet of elevation dictate a new habitat. Tumbling down these hills are waters from seeps, springs, and rainfall leading into our scenic rivers and lakes.

A longleaf pine with red-heart disease is the only place a red-cockaded woodpecker will nest. The sap flowing down this nest tree (left) protects the nest from snakes. An adult woodpecker brings a grasshopper (right) to the young.

2

Scenic Rivers and Lakes

In 1970, while the state legislature was passing Act 398 to protect selected rivers, streams, and bayous, I was in classes at LSU. Because so many of our streams were ruined by snagging, straightening, channelizing, and clearing right up to their banks, we needed this law to protect a few of them for wildlife, for recreation, and for beauty.

Today the Louisiana Natural and Scenic Streams System includes forty-nine of these waterways, and I have traveled nineteen of them. One of my favorite excursions was in Washington and St. Tammany parishes, and a journal of my trip reads like this . . .

Surely it was no fault of mine. New-blooming flowers, bubbling rapids, and glimpses of wildlife were to blame for the fact that I was well behind schedule on a hundred-mile, five-day canoe trip down the Bogue Chitto and West Pearl rivers. Here it was near twilight of the third day, and I had yet to make fifty miles. The only way to catch up would be by skipping supper and paddling on into the night.

As the sun dropped below the tree-lined banks, the crystal-clear waters turned in rapid succession to blues, then to browns, and finally to black. Slowly, stumps and fallen trees began to blend in with the river.

Every vine looked like a coiled snake as the hallucinations of nighttime began.

In the darkness, I could see little difference between the starless sky, the tree-lined banks, and the water. My feeling of wonder at the river's beauty turned to excitement and a touch of fear as the front of my canoe bounced over stumps, logs, and gravel bars. If my canoe struck something unexpectedly in the swift waters and turned over, all my gear would be lost downstream in the darkness. It was then I decided that making up lost time wasn't worth the risk, and I turned for the invisible bank. Too late. The current drove me sideways into a fallen tree, and the starboard gunnel dipped into the black waters. I leaped over the opposite side, crashing my thigh into a submerged stump.

As I sank into a four-foot hole I grabbed the canoe to keep it from flipping. Luckily, I was able to align it with the current and drag it to shore for the night.

When I started this trip on April 27, 1981, I was launching an exploration of nine of Louisiana's scenic rivers for *Louisiana Life*. (See Appendix C for a list of all forty-nine scenic rivers.) As I had planned my route down the Bogue Chitto, I figured that I could fly a small plane and in twenty-four minutes cover the forty-eight miles from start to finish, or I could

Tranquil reflections reveal more detail than the scene itself where a tributary enters the Bogue Chitto River near Enon.

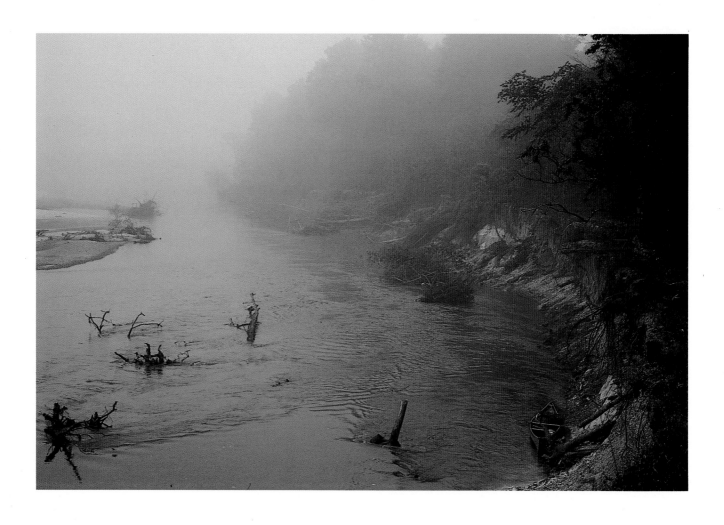

A natural stream is productive and beautiful, and Louisiana is fortunate to have forty-nine waterways protected. Act 398 protects rivers like the Bogue Chitto from channelization and straightening (above and right).

take a car sixty-three miles and do it in ninety minutes. So why take five days to bend a canoe around logs and sandbars to travel a hundred miles?

First of all, it is my job. But more than that, it is my recreation, and I love such a journey. It is a time to be alone, to think, to be free of any decision other than which sandbar to camp on tonight.

An average five-day canoe trip usually goes like this for me: Day one is filled with excitement—the thrill of getting out on the river. I feel invincible, so I soak up too much sun and paddle too hard. By day two, I am dirty, disorganized, tired, and sunburned. The luxuries of civilization are too close behind to forget. On day three, I am still tired from the sunburn and overexertion of the first day, but getting tougher. Day four is the charm. My strength has caught up with me, suntan takes over the burn, and the dirt is an accepted part of my existence. And finally, on day five, I am a part of the river. I slow down to a crawl to savor every minute before I must return to civilization. Toward the end of a two-day trip, you find yourself looking around every bend to spot the bridge and your car. But on a five-day trip, you slow at every bend hoping the end will never come.

On the first day of this trip, I had been dropped off at the Warnerton bridge near the Louisiana-Mississippi border on the Bogue Chitto River with canoe, two paddles, two gallons of water, fifteen pounds of food, and sixty pounds of cameras and

42

film. With this I planned to spend five days on the Bogue Chitto and West Pearl rivers and travel over a hundred miles to a bridge on Salt Bayou below U.S. Highway 90 near Lake Pontchartrain. What I did not have was my voice—laryngitis—but, since I didn't need to talk for five days anyway, what did it matter?

Day one took me through familiar waters, for I had paddled the stretch between Tylertown, Mississippi, Warnerton, and Franklinton many times. Passing the usual sandbars and swimming holes, I paddled on, stopping finally when I saw some cave swallows flying in and out of holes in the riverbank. A cliff rose nearly vertically out of the water, and it was almost impossible to climb because of the avalanching sand. Finally making it to one of the holes, I peered in with a flashlight. No eggs, but some feathers and leaves. Possibly a family of cave swallows will be raised here later this spring.

On day two, I awoke to see a fog rolling down the river like grandma's molasses. I crossed the river and climbed the cliff to photograph the fog. Once on top, I attempted a wolf howl to show my appreciation of the scenery, but the voice had not returned.

A few miles down the river I stopped at a little creek and climbed a steep sixty-foot bank to investigate the sound of heavy machinery. It was a sand and gravel operation, perhaps the worst enemy of Louisiana's Natural and Scenic Streams System. Later in the week, I ran into a hoop-net fisherman on the West Pearl. He had grown up in Warnerton. "The gravel pits are ruining the Bogue Chitto," he said. "Twenty years ago it was much more beautiful. The water was deeper and the stream narrower, but still with gravel bars. The gravel companies dig up the gravel and squirt the sand back into the river, and that makes it wider and shallower. There aren't as many fish here as there used to be," he told me.

According to Maurice ("Blue") Watson, with the Louisiana Department of Wildlife and Fisheries, sand is a biological desert. On the other hand, gravel has little nooks and crannies that caddis, stone, and mayfly nymphs can hide in. These form a food supply for the fish.

On down the river, I stopped to pick some of the dewberries growing profusely along the banks. I saw a hawk swoop for a mouse and later an osprey plunge into the river for a fish. The osprey stayed with me for two days. A swallow-tailed kite and the osprey were two of the rarest of fifty-plus species of birds I saw on this float.

On day three, it grew hot enough to swim, but I spent most of the time paddling hard, since I was behind schedule. The river was narrow and swifter for most of the day. On one bank completely overhung by trees, vines, and moss, I noticed a little community of moist algae, lichens, mushrooms, and spiders. Springwater dripped through the soil, and it looked as if the sun never hit this hidden bank.

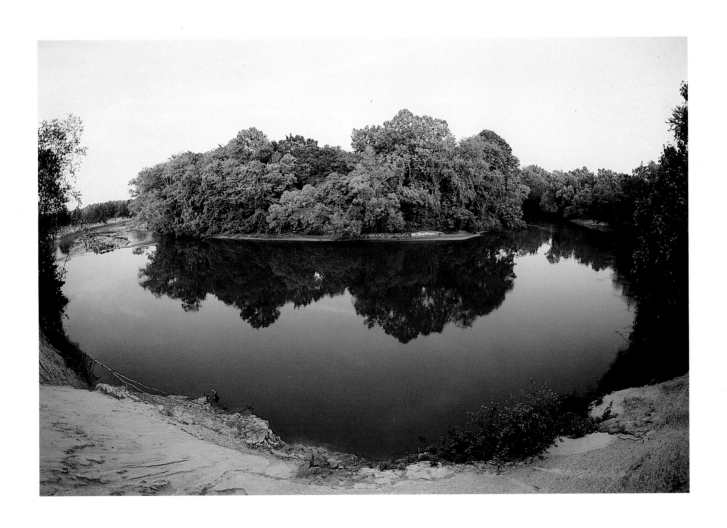

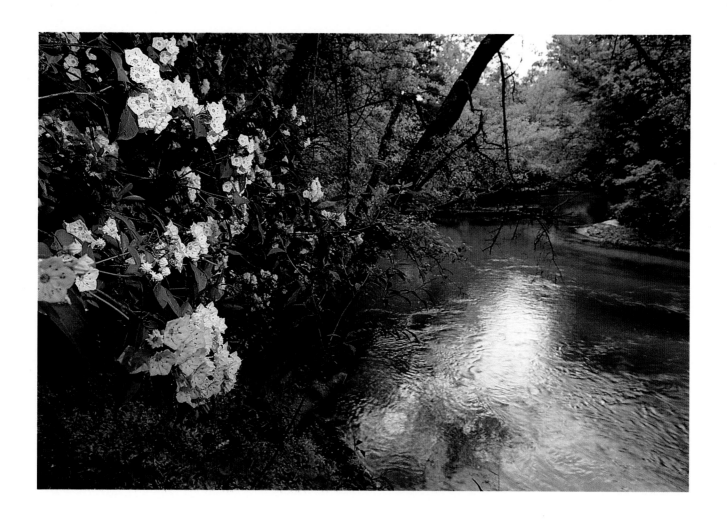

Another scenic stream is the Pushepatapa in Washington Parish (top right), *one of the few places the mountain laurel,* Kalmia latifolia, *grows* (above). *It is a favorite food of the tiger swallowtail butterfly,* Papilio glaucus (bottom right).

That night, came the series of events that ended with my leaping from the canoe, right on top of the hidden stump. The next morning, I awoke to find my thigh black and blue.

On day four, I approached the West Pearl, and it started to look more like swamp and less like a Florida Parishes stream. Lots of turtles today. At lunchtime, I finally crossed the spillway into the Pearl River Basin.

Just below the dam, a woman who was fishing with her husband noticed my camera equipment and asked if I was into photography. I was surprised when my broken voice replied, "Yes." It was the first word I had spoken in four days. She said cheerfully, "So am I. You'll see some great sights on below."

After lunch it finally rained. It was a soft rain, so after writing in my journal and watching the ink smear on my notebook, I put on my poncho and paddled on.

By quitting time, the sun had come back, and I found the governor's suite of all my campsites. On a bend in the river, layer upon layer of soft silt and fallen leaves had piled up from the previous high waters. It was almost spongy, it was so soft.

On the morning of day five, I began to regret that my trip was almost over. The skies were perfectly clear, and I ran into the nicest stretch of paddling I have ever experienced. The course was almost due east. The river was narrow with high banks. The tall

trees were beautifully sunlit from behind. The water was fast, with many obstacles, so I let out an owl hoot and shot the stream with total abandon.

At five o'clock, I passed under Interstate 59, turned up a little canal to the town of Pearl River, and ended my five-day trip.

Adventure is rampant on the varied rivers that compose the system. In Allen Parish, my bare feet have squeaked in the quartz sand on the Whiskey Chitto. In contrast, I have slapped mosquitoes and photographed alligators while standing in knee-deep mud at the edge of Bayou Penchant. Between Shreveport and Minden, I have paddled through the morning fog on Bayou Dorcheat and gazed at the rusty fall colors of cypress and sweet gum. Dodging lightning bolts from a summer thunderstorm on the Tangipahoa River was a lot less fun than finding spiderflowers to photograph or swimming in the rocky rapids below the falls on Bayou Kisatchie.

One of my favorite spring flowers is known naturally only in streamside communities of Washington Parish. I hiked and searched the banks of the Pushepatapa Creek one April day to find this shrub. The clean stream bends around so much you would think that it crosses back over itself like a carpenter's folding ruler. It seems as if you walk miles to progress a few yards in one direction.

The lovely white and pink flowers of the mountain laurel were easy to find. Between intermittent spar-

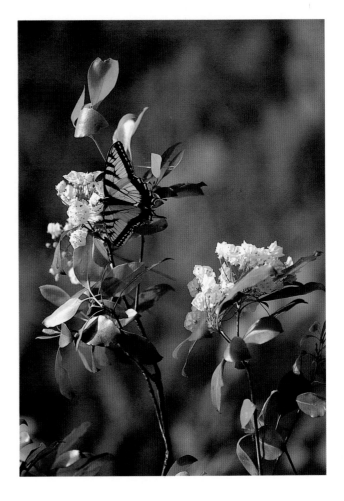

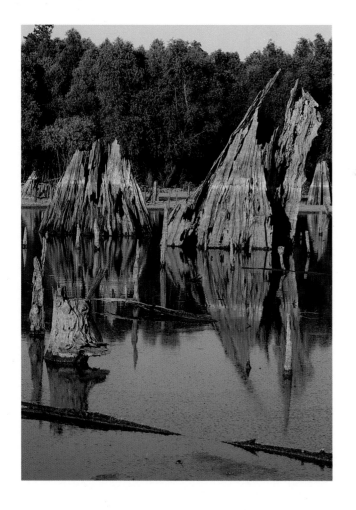

kling white sandbars, this locally common shrub was in full bloom. Close inspection revealed this flower's secret of reproductive success. Its stamens (male parts) are locked into the petals. As the flower opens, the petals release the stamens in catapultlike action to fire the pollen into the pistil (female part), thus fertilizing the flower. An insect landing on the petal can do the same thing.

Some branches, chock-full of flowers, dangled over the stream that is one of Louisiana's best creeks for small-mouth bass. The streamside vegetation here is rich and dense, a shaded, cool, hardwood community that's important to the species of plants here as well as the fish. Our Scenic Rivers Act protects the actual water and bottom of the Pushepatapa Creek, but additional legislation is needed to ensure a green-belt along the waterway.

Not only for the mountain laurel but for fish reproduction, the canopy provides shade to keep the water temperature cooler. Fish begin to breed by photoperiod (length of day) or by water temperature. Without the bankside trees, the water could warm up quicker as the sun hits the stream longer, thus triggering the fish to breed early. A cold snap could kill the eggs or the fry.

Downstream, the community along the Pushepatapa changes to higher banks and a more open, drier habitat. Here the turkey oak grows. There are only fifty, maybe a hundred small oaks of this species in

the entire state. This small area mimics like-habitats in Florida where the turkey oak is more common. Why did they name it turkey oak? Simple—the leaves look like a turkey footprint.

Scattered across the state, these forty-nine streams, rivers, and bayous are important to the aesthetics, culture, and history of Louisiana. They flow through almost every type of habitat in the state and show off such beauties as the mountain laurel. The waters are generally clear and certainly cleaner than our other rivers. Wildlife and recreational opportunities are always much greater along the diverse communities associated with water.

With its towering hardwoods, cypress, and pines, its steep, sandy banks, its clear, cold water, and its constant switchbacks, the Saline is the Miss America of our scenic rivers. Its beauty is spellbinding, but a canoe trip here is not one I would recommend to the faint of heart.

Robert Murry and I put my battered but nicely camouflaged seventeen-year-old Gruman canoe in at Cloud Crossing, a campsite in the Kisatchie National Forest. One of the canoeing guidebooks describes this as a leisurely ten-mile, six-hour trip. After twelve hours, thirty-nine minor obstacles, twenty-three pull-unders, seventeen pull-overs, and four portages, we arrived at the abandoned saltworks just east of Goldonna, dead tired but with a deep feeling of accomplishment.

Sculpturelike cypress stumps cut in the 1920s (top left), *feathery, delicate ferns along the natural levee of Upper Grand River* (bottom left), *and the golden-yellow prothonotary warbler,* Protonotaria citrea (above), *are just a few of the scenes that make the Atchafalaya Basin an important part of our scenic waterways.*

(overleaf) *Bayou Kisatchie*

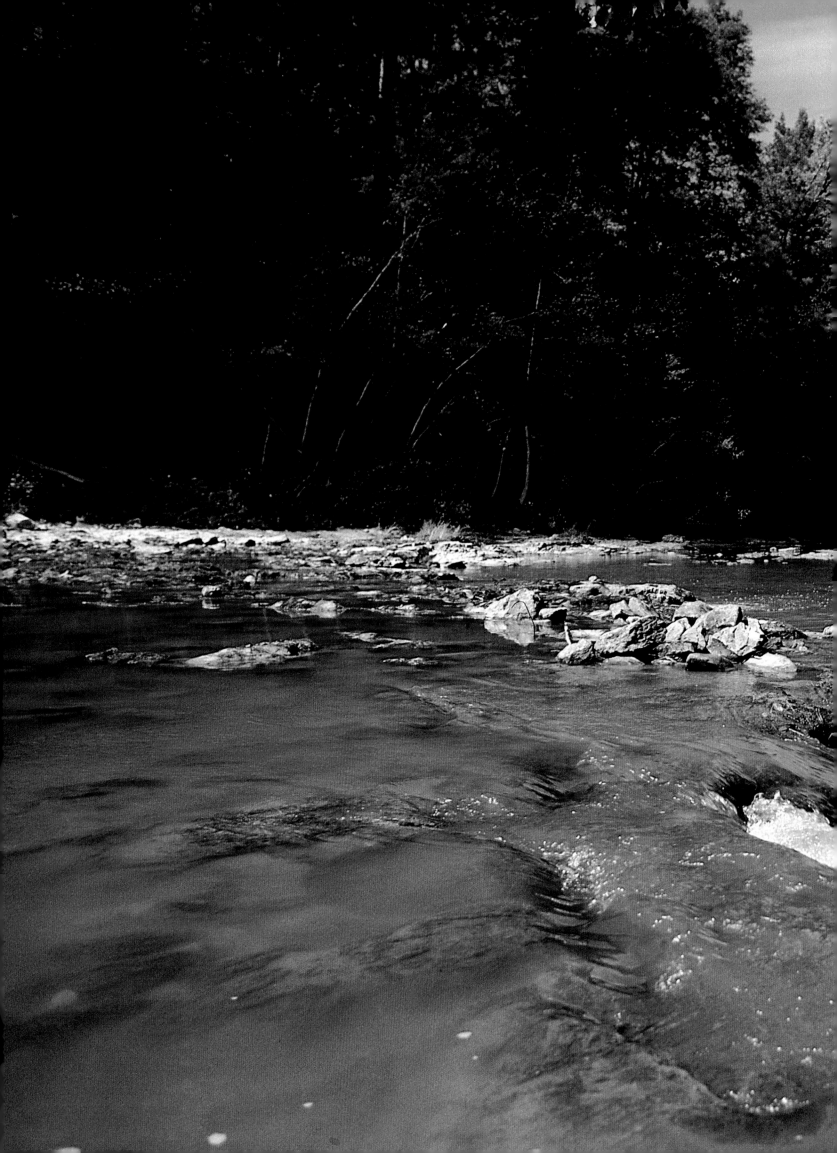

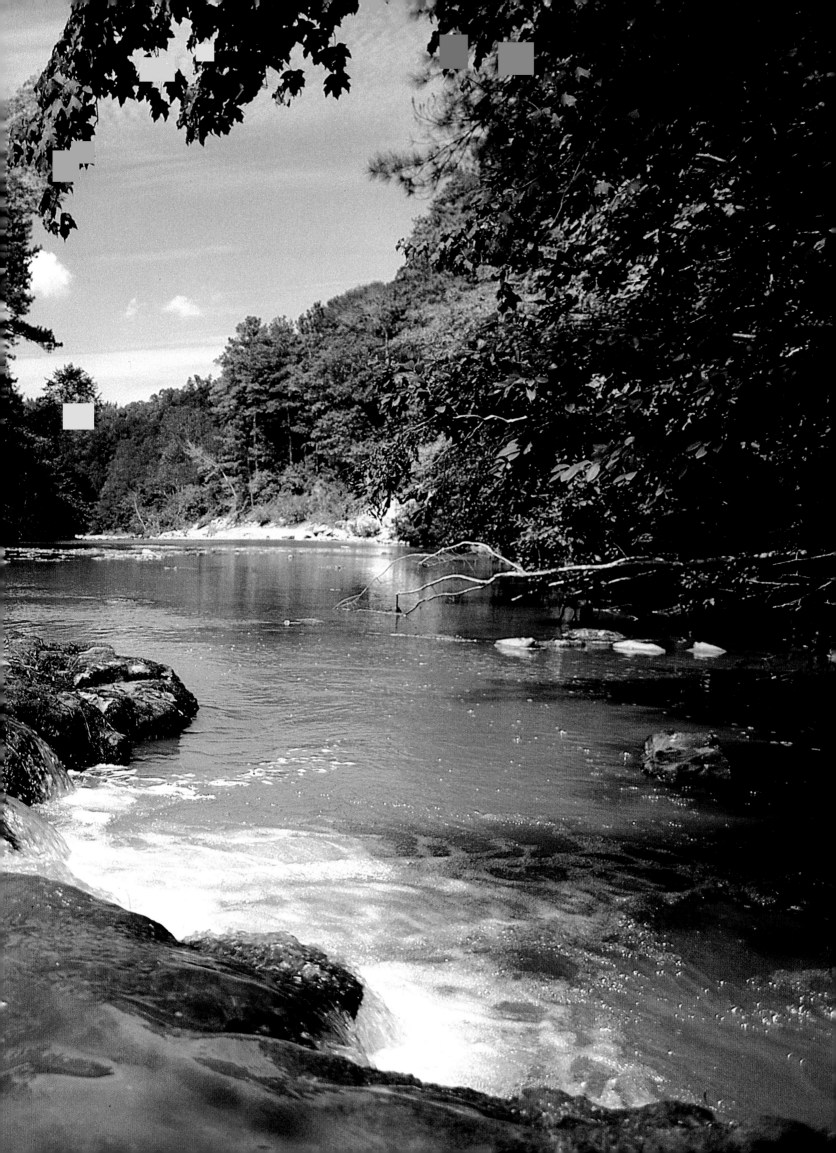

A few definitions might be helpful at this point. "Minor obstacles" are limbs, floating logjams, or mostly submerged trees that take extreme pushing, pulling, poling, and wiggling to get your canoe over. "Pull-unders" are fallen trees that lie across the stream. By lying flat in your canoe, you can pass under them without getting out. Associated with the pull-unders are dirt, leaves, mushrooms, tree bark, and spiders that fall into the canoe with you. "Pull-overs" are trees and logs across the bayou that are too low to go under. Here you have to use muscle and stand on the log or in the water to lift your canoe over. A "portage" is when you must actually pull your canoe out of the water and carry it and your gear overland to circumvent an extreme logjam or a fallen tree. With all my camera gear, each portage meant three trips.

Perhaps most significant when considering the beauty of Saline Bayou is the abundance of mature trees. This is rare, because generally trees are harvested in a national forest when they reach maturity. George Tannehill, a ranger with the U.S. Forest Service in the Winn District of Kisatchie National Forest from 1935 to 1973, was partial to the Saline Bayou bottoms and would not let trees be marked for cutting in this area.

Tales like this from Robert Murry, a wildlife ecologist at Fort Polk, made me forget the rough going. Robert knew this area and all the scenic rivers well,

because he studied them when he was with the Department of Wildlife and Fisheries at the time Act 398 was being drafted and passed.

Robert Murry once paddled down the Tangipahoa River with James Watt in the front of his canoe. Watt, who was then director of the Bureau of Outdoor Recreation under President Nixon, was trying to tell Robert, an avid spotted-bass fisherman, to cast in the middle of the river as they do in Wyoming. After a few fly-fishing attempts with a casting rod, Watt gave up, telling Robert, "If you're going to catch fish, you're going to catch fish, no matter how good you are, and I'm not going to catch any today."

Among the most interesting things we ran into on our paddle down the Saline were a couple of seven-foot ten-inch cypress knees. Throughout our ten-mile trip, the bayou was about twenty feet wide. It was the narrowest of the nineteen rivers I have traveled.

This narrowness, along with the tall, mature trees, gave Saline Bayou a magical atmosphere. A thunderstorm had rolled in while we were loading up at Cloud Crossing, and the wind and rain filled the air with sweet smells and sounds. I drank it all in and knew I soon would come back to stretch and strain my muscles again to navigate my canoe down this lovely waterway.

On another of many camping trips to Cloud Crossing, I doused my cooking fire and lay on my back, wrapped in a wool blanket. Orion was passing over-

Perhaps one day this swamp red maple, Acer rubrum drummondii *(bottom left), will become a major obstacle for canoeists like Bert Jones and Dr. Robert Fowler on Bayou L'Outre (top left). The Scenic Rivers Act prohibits clearing such obstacles, which are good wildlife habitats. (below)* Obstacle in Saline Bayou

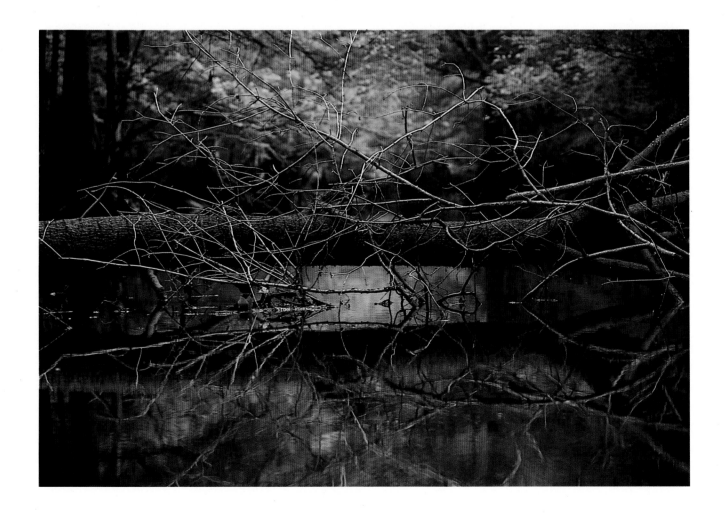

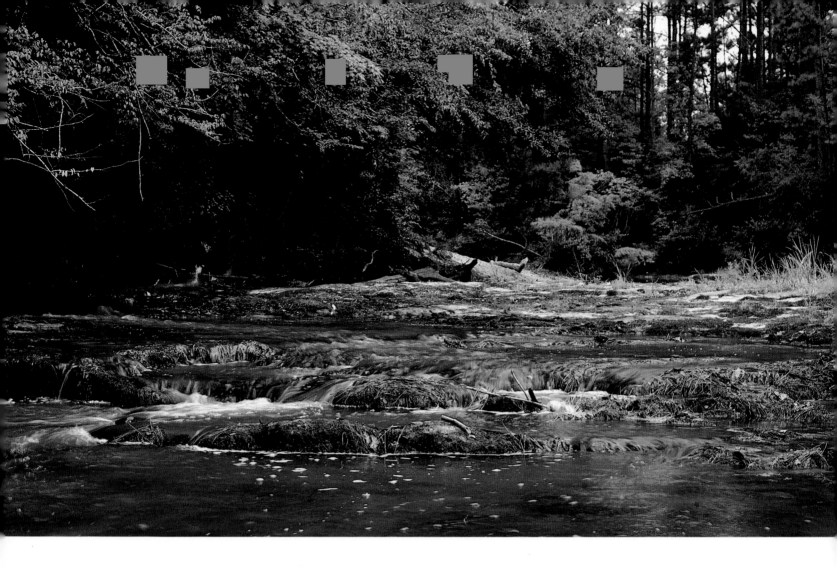

head, and I imagined that the tall pointed pines were rocket ships ready to blast me to the great hunter's belt. After that wild ride, the pines turned back to trees, and I focused on their needles and wondered if a millionaire changed all his bills into needles, would they fill a pine tree? I contemplated that important question until I dozed off under the stars.

Whenever I think I'm getting too old to battle logjams on small bayous, I remember my canoeing partner on Bayou L'Outre. Dr. J. Robert ("Chic") Fowler, slim, handsome, straight as a two-by-four from a virgin longleaf log and sharp as the tack he was when he retired twenty-seven years ago as head of the Department of Zoology at Louisiana Tech. Chic has caught about as many fish on the L'Outre as charter-boat captain Charley Hardison has caught in the Gulf. How? Well, he's been at it for almost all of his ninety-one years. Bert Jones, a L'Outre fan, came along for the adventure.

It was Bert's Old Town canoe, but Dr. Fowler told Bert to get in the front and fish. Then he told me to get in the middle and take pictures, and he would do all the paddling. We paid attention to our elder, and as we took off, I thought the L'Outre looked to be just as lovely as Saline Bayou.

The high banks were lined with oaks, pine, and baldcypress. One was so twisted, it looked like a peppermint stick. The water was as clear as tap water, and we could see small-mouth bass, carp, bluegill,

(left) A log crossing Castor Creek is one of the many points of interest along the Wild Azalea Trail.

The Natchitoches unit of Kisatchie National Forest is one of the hilliest, as Bayou Kisatchie's two sets of rapids attest (above).

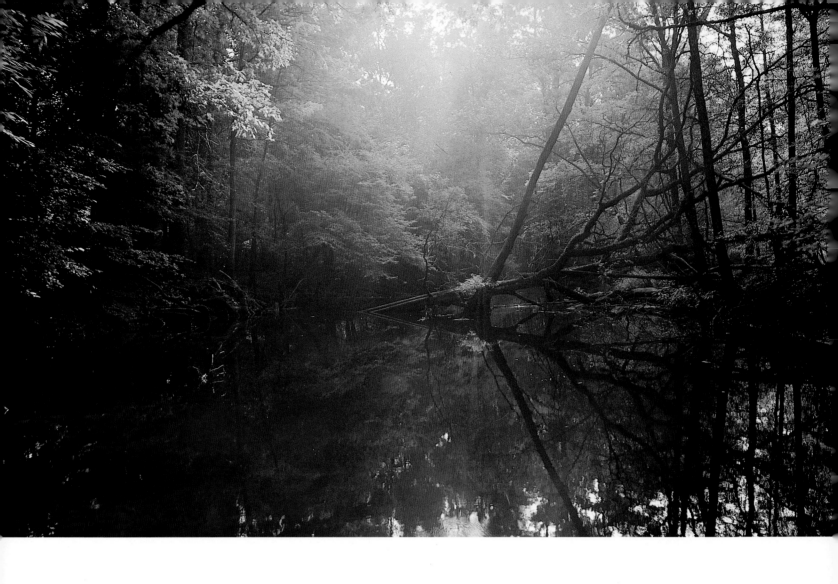

(above) *Glare from the midday sun reaches through the L'Outre's thick canopy only in a few wide places.*

(bottom right) *Though not crowned with the status of an official scenic river, Burkett Creek is just as deserving—even with its naked winter limbs.*

(top right) *Covered with duckweed, Clear Lake near Mansfield offers a temporary resting spot for this northern cricket frog, Acris crepitans.*

snapping turtles, and a couple of "no-necks," as Bert called small cottonmouths. The water level was low, and the going got tougher as we proceeded downstream. The L'Outre braided into two, three, even five channels at intervals, and with our combined woodsmanship the three of us usually picked the best channel. I'd never admit we had to back-track once.

Red-bellied, pileated, and downy woodpeckers drummed trees above while we pulled over fallen trunks below. The sweet gums were well chewed by beavers. We passed over two dams and one lodge. Soon the ringed sweet gums would fall over the bayous, creating more wildlife habitat and making for harder paddling.

Then just as we were noticing the heat of the day, a paddle jammed between a cypress stump and the canoe. Over we went. I jerked to the surface, trying to keep my camera dry, then swung around to look for Bert and Dr. Fowler. Bert was looking straight at Chic's hat floating on the surface. Before either of us could move, up popped the nonagenarian, right under his hat. All was well.

While drying out on the bank, we saw another no-neck. This one was on dry ground, eating a toad. I noticed the toad was being eaten legs first. When a snake eats a fish, it always swallows the fish head first to avoid the sharp dorsal fins. After we were under way again, I saw the cardinal flower in bloom.

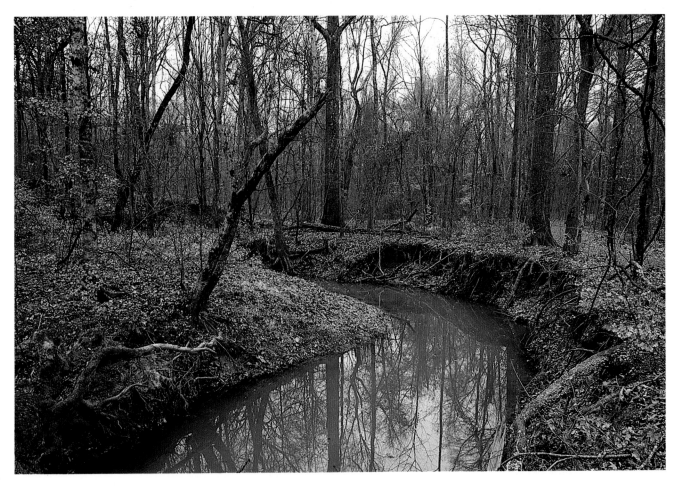

(above) *The water-tupelo,* Nyssa aquatica, *can show the fresh green of spring while it loses its fall leaves on Pope Lake in September.*

(top right) *Double-crested cormorants,* Phalacrocorax auritus, *fly past the setting full moon as they leave their roost on Lake Bistineau.*

(bottom right) *An aerial of Clear Lake shows what elevation can do to the vegetative zones—baldcypress in the lake, hardwood bottomlands on the north shore, and piney woods above them.*

It's one of my favorites, for it's the reddest of reds. Some say it signals summer's end.

Our estimated six-hour trip was already approximately eight hours as we portaged around a major logjam. Back in the water, we paddled around a midstream cypress giant—hollow, though—and Bert said, "Be quiet. I usually see deer up ahead."

Two bends later, we saw that he was right. A spike and two does were under a magnificent longleaf pine. As our canoe quietly edged up to the bank, one doe snorted and pounded the ground with a front foot. We sat still and watched as she continued her warning signal. The three soon became bored with us and ambled off. I climbed ashore to measure the big pine. It took two hugs and an extra foot to get around it. I like those big ones. Imagine standing there for over a hundred years, watching those deer . . . why, he's probably even seen a red wolf.

Dr. Fowler pushed onward, and finally Bert and I started to help. It wasn't long before I had a blowout in my ancient running-hiking-wading shoes. Bert taped the sole to my foot with the expertise of an NFL trainer. But the sand and the water of the L'Outre proved mightier than the adhesive tape.

It was eleven hours later and dark when we pulled out of the river. After seven portages, four pull-unders, and forty-seven minor obstacles, Mr. Jones wasn't even breathing hard. Chic and I, though not admitting it, knew we would feel the effects of our

adventure in the morning. But we all agreed there that the L'Outre is one special river.

I had spent the day before with Dr. Fowler on Pope Lake, another part of the L'Outre. Doc caught a few fish and told me in his clear, carefree voice stories of teaching, family, friends, fishing, travels, and wildlife. The professor explained the bubble trail of the buffalo fish as it fed along the bottom. He told me of teaching Dr. George Lowery, LSU's famous ornithologist, in an ecology class and later being in the Singer tract in 1943 when one of the last official sightings of the ivory-billed woodpecker was made. Doc saw three. I admit I was jealous.

Pope Lake is lined with some big second-growth tupelo, and I got some nice images of those trees as the leaves first began to fall. Leaves from the streamside vegetation are just as important as the shade factor for water temperature and photoperiod. The detritus, decomposed leaf litter, is the basis of the food chain. Lakes can make their own food; moving streams can't.

Pope Lake is just a wide place in the L'Outre, and is one type of lake in Louisiana. Lakes such as this are caused by logjams and terrain. Here a wide low area above a narrower part of the stream with not much drop in elevation becomes a lake.

Other types of lakes in Louisiana include cutoffs or oxbows, formed by abandoned channels in a river. Bluff lakes are caused by a depression between a

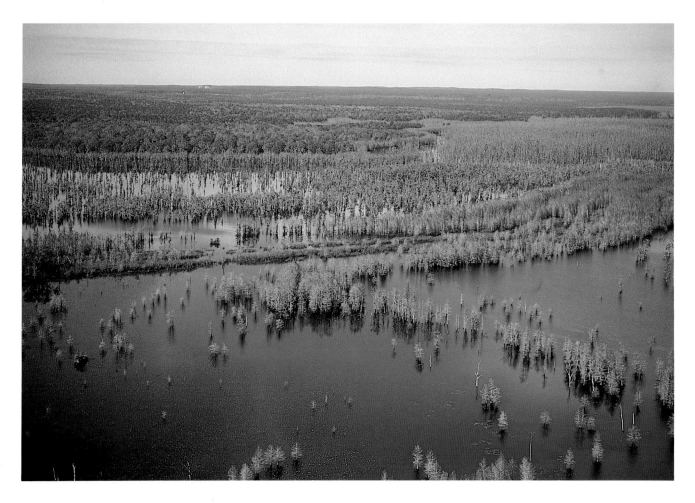

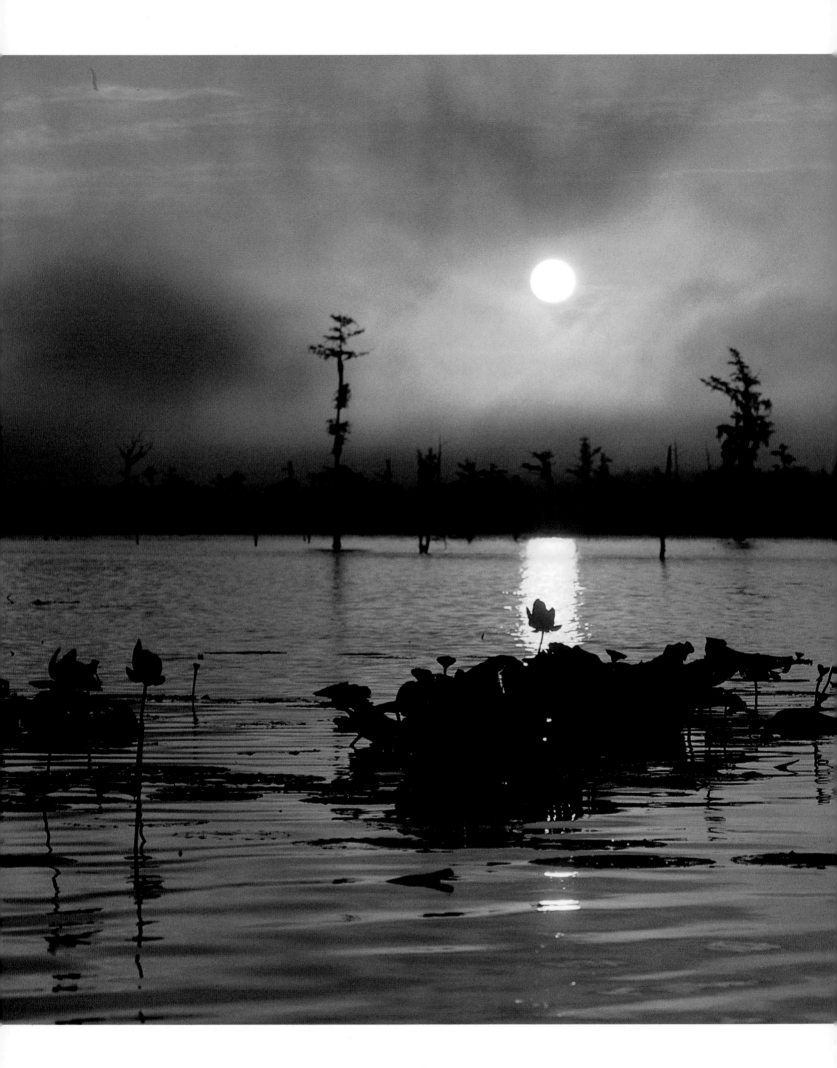

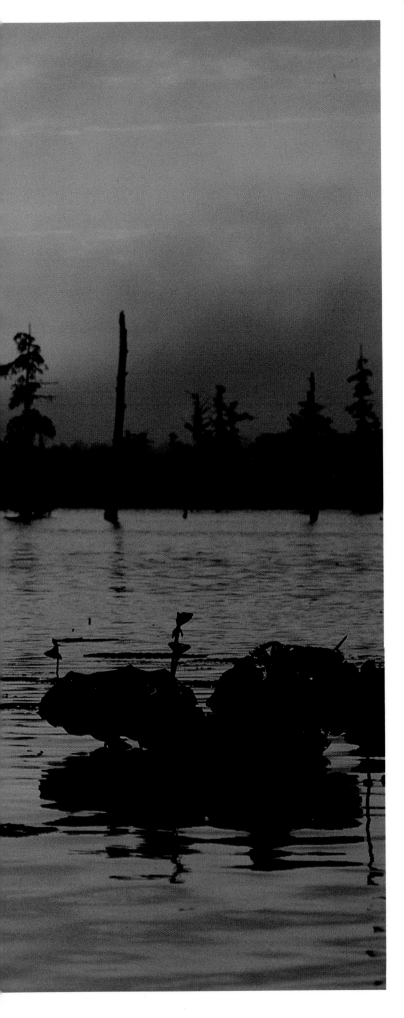

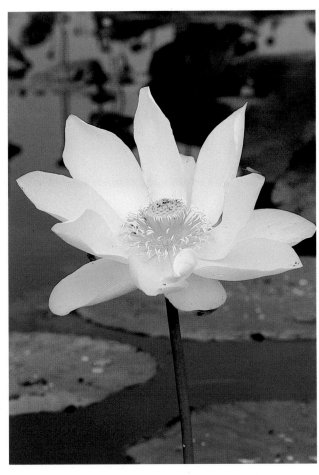

Sunrise on Lake Iatt silhouettes an American lotus, Nelumbo lutea *(left); the creamy flower is six inches wide* (above).

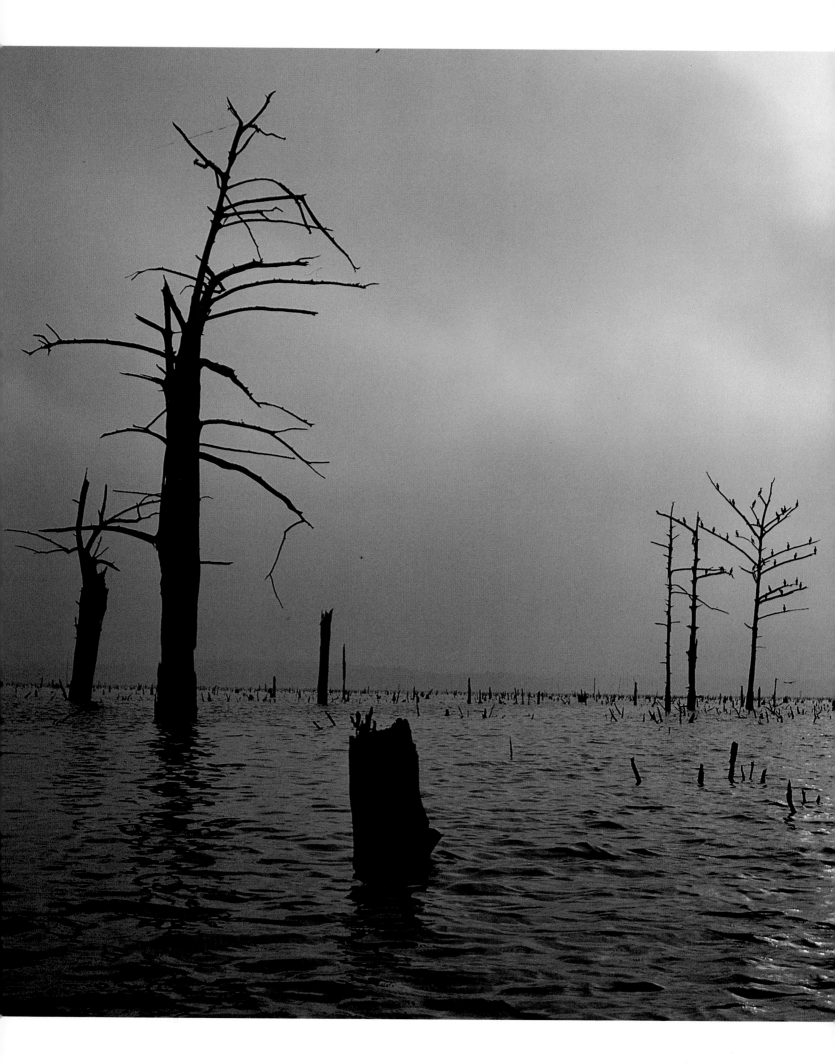

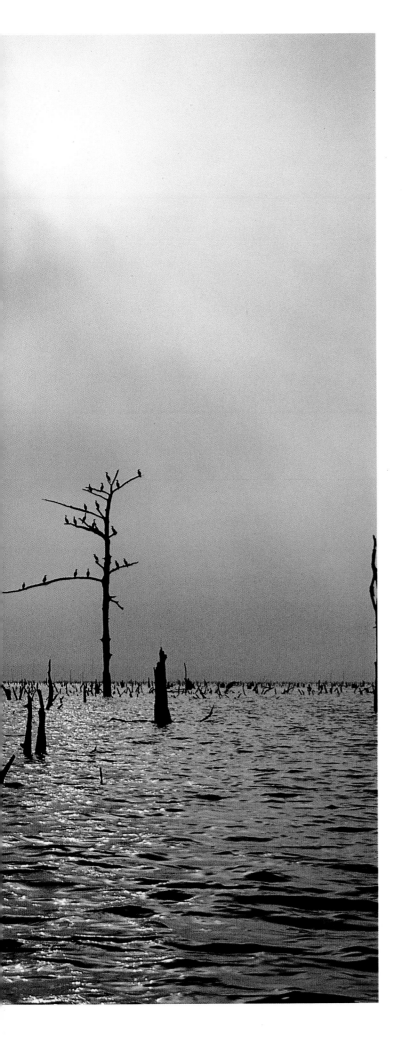

bluff and the natural levee of a nearby river. Then there are round and lagoonal lakes in the marsh and near the Gulf. And finally there are reservoirs or artificial lakes such as Toledo Bend.

Toledo Bend Reservoir, covering 284 square miles, is the fifth-largest man-made lake in the United States. We share it with Texas, as it was made by damming the Sabine River, which separated Texas and Louisiana. This river is actually still the Texas-Louisiana border, but you can barely distinguish the old channels meandering through dead cypress trees in the center of the lake.

It was first flooded in 1966 after completion of a massive earthen dam, and the cypress as well as the oaks in the lake remained alive for a few years. Roy Webb, retired sheriff of De Soto Parish, told me that it was a green-tree reservoir supreme. Roy said, "Those first three years the duck hunting was as good as anyplace in the world. The bass fishing, too. It's still good, but it was great then."

I went fishing with Roy one foggy October morning, and he told me stories of the early Toledo Bend days as he maneuvered his small bass boat through the stumps. Even cypress die in water that is too deep for too long. The scene was like the set of a Steven Spielberg movie: fog shrouding dead cypress that resembled disfigured monsters. Up in the branches, double-crested cormorants roosted, their necks crooked, silhouetted against the gray mist. I wouldn't have been surprised to see Vincent Price come paddling out of the fog in a floating coffin.

Roy caught a few fish in between showing me around and said I ought to come back in the winter if I wanted to see more birds.

Later near the dam, I visited with Herbert Peavy, who loves to talk and can keep up with you on any subject. He is an arrowhead collector, gold miner, rodeoer, hunter, junk collector, storeowner, and eagle lover. His dream: to get a twelve-foot rattlesnake, stuff it, and tour the USA, charging a dollar a head to see it.

Herbert and I paddled a small bateau down the Sabine River from the dam, looking for eagles. We saw two eagles and two osprey that day and put up my blind on a set of rapids called Second Rocks. I returned the next three days to sit and wait for the eagles to come feed on the fish I staked out as bait. Eagles flew by, but only vultures stopped to snack on my smorgasbord.

(left) *In the background of an eerie Toledo Bend landscape, Texas can barely be seen. Cormorants rest on baldcypress that mark the now-flooded Sabine River channel.*

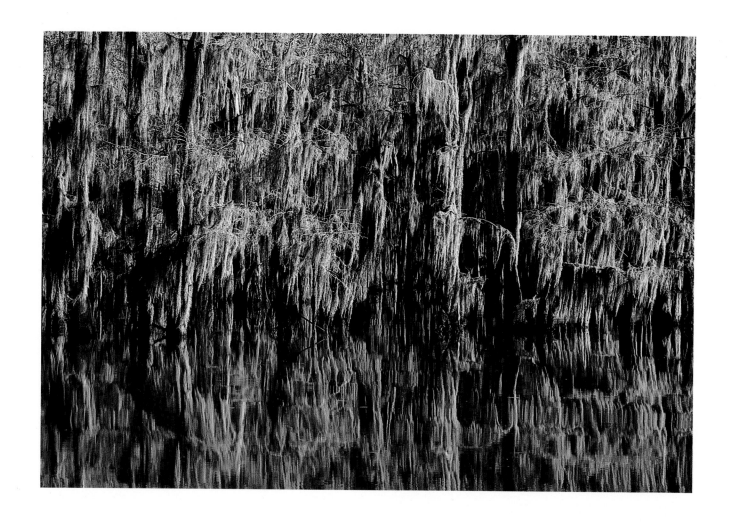

Leaving the blind late one afternoon, I sneaked up on some wild pigs. I crept carefully to within eight feet of six piglets and watched them root around for acorns before the big sow snorted danger and they bounded away. Wild pigs are quite common in a lot of Louisiana's forests. I have seen them in the Pearl River Swamp as well as the Atchafalaya.

They are born yard pigs but escape or are let go to forage on their own. After a few generations, though, they are just as wild as a Russian black boar, some growing tusks. They eat about anything. In some areas, they can cause real problems. They destroy plants, roots and all. Wild pigs, traveling in groups with big appetites, can destroy whole areas.

Eagles that winter at Toledo Bend are especially fond of the area below the power station, for the fish injured in the turbines are easy prey. Northern bald eagles also winter on Cross Lake and Caddo Lake as well as other north Louisiana lakes.

The winner of the Spanish Moss Award, if there was one, would be Lake Bistineau. A natural lake that has been helped by an earthen dam, it was formed by a rift in the Red River. Before man's help, the water level in Bistineau varied as much as the Atchafalaya Basin, depending on the season.

Before the Red River logjam was removed, steamboats from New Orleans used to travel Loggy Bayou to Lake Bistineau, then up Bayou Dorcheat to Overton, then the Webster Parish seat and a center of commerce.

In spite of north Louisiana's reputation as hill country, it can look just as swampy as the Atchafalaya Basin—as the Spanish moss, Tillandsia usneoides, *on Lake Bistineau* (above) *and the morning glow on Bayou Dorcheat* (right) *attest.*

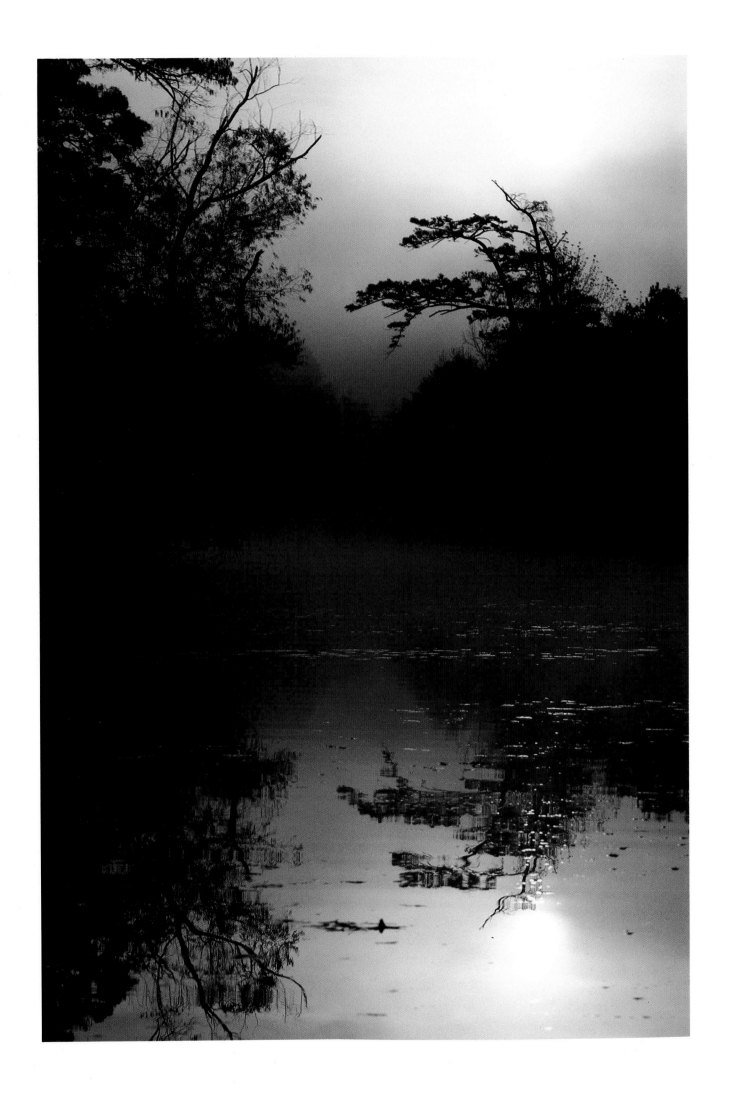

Louisiana's biggest lake is Pontchartrain, covering 621 square miles. Along with its smaller sister Lake Maurepas, and rivers such as the Blind, Amite, Tickfaw, Tangipahoa, and Tchefuncte, the Florida Parishes are a boating paradise. Where these rivers enter the north side of Pontchartrain, the habitat is cypress swampland. To the south is marsh, where Pontchartrain pushes its waters through to the Rigolets and into Lake Borgne, Mississippi Sound, and finally the Gulf.

Pontchartrain has shrimp, oysters, crab, croakers that live in a shell, and a sea-grass community. There is a never-ending controversy concerning the shell-dredging industry, and personally I think the shells are doing us much more good on the bottom of Pontchartrain and Maurepas than on our roads. We could very easily make these lakes one big mudhole by harvesting too many shells.

Miller Lake and 15,000,000 blackbirds. What a show! Now I didn't personally count them, but the U.S. Fish and Wildlife Service survey estimates 15,000,000 blackbirds at Miller Lake and statewide at least twenty-seven other roosts with over 1,000,000 birds. After visiting Miller Lake twice during the winter roosting season, I won't refute their figures.

First time. It was the Sunday before Christmas, and I was just returning from the Audubon Christmas Bird Count at Sabine National Wildlife Refuge. A raging cold front had passed, and the winds were chipper, chilly, downright freezing from the northwest, especially over Miller Lake as I stood on the south levee. The sky was the bluest of blues as I watched a few blackbirds in the surrounding soybean fields. About 4:30 P.M., a small group of grackles appeared, followed by a flock of redwings. Then a gang of mixed blackbirds arrived and finally, by 5:00 P.M., the fields south of Miller Lake were covered with a fantastic, undulating blanket of blackbirds. As the northwester blew in at twenty-five miles an hour the birds, weighing fifty-seven grams, could make headway only close to the ground. Coming to a fence, they would flare up to clear it, get caught in the wind, and tumble backwards like gymnasts running to the pommel horse and doing a backflip. After two or three false starts, the birds would finally get the angle to make the fence.

(right) *A few of the 15,000,000 blackbirds that winter on Miller Lake, one of the largest roosts in Louisiana*

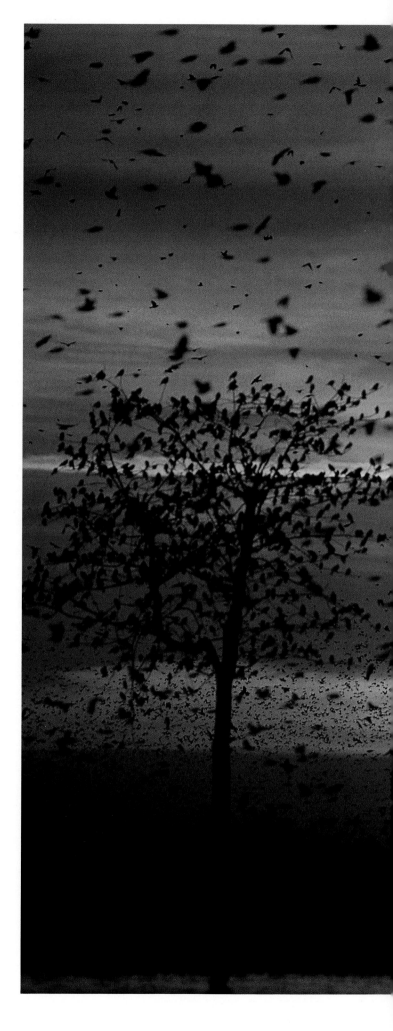

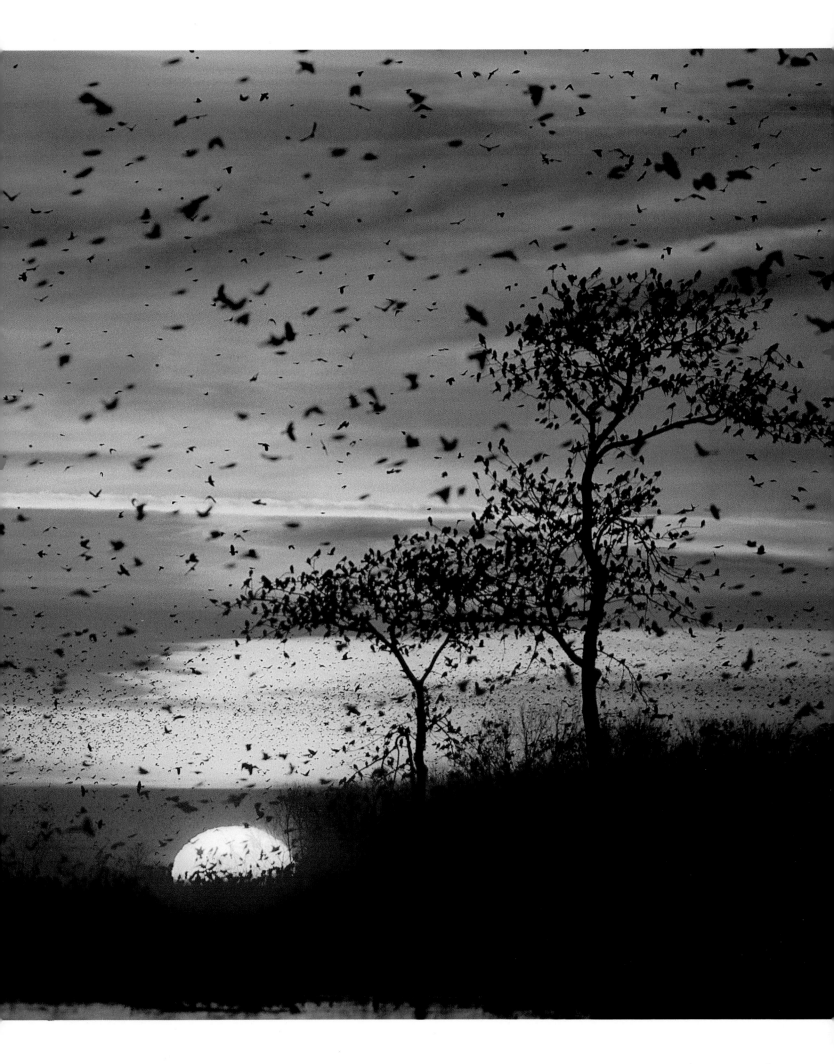

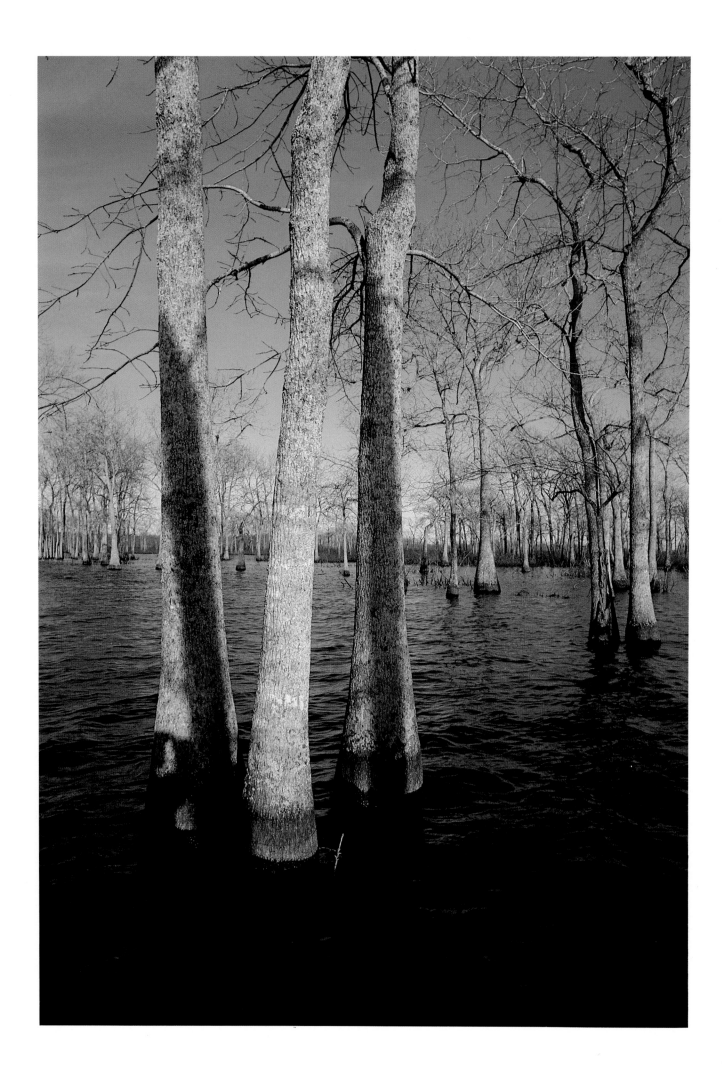

Fascinated with the show for some time, I finally turned to see where these determined fliers were going. It was then that I saw the leafless cypress and tupelo trees completely covered with millions of blackbirds.

Louisiana and Arkansas have the distinction of wintering more blackbirds than any other state. Today there are many more blackbirds than there were before man cleared the forest. Just like the coyote, the blackbird moved in and multiplied when the demand for cropland created more open space.

With more birds and bigger concentrations, the birds have caused problems when roosting near towns, but here at Miller Lake, they cause nobody any trouble.

To get a closer look at the treetops full of noisy birds, I had to come back in a boat. On my second trip, the day was almost as cold, just as clear, and promised a spectacular sunset. Drifting for two hours, I photographed the lovely nakedness of the water-tupelo trees and watched the coots skiddle across the lake. The coot must run across the water flapping its stumpy wings to get enough speed to take off.

In the spring, Miller Lake hosts a rookery of anhingas, little blue herons, and twenty thousand cattle egrets among the blooms of fragrant water lilies, water hyacinth, and buttonbush. But on a cold day in December, the lake is empty save for a few coots and skittish ducks.

(above) *Two American coots,* Fulica americana, *swim on Miller Lake.*

(left) *The water-tupelo, leafless sentinels on a lonely winter afternoon in Miller Lake*

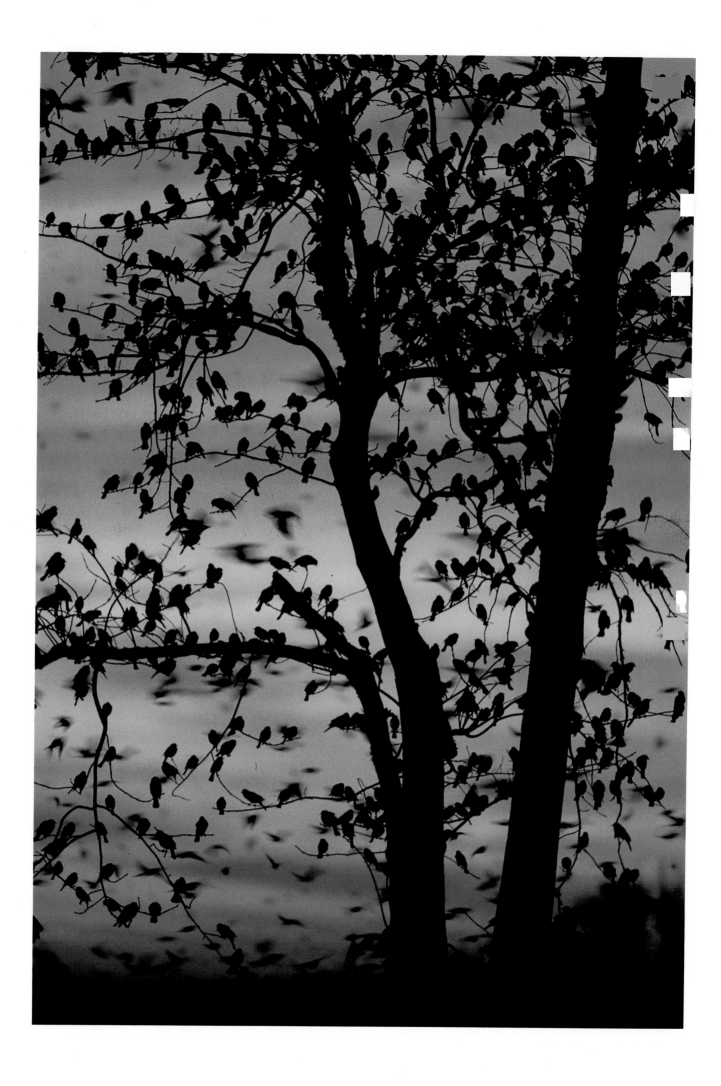

From my position in the middle of the lake, the scene seemed to be transformed more quickly. Once again, at 4:30 P.M. that emptiness was replaced by throngs of whirling blackbirds. One minute no birds, then birds were appearing from everywhere. They had no fear whatsoever. I suppose they feel safe in numbers. Buttonbushes ten feet away harbored thousands of blackbirds. I was soon surrounded. Alfred Hitchcock missed the best place when he filmed *The Birds*.

The previous day I had only seen the birds coming from the south. Now I saw them coming in from all directions. Looking west, I steadied my boat and framed a baldcypress loaded to the hilt. It resembled an overly ornate Christmas tree with a buzz of activity in the background. I couldn't shoot fast enough. I needed more cameras, film, tripods, hands, eyes, and imagination to capture the spectacle.

A group of five thousand birds would flush and then turn in perfect formation, then turn again as if they were one and settle in another tree a few feet away. How'd they do that? I wanted to find out. After talking to a few professional ornithologists, I tracked down some papers on the subject. From what I could discover, no one knows for sure how shorebirds, ducks, or blackbirds fly in formation. (Nor is it known how schooling fish do much the same.)

The best guess for the blackbirds' curious aerials is that they are protecting themselves from predators. A peregrine falcon has a better chance if it is diving on one bird than into a whole flock performing confusing acrobatic maneuvers. You and I might be in a similar situation, trying to catch ten-dollar bills falling out of the sky. We'd do better to single in on one, catch it, pocket it, and then go for another. But our greedy instincts would probably cause us to spread out our arms to catch them all at once. And we'd probably lose the whole wad.

There are a lot of theories about how the birds perform their sky tricks. Early theorists supposed the birds might have a common soul. Later, telepathy was considered. Other scientists have suggested that a lead bird provides a signal, possibly visual or vocal. The theory that makes the most sense to me is the chorus-line hypothesis outlined by W. K. Potts in *Nature* (1984).

When a wave gets started at a football game, the coordination is slow on the first trip around the stadium, and then by round two everyone is anticipating his move and the wave goes faster and more smoothly. Since animals are much more coordinated than humans, it seems as though they all move at once. Actually, a few blackbirds flush and within milliseconds nearby blackbirds flush and farther on down the chorus line, the rest anticipate their takeoff time just like the dancers of the Ziegfeld Follies. It was wonderful to watch the blackbirds perform in front of the setting sun.

As the glow faded to dark, I wished for an encore, but was rewarded instead with my first glimpse of Halley's Comet above the evening star, Jupiter.

Logjams and lily pads, beaver and blackbirds. They're all part of our scenic waterways, and the water that fills our bayous, rivers, streams, and lakes also nurtures what we're probably most famous for . . . the swamps.

(left) *Like Christmas ornaments, redwing blackbirds come to roost.*

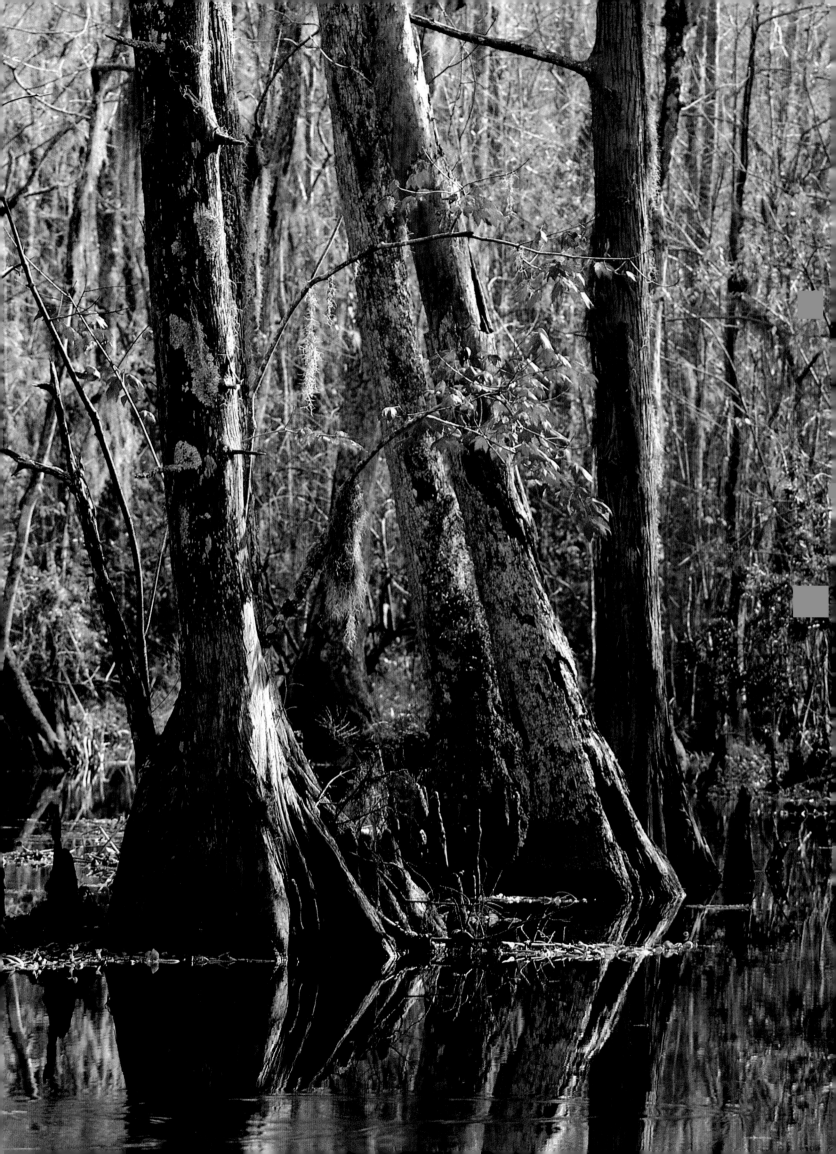

3

Swamps and Bottomlands

Teddy Roosevelt hunted black bear in 1907, and Dr. George Lowery later saw one of the last ivory-billed woodpeckers in the same area. I was fortunate enough to follow their footsteps, looking for both those species. I was on the Tensas River paddling through what's now the Tensas National Wildlife Refuge. It was January and winter was real that day. Gray overcast skies through leafless trees. I was bundled up to near discomfort for the 28° day. The wind over the water was not too strong, but enough to chill Andy and me.

I was young and in high hopes of finding the ivory-billed woodpecker. Andy Zizinna, a student at LSU, had come along to help me look. Winter's the best time because the unmistakable nasal *kent kent kent* call of the United States' biggest woodpecker carries much farther through open forest.

Little did I know at that time in 1972 that the great hardwood forest where Roosevelt and Lowery had walked had all been cut. A good part of the Tensas was in nice second-growth forest, but the ivory-billed woodpecker needs virgin timber. Each family requires six square miles to survive. In a plot of natural forest that size, there would be plenty of old and dying trees where this bird would peck away for wood-boring beetles.

It's a shame that modern forestry practices eliminated this habitat so important to much more wildlife than just the ivorybill. The lack of overmature trees has become so great that a couple of chimney sweeps I've talked with say they do a rousing business every spring, removing raccoons from chimneys (just the same as a hollow tree to a raccoon).

In the exuberance of youth, though, I strained my ears for every sound, determined to find the white-billed bird. My fifteen-foot Gruman canoe was loaded to the gunnels. When we pulled up to the muddy bank to walk through the woods, we had to be careful or water would spill in. The Tensas was once clear and full of small-mouth bass hitting the bait of V. C. Rives's fly rod as he stood on the gravel bars. When I told him I was going to paddle the river, he wondered why I was crazy enough to waste time on that muddy ditch. Now straightened, snagged, channelized, and full of agricultural runoff, it's not quite the same . . . but I was looking for the woodpecker.

In his book on mammals, Dr. Lowery describes his tours of the Tensas in the years between 1933 and 1943, when there still was virgin hardwood bottomland forest. He writes of red wolves and ivory-billed

Swamp red maple adds a splash of color to the Pearl River Swamp, our state's second-largest swamp.

woodpeckers. "As late as the 1930s, the Red Wolf was still present in some numbers in various localities in Louisiana, especially in the northeastern part of the state. In 1933–1935, when I was studying Ivory-billed Woodpeckers in Madison Parish, my companions and I often found wolf tracks and other sign, and on several occasions while camping in the heart of what was then a vast, virgin hardwood bottomland forest in Madison Parish, we would hear wolves at night howling not far away. But that magnificent stand of trees, from which at that time not even a matchstick had been removed, is today a thing of the past. First the large trees were felled, then the smaller ones, and now only soy beans grow over much of the area that formerly provided sanctuary for countless numbers of wild creatures. The Ivorybills are gone, and so are the wolves, the panthers, the Swallow-tailed Kites, and most of the other spectacular denizens of that original forest primeval. What a pity! The thought of what was allowed to occur gives one cause for grief. My grandsons will probably never have the thrill, as have I, of standing in a secluded forest under a giant tree, sporting a dbh [diameter at breast height] greater than the expanse of one's arms, with an Ivory-bill pecking away overhead, and catching one of the chips before it hit the ground. Imagine holding a piece of wood personally autographed by an Ivorybill! The youngsters of today might sometime hear the howl of a wolf, but it will likely be in a city

(above) *Much of Louisiana's hardwood bottomlands has ended up in marginal farmland, which floods in most years.*

(right) *Louisiana deer have adapted to the state's environment by having wider hooves to negotiate the soggy soils.*

zoo after the shriek of a nearby police siren has stimulated one of these sad creatures into one of its vocalizations. But so much for that . . ."

That night I huddled close to the campfire, turning two wood ducks on a spit. Andy spent two shells to bag these colorful birds, and they turned out to be much tastier than anything we could have picked up at the supermarket. The lingering smell of roast duck, woodsmoke, and cold air guided our conversation. I told Andy about all the educators, ornithologists, and famous people, such as Lowery, Fowler, Dr. A. A. Allen, Paul Kellogg, and President Teddy Roosevelt, who had been here to see the ivorybill.

Andy asked, "Roosevelt, was he a bird watcher?"

"Well, not a bird watcher with a little checklist," I answered, "but he was a hunter, fisherman, adventurer, conservationist, founder of our national parks. I'd guess he would have liked to watch birds. He came in 1907 to go bear hunting right here along the Tensas River."

"Bear hunting? I hadn't heard of anybody going bear hunting here."

"Well, there aren't many bears here anymore," I said. There were plenty in the early 1900s when the virgin forest and the great canebreaks of switch cane still existed. There is still a bear season in the state. The Department of Wildlife and Fisheries estimates that there are only a few more than 125 bears in Louisiana. But Holt Collier, a Negro hunter who was in charge of the dogs on the Roosevelt expedition, was reportedly involved in three thousand bear kills.

Roosevelt wrote about part of his hunt in a 1908 magazine article and described the Tensas bottomlands quite well. "When the Father of the Waters breaks his boundaries he turns the country for a breadth of eighty miles into one broad river, the plantations throughout all this vast extent being from five to twenty feet under water. . . . Conditions are still in some respects like those of the pioneer days. The magnificent forest growth which covers the land is of little value because of the difficulty in getting the trees to market. . . . In consequence, the larger trees are often killed by girdling. . . . At dusk, with the sunset glimmering in the west, or in the brilliant moonlight when the moon is full, the cottonfields have a strange spectral look, with the dead trees raising aloft their naked branches. . . .

"Beyond the end of cultivation towers the great forest. Wherever the water stands in pools, and by the edges of the lakes and bayous, the giant cypress loom aloft, rivalled in size by some of the red gums and white oaks. In stature, in towering majesty, they are unsurpassed by any trees of our eastern forests. . . . The canebrakes stretch along the slight rises of ground, often extending for miles. . . . They choke out other growth, the feathery, graceful canes standing in ranks, tall, slender, serried, each but a few inches from his brother, and springing to a height of

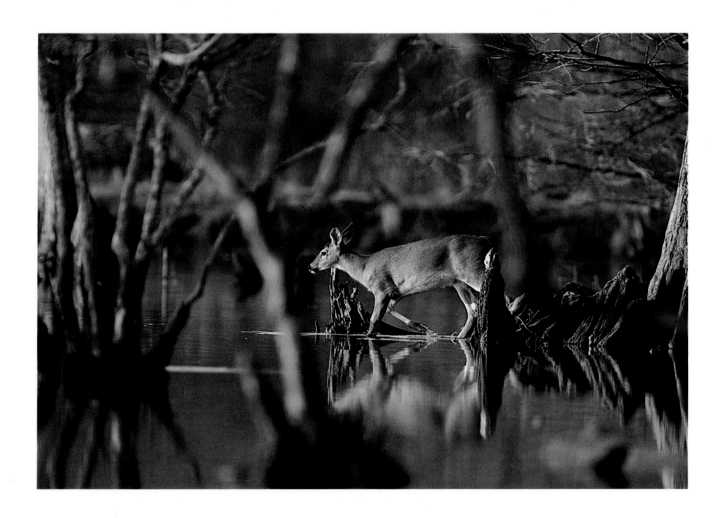

fifteen or twenty feet. They look like bamboos: they are well-nigh impenetrable to a man on horseback; even on foot they make difficult walking unless free use is made of the heavy bush-knife. It is impossible to see through them for more than fifteen or twenty paces, and often for not half that distance. Bears make their lairs in them, and they are the refuge for hunted things. . . .

"The most notable birds and those which most interested me were the great ivory-billed woodpeckers. Of these I saw three, all of them in groves of giant cypress; their brilliant white bills contrasted finely with the black of their general plumage. They were noisy but wary, and they seemed to me to set off the wildness of the swamp as much as any of the beasts of the chase. . . .

"Bears vary greatly in their habits in different localities. . . . Around Avery Island, John McIlhenny's plantation, the bears only appear from June to November; there they never kill hogs, but feed at first on corn and then on sugar cane, doing immense damage in the fields, quite as much as hogs would do. But when we were on the Tensas we visited a family of settlers who live right in the midst of the forest ten miles from any neighbors; and although bears were plentiful around them they never molested their cornfields. . . .

"We waited long hours on likely stands. We rode around the canebrakes through the swampy jungle, or threaded our way across them on trails cut by the

(below) *Palmetto,* Sabal minor, *and greenbrier,* Smilax *sp., line the banks of many small bayous in the Honey Island Swamp.*

(right) *A stately baldcypress,* Taxodium distichum, *shows off its dangling moss, buttress base, and knobby knees as the sun sets over Flat Lake.*

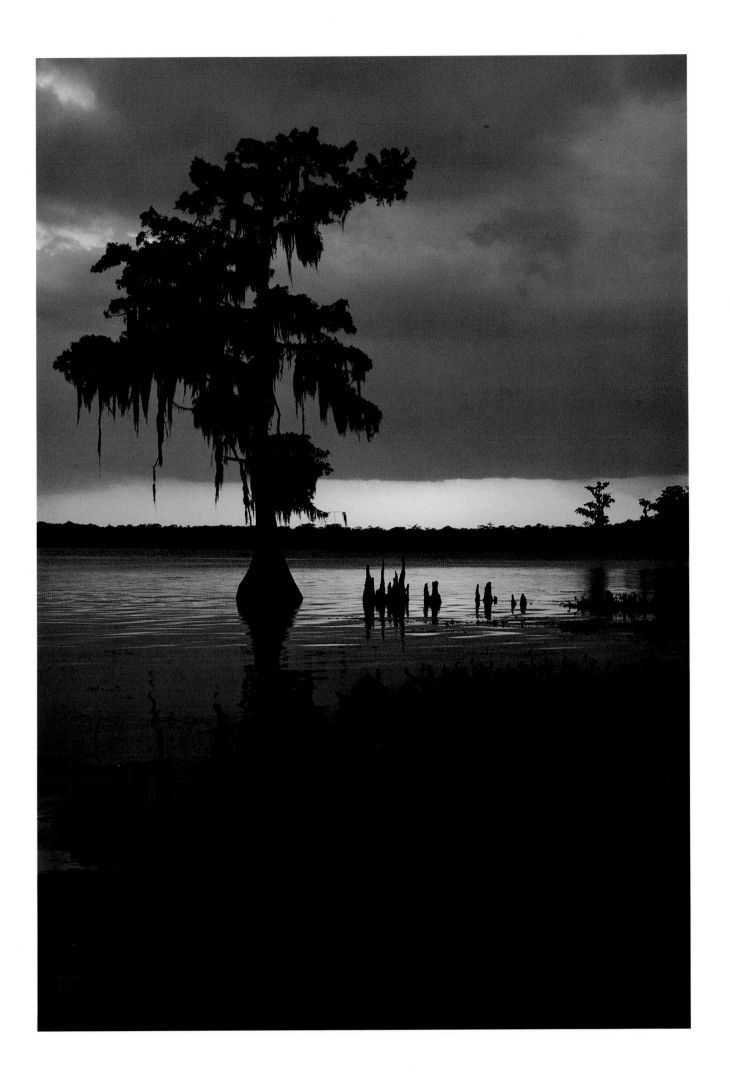

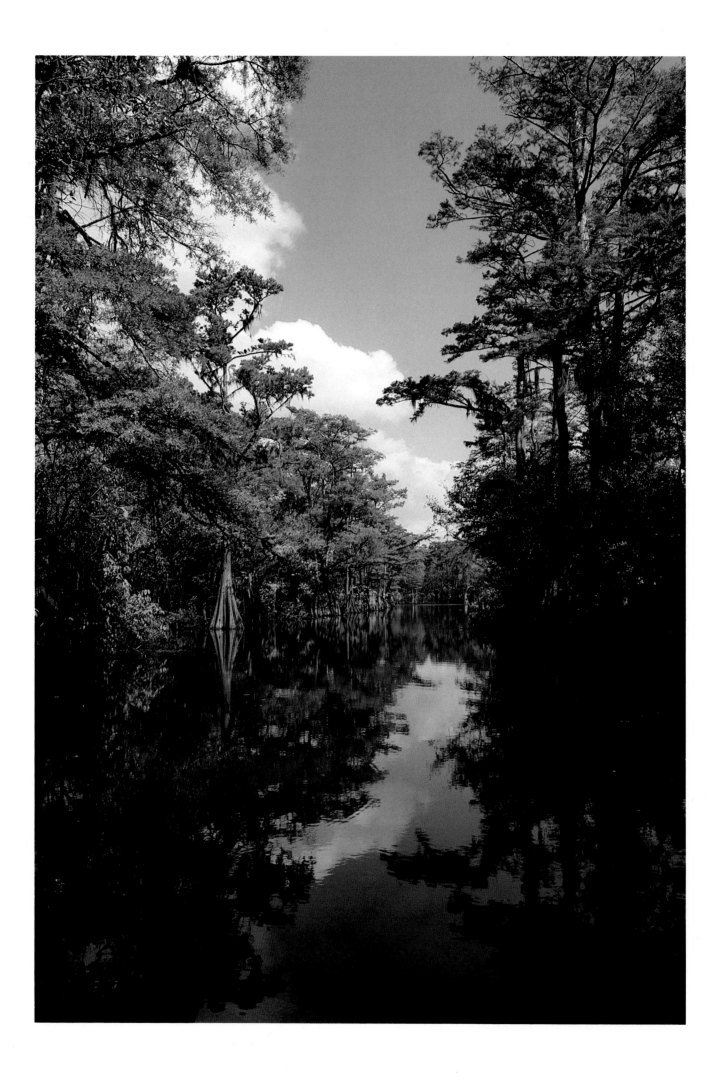

heavy wood-knives of my companions; but we found
nothing. Until the trails were cut the canebrakes were
impenetrable to a horse and were difficult enough to
a man on foot. On going through them it seemed as
if we must be in the tropics; the silence, the stillness,
the heat, and the obscurity, all combining to give a
certain eeriness to the task, as we chopped our wind-
ing way slowly through the dense mass of close-
growing, feather-fronded stalks. Each of the hunters
prided himself on his skill with the horn, which was
an essential adjunct of the hunt, used both to sum-
mon and control the hounds, and for signalling
among the hunters themselves. The tones of many of
the horns were full and musical; and it was pleasant
to hear them as they wailed to one another, back-
wards and forwards, across the great stretches of
lonely swamp and forest.

". . . Clive Metcalf and I separated from the others
and rode off at a lively pace between two of the cane-
brakes. After an hour or two's wait we heard, very
far off, the notes of one of the loudest-mouthed
hounds, and instantly rode toward it, until we could
make out the babel of the pack. Some hard galloping
brought us opposite the point toward which they
were heading. . . . The tough woods-horses kept
their feet like cats as they leaped logs, plunged
through bushes, and dodged in and out among the
tree trunks; and we had all we could do to prevent
the vines from lifting us out of the saddle, while the

(above) *One of the treats of the Caroline Dorman Nature Pre-
serve is the bigleaf magnolia,* Magnolia macrophylla. *Its
leaves are up to thirty inches long.*

(left) *Bodcau Bayou, northeast of Shreveport, is one of the
many wildlife management areas administered by the Depart-
ment of Wildlife and Fisheries.*

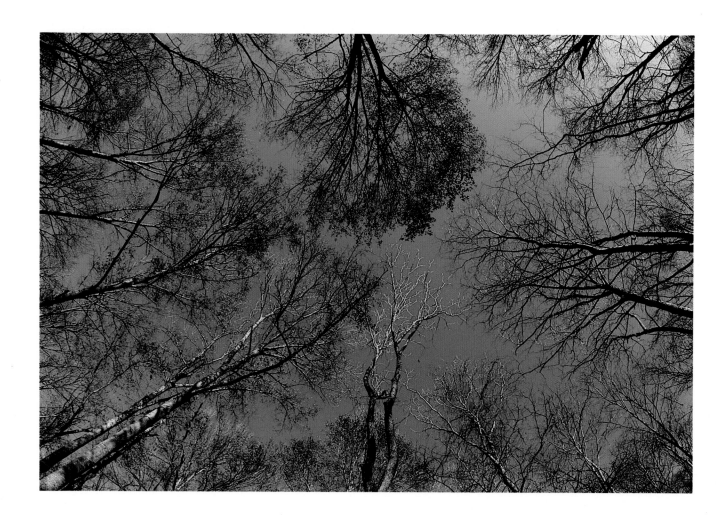

(above) *An ant's view of Louisiana woodlands*

(top right) *The fox squirrel,* Sciurus niger, *is Louisiana's largest squirrel.*

(bottom right) *Cypress vine,* Ipomoea quamoclit

thorns tore our hands and faces. . . . We rode ahead, and now in a few minutes were rewarded by hearing the leading dogs come to bay in the thickest of the cover. . . . We threw ourselves off the horses and plunged into the cane. . . . Clive Metcalf, a finished bear-hunter, was speedily able to determine what the bear's probable course would be, and we stole through the cane until we came to a spot near which he thought the quarry would pass. . . . Peering through the thick-growing stalks I suddenly made out the dim outline of the bear coming straight toward us. . . .

"I fired for behind the shoulder."

Of course the president got his bear, a 202-pound female, but more important, he gave us a description of a habitat that is gone.

I finished that canoe trip and took another the following summer—I again failed to see the woodpecker or a bear. Today the bear is hard to find and in my opinion the ivory-billed woodpecker is extinct.

Perhaps the bear will survive. Tensas has a second chance. In 1982, Tensas National Wildlife Refuge was formed, and it now protects 53,640 acres of Madison Parish as a wildlife and recreational habitat forever. I visited again to tramp through the second-growth forest with Wylie Barrow, a doctoral candidate at LSU who studies the warblers that nest in this hardwood bottomland.

Wylie migrates with the warblers, checking on

wintering biology in Mexico as well as their nesting biology in Tensas. One of his preliminary theories disturbed me. He said, "We've blamed the Mexicans for the decline of our warblers because of their slash and burn habitat destruction. But I've learned that some species of warblers adapt and do well in the fields and scrub there. It's here, when we clear the hardwood bottomlands, that the population suffers. They have to have these woods to nest. Other species are declining because of threats from both ends of their migration."

It sounded logical to me. Ruin the nest plot, the home, and there goes reproductive success. Just like me, I want my bed at home to stay just the same, but let me go on vacation. Que será, será.

Slogging through the swamp, we saw a lot of warblers and woodpeckers, including a pileated. We both wished it was three inches taller with a white bill. Wylie said it was a little late in the year to see nesting Swainson, hooded, or yellow-throated warblers, but maybe we'd see a prothonotary. Sure enough, we came across a nest in a dead tree stump. I set up my remote camera, hid in a thicket, and caught the parents bringing caterpillars to their young.

The next day Talbert Williams, biological technician at Tensas, carried me all over the refuge and the surrounding farms in his 4WD truck. As we watched Prentiss loaders stack hardwood logs on a corporate

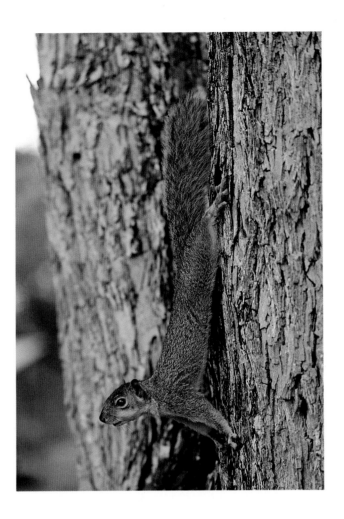

farm bordering the east side of the refuge, Talbert told me how efficient today's land-clearing equipment is. "They can come into a forest like we were in this morning and in no time have it planted in soybeans.

"See that machine? A big Caterpillar tractor with a V blade. It slices the stumps off at ground level and can do ten to twelve acres per day."

I took a closer look. The blade, more than twenty feet of triangular steel coming off the front of a massive bulldozer, was serrated like the sharpest kitchen knife. This thing could slice a house right off its foundation, I thought.

Talbert said, "I'm so proud of all those young folks, conservationists, and the legislators who helped set this refuge aside. You see, we've already lost our entire virgin hardwood bottomland forest and a few animals with it. Tensas here is some of the last of the second growth. I'm glad we got it."

The first growth went for lumber and farms, but not all the lumber was used—Roosevelt spoke of girdling trees. The second growth too went for lumber and farms, and again not all the lumber was used. I've watched some hardwoods windrowed and burned. It is painful to watch.

Why would you waste good trees? I call it the soybean phenomenon or, simply, ten-dollar beans. In 1973, because of the Mississippi River flood and a growing world market for soybeans, the price per bushel shot up to over ten dollars. At this price, a couple of farmers told me, anyone who could point a tractor in a straight line could make a profit.

It's too bad, for ten-dollar beans lasted just long enough for a lot of people to borrow bunches of money and clear marginal land. Now that the bushel price is back to around five dollars, the farms with big land and equipment notes are going bankrupt.

And that marginal land, it wasn't supposed to be farmed. It flooded on the farmers, occasionally causing them to lose entire crops, and soggy land never gave the bushels per acre that good land gives. Now it sits in weeds, most likely to be bought up by a large corporate farm. These conglomerates have the staying power to wait for beans to go back up or to make their money by renting the land to a hardworking farmer. The farmer will have just as much trouble making it as he did when he had the notes, and the corporation will collect government subsidies.

(right) *A fallen tree harbors a diverse community of plants and animals on the forest floor. This attractive fungi is turkey-tail,* Trametes versicolor, *and it is covered with green algae.*

Showing its first green of spring, a hackberry, Celtis laevigata (left), *contrasts with the fall colors of the sycamore,* Platanus occidentalis (far left), *and the sweet gum,* Liquidambar styraciflua (below).

There is a slight ray of hope in Washington right now that the farm bill will help get some of this marginal land back into production. The secretary of agriculture may implement regulations so bankrupt farmers can reduce their FHA loan debt if they give a fifty-year surface easement on their marginal land to the Department of Agriculture. I hope this land can be managed back into a hardwood wetland habitat and be available to the tax-paying public for recreational use.

Can beans go back up? It's unlikely, for our technology has taught the Brazilians bean farming. Our world-market share dwindles as they rip the Amazon jungle apart to grow cheap beans. Twenty years ago, Argentina and Brazil produced hardly a bean. Now they have nearly caught up with us.

In the meantime, we've lost productive hardwood bottomlands to marginal soybean farmland that is not even worth using for agriculture.

How valuable are hardwood bottomlands? We're learning more every day. Take migratory waterfowl, for instance. Lollygagging around in the marshes, they can eat aquatic grasses, seeds, rice, and soybeans left from the harvests, but these are not the right foods to store up the fats and proteins they need for the incredible flight to their nesting grounds in Canada. Recent studies show that the ducks use the hardwood bottomland in anticipation of migration. They search for insects under the leaf litter to

Current forestry practices rarely let trees mature and die. These trees are important to the feeding and nesting of woodpeckers and raccoons (below) as well as many other species. If left alone, this big water oak, Quercus nigra *(right), could become a wildlife condominium.*

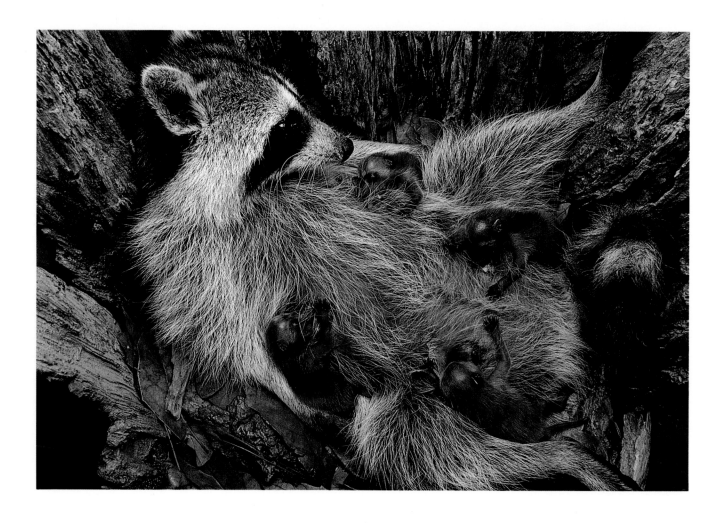

(above) *Mallards,* Anas platyrhynchos, *as well as other ducks, utilize the hardwood bottomlands to feed on insects before their journey to Canadian nesting grounds.*

(top right) *The loose bark of the sycamore tree sometimes falls completely off, leaving a smooth greenish white trunk.*

(bottom right) *The nutria,* Myocastor coypus, *has teats on her side, thus allowing the young to nurse while in the water.*

get the food they need for pair bonding, mating, the long flight, and nest building. Those with improper nourishment have much less nesting success.

Hardwood bottomlands are also valuable in flood control. First of all, they are an area that doesn't mind getting wet. The fact is, they need water to be productive. If you consider the average tree, it holds 120 gallons of water and uses another 10,000 gallons during the year. That adds up to 10,120 gallons of water. Multiply that by 100 trees per acre and that by 6,300,000 acres of hardwood bottomlands cleared in Louisiana and you have 63,756,000,000 gallons of water that used to be utilized by trees. That's a lot of extra water to contend with during a flood year. Furthermore, the leaves and branches break the rain's fall. Then the leaf litter on the ground soaks it up, thus slowing the runoff.

Now with only 5,000,000 acres of hardwood bottomland left, it's immensely important to keep them. And we need to let some of that marginal farmland grow back to woods.

On my last trip to the Tensas forest, I saw three turkeys cross a ridge as they walked down to Africa Lake. Paddling a leaky bateau by the towering cypress of this oxbow lake, I saw the Spanish moss nest of a yellow-throated warbler. Tensas National Wildlife Refuge, with its fowl, fish, and animals, is a special place, and it will only get better as it matures.

Just about twenty miles southeast of the refuge, a

college friend of mine farms Somerset Plantation. Pat Mabry has five thousand acres of prime hardwood bottomland right off the Mississippi River. The jewel of that woodland is Grassy Lake. Pat wanted to try to call some mallards in for me, so we headed for his duck blind.

In the predawn hours we traveled by truck, then by three-wheeler, and finally by pirogue to get to the blind. It was under a lone tree in the middle of the lake. It's not a big lake, being a hundred yards wide at most, but there are many fingers that reach into the woods. Pat called mallards in that were so high, they were probably tuned in to Houston flight control.

Down they spiraled until finally, with a splash, they dropped into the duckweed-laden lake, making ripples of tannin-colored water vibrate out in concentric circles. The mallards must really like these little wooded lakes. A nutria neighed as we paddled out to look at the rest of Pat's woods.

A few weeks later, I photographed a nutria yawning as she nursed her pup from teats on her side. With this adaptation a nutria does not have to lie on dry land to nurse her young. The nutria is not native to North America but has adapted readily to Louisiana's wetlands, and now is the major furbearer in the South. It perhaps is one of the reasons for the strong comeback of the alligator, which finds it easy prey.

Another nice patch of hardwoods grows on Davis

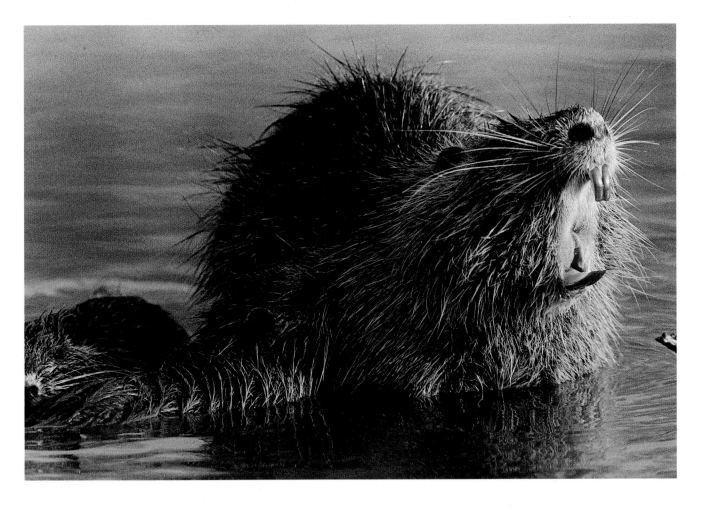

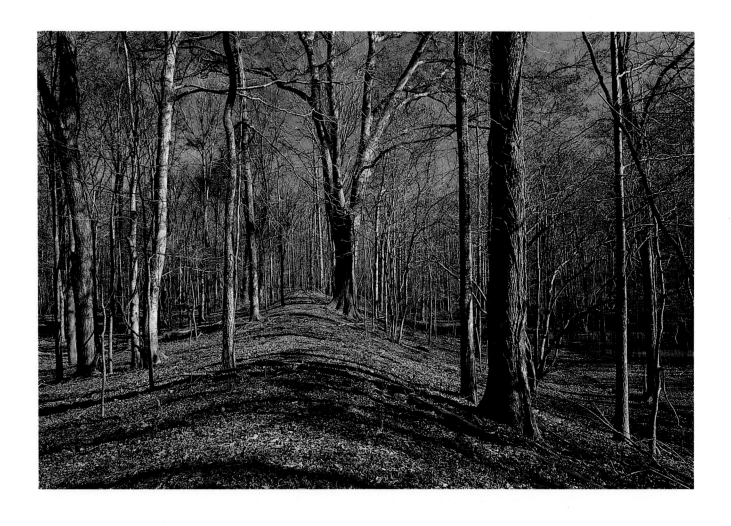

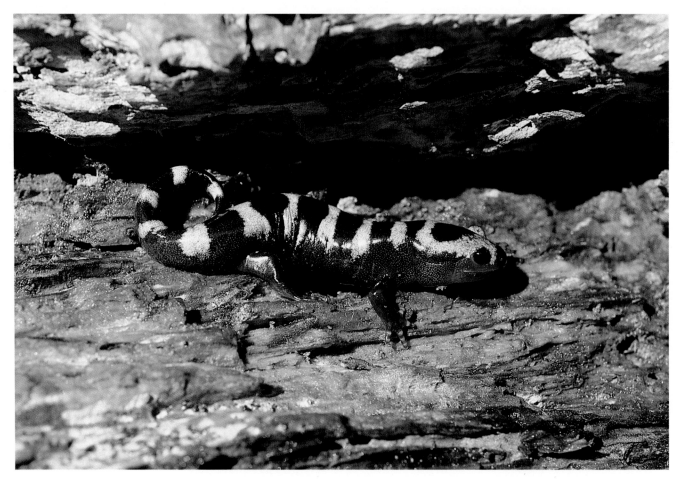

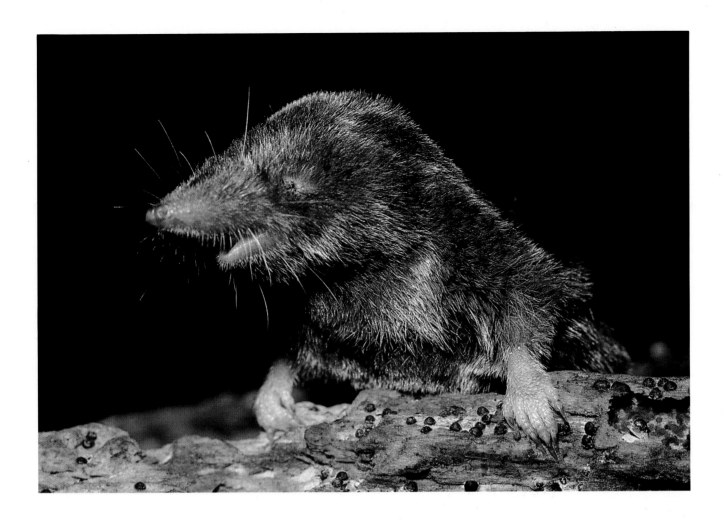

Island. Named after Jefferson Davis' brother who once had a farm there, the island was formed when the Mississippi River changed channels. Massive oaks now grow on a small levee built more than a hundred years ago by slaves with mules . . . no machines.

It's a muddy island, but full of deer, turkey, and ducks, and it's one of the last places the red wolf existed in north Louisiana. As I was hiking down the old levee, a sycamore caught my eye. Its peeling bark portrayed camouflage in both pattern and color. Who invented camouflage? I wondered.

Near Ville Platte, I searched for salamanders with Bob Thomas, director of New Orleans' Nature Center. Turning logs, we found two species, the marbled salamander and the small-mouth. The marbled, with its blotchy white stripes, was a doll compared to the small-mouth's black with a few gray dots. Actually, I guess you have to be a dyed-in-the-wool herpetologist to love these ugly little amphibians.

These salamanders live deep in the ground most of the year, crawling through small tunnels and eating any invertebrate they can get their mouth around. Only in the winter do they come up to lay their eggs under logs that will be inundated by high waters in the spring.

We also found a few short-tailed shrews, voracious citizens of the log-and-leaf-litter community, which can eat their body weight in food each day. This is

(top left) The changing course of the Mississippi River left this old levee, built by slaves with mules, stranded on Davis Island.

Both the short-tailed shrew, Blarina brevicauda (above), *and the marbled salamander,* Ambystoma opacum (bottom left), *are rarely seen. They live in burrows and under logs.*

89

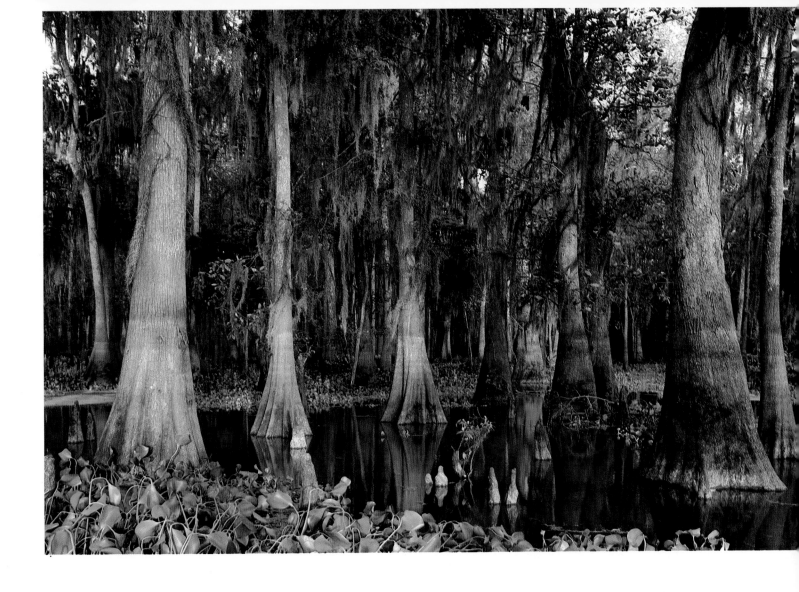

one of three shrew species in Louisiana. It has a poisonous bite, so it can often kill and eat things larger than its own nine-gram (about one-third ounce) size. Shrews and moles are the smallest and some of the most primitive animals in the United States.

Louisiana has twenty-two species of salamanders. Some are rare here because we are on the edge of their range. Others are rare because of loss of habitat. The zigzag salamander is found in only one site in the Tunica Hills. What a name. Researching rare plants and animals, I found that quite a few had humorous or peculiar names—two-toed amphiuma, dubirafian riffle beetle, Louisiana quillwort, shadow witch orchid, and the long-sepaled false dragon head.

Seriously, though, each of these and many more need their little niche to survive. Take the Louisiana quillwort, for instance. This plant has to have a clean, flowing, gravel-bottom stream to survive. I need a diverse habitat too, but for now let's stick to swamps.

The Pearl River Swamp is a little different from the smaller patches of bottomlands in north Louisiana. For one thing, it's much bigger, covering the Louisiana-Mississippi border for most of St. Tammany Parish. It's river-basin swamp, and its main artery is the Pearl River. The river, lined with baldcypress, water-tupelo, catalpa, and swamp red maple, sometimes branches out into five main channels.

Baldcypress, Taxodium distichum, *line the banks of Lake Concordia* (left) *as well as those of Flat Lake in the Atchafalaya Basin* (above).

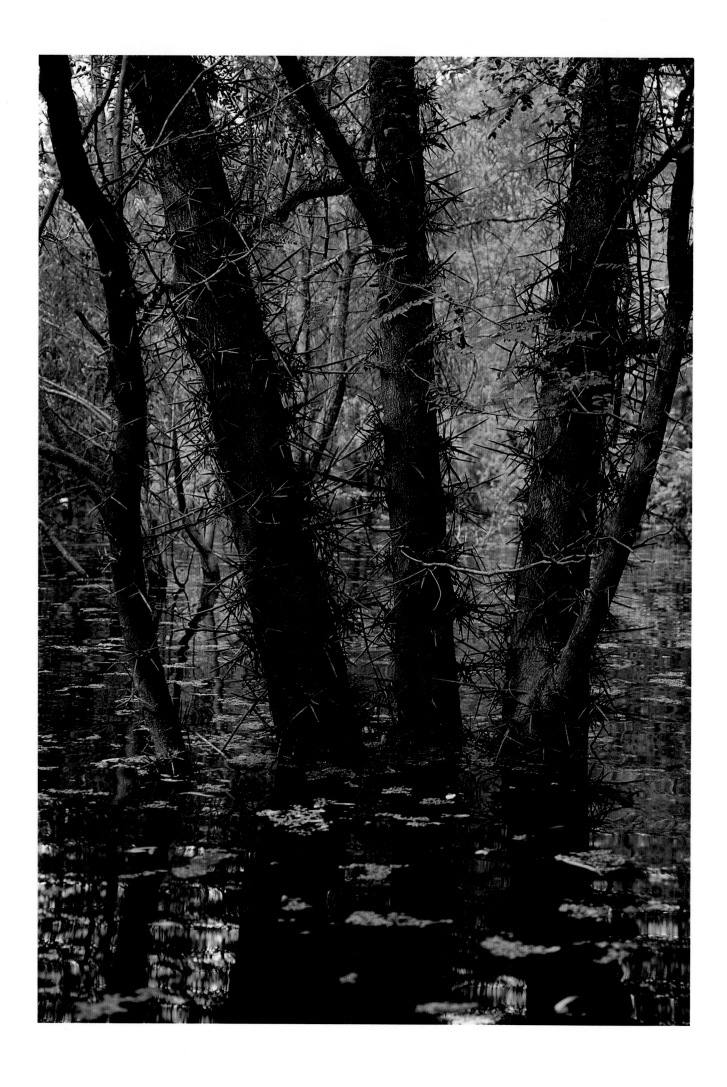

When they named the swamp red maple, they did well. On a December float through the Pearl, the banks were aflame with the dying maple leaves. The winter light on those red leaves was special on that sunny day. In winter the North Pole has tilted away from the sun, and thus old Sol drifts across the southern sky, giving a good light (for photography) all day long.

In February, the first green of spring is red. The maples send out their winged samaras, just as red as those fall leaves, and before any other tree has put out a leaf. There are so many of these seeds that at a distance the tree seems covered in red leaves.

The Pearl is fairly safe from conversion to other uses because of its extreme seasonal flooding and the existence of the Bogue Chitto National Wildlife Refuge and the Pearl River Wildlife Management Area near Honey Island Swamp. Honey Island was named because early explorers noticed a lot of bee trees.

A big hollow cypress full of bees is really something. You hear it first from a couple of hundred yards away, an incessant buzzing. On closer inspection you see some small holes (where limbs once grew) with bees pouring out and climbing in. I think about all that delicious honey inside and dream of a black bear climbing the tree to raid the bees' precious treasure.

When the five channels of the Pearl cross under Highway 90, the swamp quickly changes to marsh—

(left) *Heavily armed with sharp spines, this water locust,* Gleditsia aquatica, *can stand periodic flooding in the Manchac swamp.*

(below) *Fowler's toad,* Bufo woodhousei fowleri

(overleaf) *The cypress along Bayou Dorcheat near Ruston show much more fall color than those in south Louisiana.*

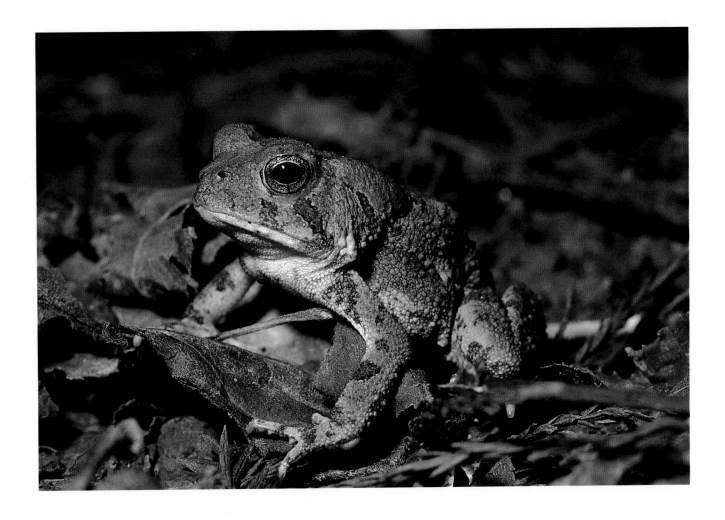

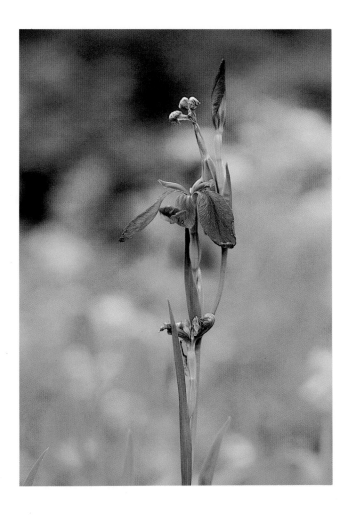

(far left) *North of Baton Rouge, the mighty Mississippi River meanders toward the setting sun.*

(left) *Copper-colored iris,* Iris fulva, *was first collected in Louisiana.*

(below) *Coral honeysuckle,* Lonicera sempervirens

a completely different but co-existing habitat. Moving on to south central Louisiana . . .

Louisiana's celebrity swamp is the Atchafalaya, North America's largest river-basin swamp. Currently it is contained within the east and west protection levees that average 18 miles wide, and the river runs about 120 miles from the Old River Control Structure to Atchafalaya Bay. Historically it was much bigger, stretching from the natural levee of the Mississippi River in the east to Bayou Teche in the west.

Atchafalaya, meaning "long river" to the Attakapa Indians, is actually the shortest trip to the Gulf for the Mississippi's waters. That tumultuous flow can reach a volume of 1.3 billion gallons of water a day during flood stage. The Corps of Engineers prefers to keep the Mississippi in its old course, meandering by Baton Rouge and New Orleans and out the Plaquemine Delta.

Since the end of the last ice age, the Mississippi River has snaked along coastal Louisiana in five separate deltas, building the bottomlands, the marsh, and the coast virtually everywhere south of Baton Rouge. Without the control structure, engineers theorize, the Atchafalaya would have been the sixth delta and, in about 1964, would have captured over 50 percent of the Mississippi's flow.

To keep the status quo, the Corps regulates the structure to let about a third of the Big Muddy's flow

into the Atchafalaya, and that water carries tons of sediment from farmlands across the nation. This mud has greatly changed the basin over the last sixty years. Bayous change course and lakes are filled as Old Man River builds land like it always has. When Grand and Six Mile lakes were filled, the sediment flowed onward to Atchafalaya Bay and a new delta was formed. It was 1973, the year of one big flood, and islands began to appear in the bay.

In 1974, I noticed plants growing and birds nesting on the newly accreted land. The next year, mammals invaded. Signs of raccoon, nutria, otter, and deer were apparent. Atchafalaya Bay is one bright point in the disastrous loss of coastal land elsewhere.

What about the rest of the swamp? After the controversy of the 1970s, the Atchafalaya situation has been sort of calm lately. The landowners, the Corps, the environmentalists, the oil industry, and many other groups finally came to a compromise agreement to protect the swamp. Slow to implement for lack of funds, but at least on the right track.

I hope so, because of all the natural areas in the world, the Atchafalaya Basin is the closest to my heart. It's as familiar as a twin brother and as beautiful and peaceful at my favorite spots as sleeping on a cloud.

I returned last summer to one of those favorites—an egret and heron rookery in a baldcypress backswamp. It was Mother's Day, so with the flowers al-

(right) *Near Lecompte, a cypress-tupelo bottomland is tucked between surrounding hills.*

(below) *A swamp red crawfish,* Procambarus clarkii, *maintains a defensive posture toward the photographer's lens.*

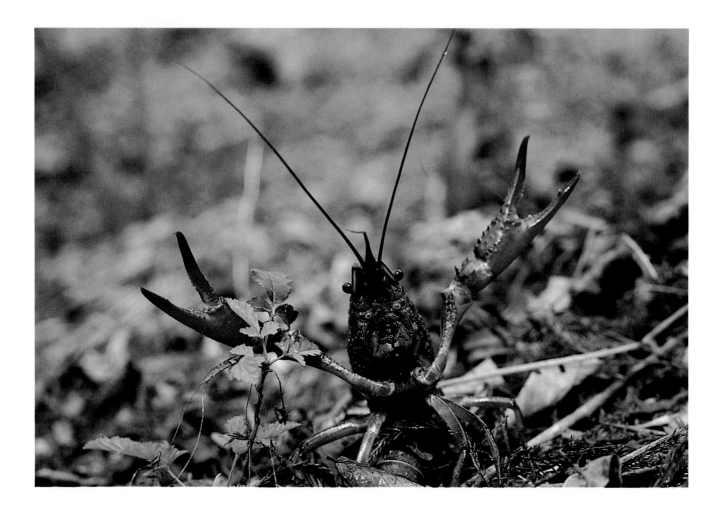

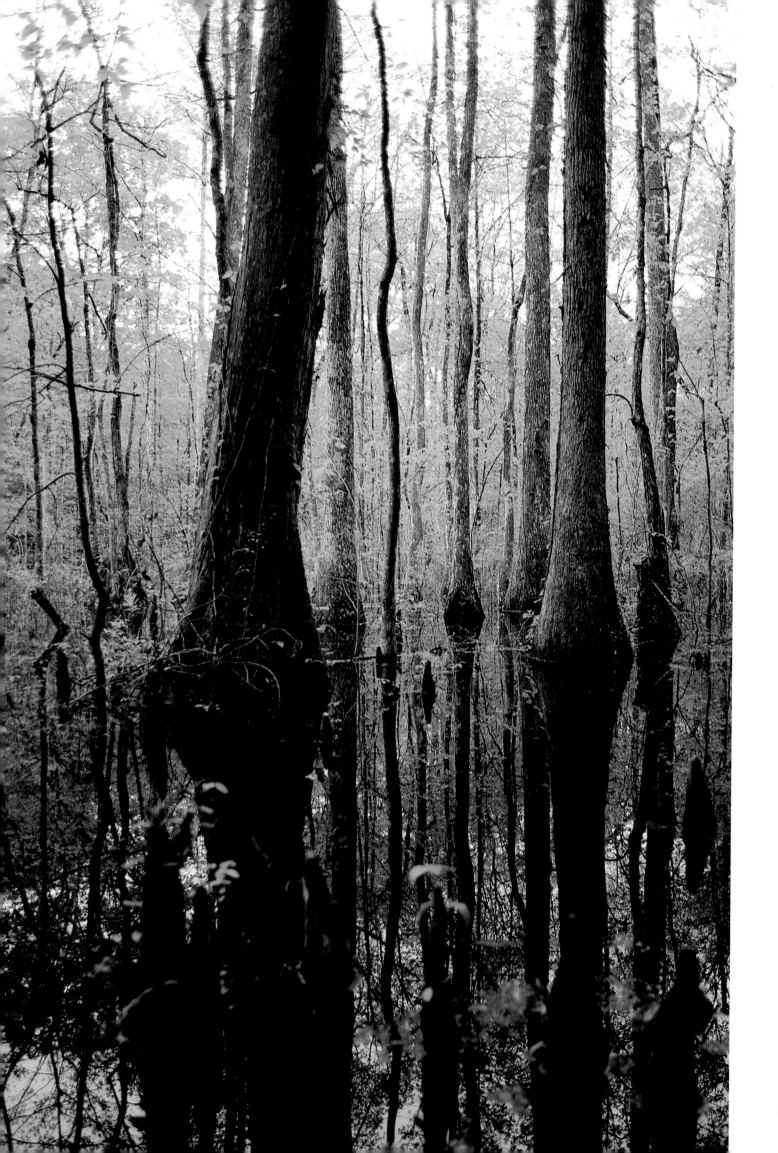

ready sent, I set out in my canoe. White wispy clouds decorated a blue-skied cool morning. The water was lower than I expected, and the dead hyacinth from last year made the going somewhat tough.

Once among the egrets, I hid in my blind and watched parents feed their young. Some were almost full grown. The young birds make a strange sound that I would describe as a "ticking hiccup." It is a constant monotous tone that turns to squawks while they're being fed.

Through binoculars, I watched their behavior and was enjoying the day so much, I almost forgot lunch. Then I caught sight of a hole in a dying tree, and before I could comment to myself that that would make a good wood-duck nest, I noticed a snake skin hanging on the edge.

I paddled over to investigate. The V-shaped hole was eighteen inches tall and almost wide enough to get my head in. But since there was a four-foot-long rat snake in there with an egg in his mouth, I opted for just looking in.

The scene was as exciting as swimming with twenty-eight hammerhead sharks in the Galápagos Islands. Face to face with a Texas rat snake for one hour, watching him eat the three remaining eggs in the wood-duck nest. (Wood ducks can lay ten or more eggs.) Since his skin was hanging there, he had obviously been around for a while.

His technique was incredible. He would push the

With the ability to unhinge its jaw, a Texas rat snake, Elaphe obsoleta lindheimeri, *eats a wood-duck egg larger than its head* (below *and* right).

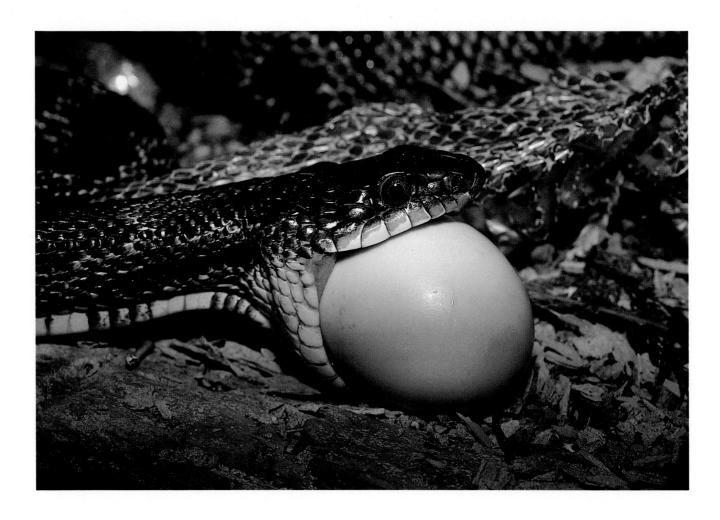

egg, the size of a small chicken egg, around til he could take it in the long way. Still, he had to open his mouth to almost twice the size of his head and start working the egg in. The snake is able to do this because of special ligaments that allow him to unhinge his jaws. When he turned toward me, all I could see was an egg in the middle, lips and a portion of his eyes peering over on top, and, down below, lips and a round air tube called the glottis.

Once his mouth closed, he looked somewhat like a cobra, with his now-wide cheeks. Then he edged over to the tree trunk and rubbed his head against the wood until the egg cracked. Finally I watched as he contracted his ribs to move the less bulbous cracked egg on down inside his body. After a few minutes' rest, he went on to the next egg.

Paddling off, I chalked this up as a worthwhile day. The coolness had worn off, and I sweated profusely as I worked the canoe through the duckweed and emerging hyacinth.

Through the cypress, I stroked until a mother wood duck and seven ducklings swam by. Resting, I turned to look toward the sun. The duckweed shone silver while the young shoots of hydrocotyles showed the fresh green of spring in the dappled understory. Truly a painter's delight, but beyond the capability of Kodachrome.

Rested and paddling home, I heard an osprey speak and glanced up to see him flying toward Bayou Sorrel. The Atchafalaya recently had a successful osprey nest in that area. More exciting, though, in the birds-of-prey news was that an eagle pair had set up housekeeping in the Atchafalaya north of Morgan City—the first time in recent history.

Eagles' nests have always been in the lower Atchafalaya and the area to the east, but now they're doing well enough to spread out. In 1976, when I filmed one of the nests for my Atchafalaya movie, there were fewer than ten known nests, and only seven were active that year.

As of February, 1986, Wayne Dubec, volunteer eagle watcher for the U.S. Fish and Wildlife Service and Louisiana eagle expert, says there are fifty-six known nests with twenty-six active.

Some of the more toxic pesticides have been banned, so eagles are now nesting more successfully. Wayne claims that now they've reached a saturation point on nest sites. Not enough big old trees available.

He's also worried about another poison—lead. Bald eagles are scavengers, not quite the carrion eaters the vultures are, but eagles like to pick up crippled waterfowl. Those birds are carrying lead shot. They usually have been wounded by a hunter or have picked up spent shot in the marsh mud while feeding. It's too bad we can't quickly switch to steel shot.

Most of the eagles nest at the edge of the swamp

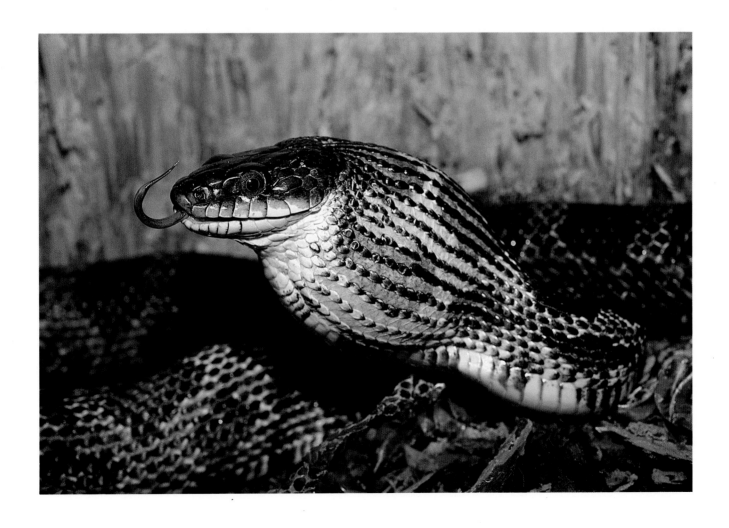

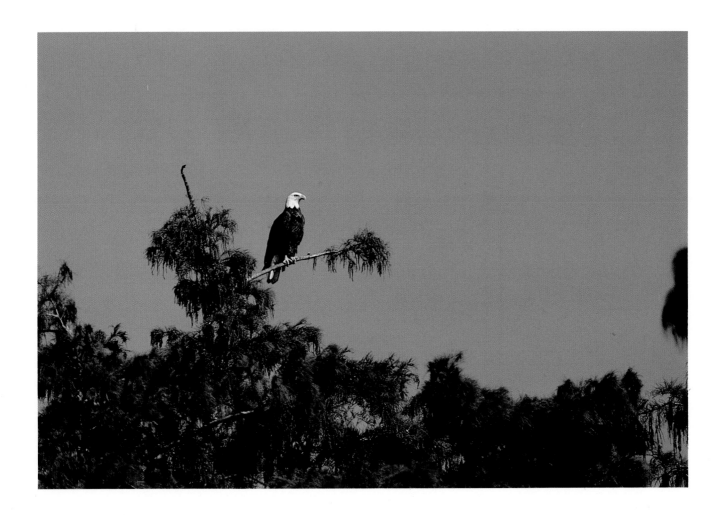

and marsh. This interlocking habitat is one of our richest in terms of wildlife, especially the type we like to view. Swamp tours like Annie Miller's in Houma and Paul Wagner's in the Honey Island Swamp prove this—they take tourists daily to see nutria, raccoon, alligators, snakes, turtles, egrets, herons, owls, and eagles. In other habitats, it would take days of stalking by ourselves to see these animals.

The animals like their habitat because it's diverse, vibrant, and fast-growing. The swamp-marsh habitat produces thousands of pounds of vegetation, detritus, larva, and fry. The eagle can live in the cypress trees and fish in the marsh. To me these trees are the most important in Louisiana.

(above) *Our national emblem sits on a baldcypress branch at the fringe of the swamp and marsh. Thanks to the ban on some hard pesticides and to protection by the Fish and Wildlife Service, Louisiana now has twenty-six active nests.*

(left) *Part of the second-growth hardwood bottomland forest in the new Tensas National Wildlife Refuge*

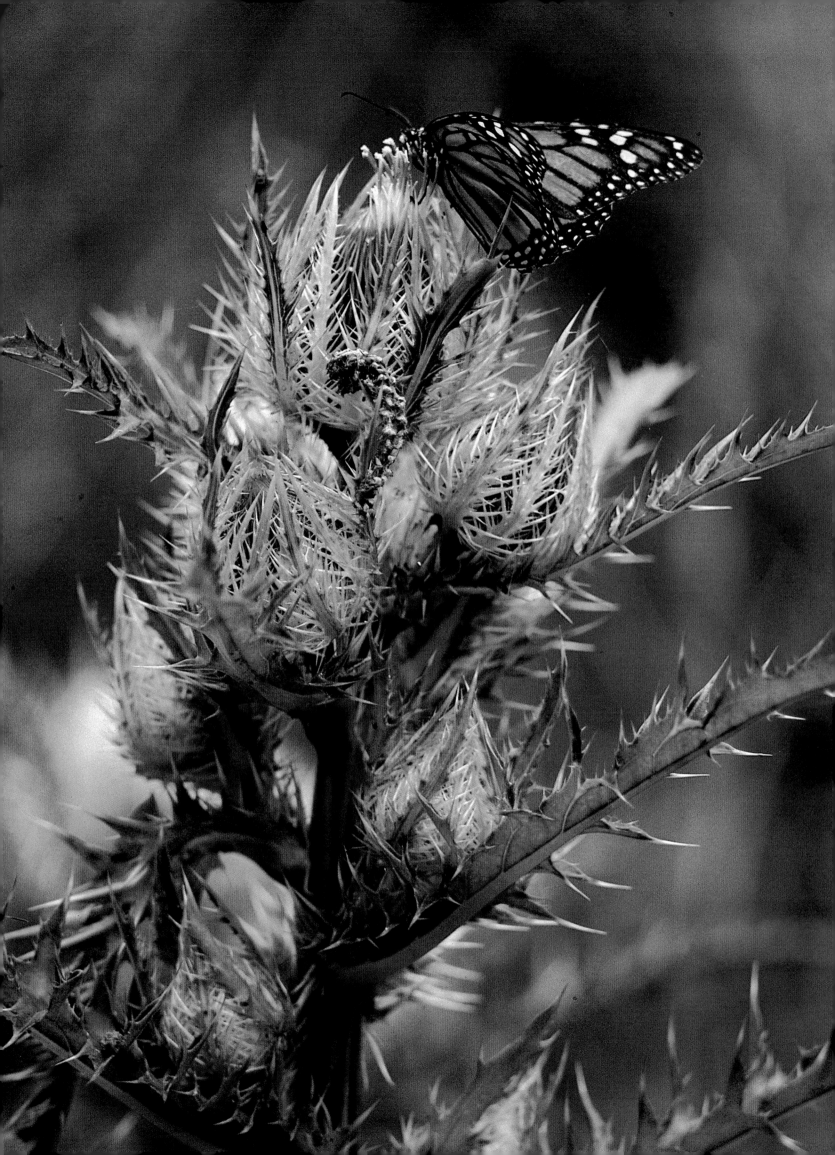

4

Prairies, Cheniers, Bogs, and Salt Domes

Scattered across Louisiana are many lesser habitats. Their diminutiveness is in size only, for the wildlife community they shelter is just as impressive as our larger habitats.

PRAIRIES

Prairies historically were one of Louisiana's major landforms, covering more than 15 percent of the state. Samuel Lockett, while working on a geographical description of the state in 1869, crossed the Great Prairie on horseback. He described his journey: "I feel a good deal like a mariner on an unknown sea. . . . The surface of the prairies though generally level is yet not perfectly so. It is gently rolling like the billows of a deep sea. In fact, one cannot ride through the prairies without having their striking resemblance to larger bodies of water constantly recurring to his mind." I can imagine Lockett's view. His sea of grass was called the Great Southwest Prairie. Roughly a triangle between Vinton, Ville Platte, and New Iberia, the majority of this flowing expanse of grass was in Calcasieu and St. Landry parishes.

The rivers and bayous that drained this region were lined with bottomland trees while the open expanses were covered by grasses such as bluestem, switch, and Indian. According to Paul D. Coreil of the Cooperative Extension Service in Cameron, Louisiana, trees could grow in the prairie but fires would knock them back. "Nowadays," he says, "with fires controlled, idle farmland grows up in tallow trees."

Today, the prairie is gone. Millions of acres have been plowed under for farm and grazing land. Gone forever is the wide expanse of waving grasses and many of the birds associated with it. The whooping crane's story is the best known. The prairie, with the adjoining marsh, made an excellent crane habitat, perhaps better than their current winter range at Aransas National Wildlife Refuge in Texas.

Unlike its neighbor state, Louisiana had both wintering birds and a resident breeding population of whooping cranes. The bird was considered a common species as late as 1899 by naturalist Vernon Bailey. Pressured by loss of habitat and random shooting, the crane quickly declined. One rice farmer shot twelve cranes while they fed on grain spilled from his combine. The last one was seen in Louisiana in 1949, the year I was born.

A smaller crane, the sandhill, as well as the greater prairie chicken and the trumpeter swan, are now gone from Louisiana, partially because of the loss of this habitat.

A monarch butterfly, Danaus plexippus, *feeds on the nectar of the spiny thistle,* Cirsium horridulum.

(overleaf) *Periodic outbreaks of wind-borne spiders spread webs over the marsh and former prairie of southwestern Louisiana.*

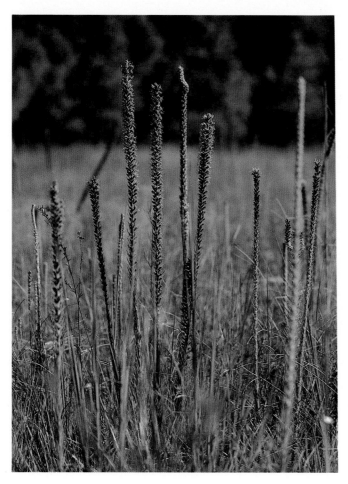

The Mississippi kite, once a common breeder, no longer nests in southwestern Louisiana.

The trumpeting call of the great swan or the booming courtship antics of the prairie chicken are probably missed much more than the prairie vole, but the disappearance of any species is a sad occasion. This small rodent, sometimes called the meadow mouse, was last seen in 1899 near Iowa, Louisiana. Vernon Bailey found its nesting burrows on pimple mounds.

Pimple mounds are an unexplained feature of Louisiana's landscape. The miniature hills, up to six feet tall, are round or sometimes elliptical. They occur only west of the Mississippi River, mainly on the terraces, and have been attributed to Indians, ants, wallowing bison, and burrowing animals.

Perhaps no one will miss the prairie vole, but they certainly won't welcome one of his replacements.

In the 1930s, Dr. George Lowery caught house mice where three decades before Bailey had caught none. The house mouse, a European immigrant, can carry diseases and is a less desirable creature by far to have around than the prairie vole.

The prairie was not limited to the southwestern part of our state, just the great expanses. Many smaller prairies were common in the area drained by the Ouachita River and in Vernon, Avoyelles, East Baton Rouge, and Livingston parishes.

Today there is an acre patch here and there that hasn't been plowed because it is in a railroad right-of-

way or for some similar reason. The big expanses are gone. Annette Parker, Nature Conservancy botanist, guesses that we could never get them to grow back because the seed stock has long since been plowed under or killed by herbicides. This, and the virgin baldcypress forest, are two habitats I'll never see.

CHENIERS

Chenière is a French word meaning "place where oaks grow." I call them "islands in the marsh." Cheniers are limited to Cameron and Vermilion parishes. Formed by the Mississippi River sediments, they serve as a geological record of the various deltas.

When the river was on a western delta such as the Teche Delta, longshore currents would carry clay and silt to southwestern Louisiana, building marsh. When the river shifted east, beach deposits consisting of shell fragments would build up to six-foot elevations. Later the river would shift again and add marsh seaward of the beach front, which would become a chenier.

Lockett described the weather on the cheniers as delightful, but commented negatively on the swarms of mosquitoes and deerflies. As for wildlife, the cheniers are most important for birds. A two-ounce bird bucking a north wind for 700 miles across the Gulf of Mexico needs a rest before traveling on to its breeding grounds. The wind-bent live oaks are way stations on the spring migrations.

(top left) *The web of a golden silk spider,* Nephila clavipes, *stretches between two hackberry trees on Little Pecan Chenier.*

Blazing star, Liatris pyncostachya (bottom left), *and meadow beauty* (above) *are two wildflowers that probably grew on the prairies of Louisiana's southwest.*

Massive live oaks, Quercus virginiana, *shade out the understory on a Cameron Parish chenier* (above) *while giant blue iris,* Iris giganticaerulea, *grow on an island in the marsh in Vermilion Parish* (bottom right).

(top right) *Springs such as Hannah's in Natchitoches Parish are another of Louisiana's minihabitats.*

Cheniers are ten to fifty miles long and are rarely over a quarter of a mile wide. The tallest ones may reach ten feet above sea level and so were the first places settled in the marsh country. They are characterized by a gentle slope that blends with the marsh on the north side and a steeper slope on the seaward or south side. The high and dry cheniers support live oaks gnarled beautifully by the constant sea breezes. The edges are lined with baldcypress, and as the elevation drops, the chenier is surrounded by marsh.

Besides being a great birding area, cheniers provide the only habitat for the marsh deer to dry its hooves. I've seen deer at dawn or dusk on every trip I've made to Pecan Island.

In Vermilion Parish, Pecan Island is one of Louisiana's larger cheniers. It's excellent for bird watching, and I always spend at least a few spring days at a friend's duck camp. I can travel in the marsh between the cheniers and White Lake to see the last of the mallards or walk through woods to view scarlet tanagers, American redstarts, and black-throated green warblers. Last spring I was watching a veery with my binoculars when I made a lucky discovery. Lowering the glasses, I caught a gleam on the otherwise muddy ground. Upon closer inspection, it turned out to be a woodcock.

This bird lies still in moist woodlands all day and goes out into fields and pastures to feed at night. When I approached, he lost confidence in his camou-

flage and blasted into the air and maneuvered expertly through the thick understory of willows and hackberries.

Next I came upon a full acre of giant blue iris. Most were lovely lavender blue, but some were white. They stood three feet tall and made these wet woods look like a cultivated garden. On my walk back to the camp, I saw a raccoon in a high fork of a tree and a great horned owl asleep in another. Just a few of the many animals that inhabit a chenier.

BOGS

Bogs are tiny habitats, for they are small compared to the area cheniers occupy. The wet, oozy ecosystems do not generally fit in with man's developmental attitudes and so have been drained or filled throughout much of the Southeast. Some scientists think that 98 percent of the Gulf Coast bogs have been destroyed.

Two types of bogs exist in Louisiana: the flatwood bog in the southeastern part of the state and the hillside bog in Kisatchie. The flatwood bog has a more diverse plant life, but both are characterized by a wet, acidic soil and unique plants.

Perhaps the most interesting plants found in bogs are the insectivorous plants, of which there are two types. These are the Venus flytraps of Louisiana. The sundew is a petit, ground-hugging plant except for the flower that grows on a tiny stalk about two inches tall. Its leaves are covered with many little shafts that have a drop of a sweet and sticky red substance that attracts insects. Upon landing or crawling on the patient sundew, the insect is trapped by the stickiness. Then the sundew's enzymes start decomposition, thus feeding the plant, which uses the extra nutrients for seed production.

The much larger pitcher plant, with two species in the Louisiana bogs, uses a different method to capture its prey. The leaves are tubelike, about fourteen inches tall, and resemble a piccolo. The opening is wider at the top, and with its little carportlike roof, the mouth is an inviting hiding place for insects. After entering, insects are trapped by the plant's downward-pointing hairs. Secreted enzymes begin the process of decomposition, and the plant is nourished.

(right) *A pitcher plant bog in Fort Polk harbors many beautiful bog flowers.*

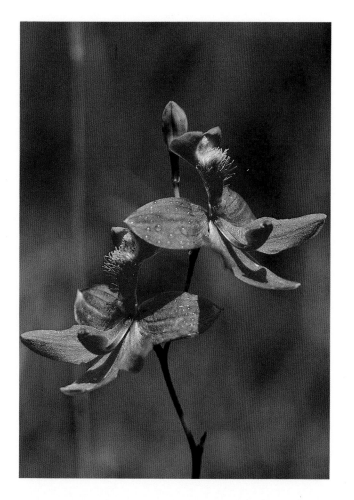

Slightly less interesting perhaps, but more beautiful, is the grass pink, an orchid. The rosy flower is about two inches in diameter, with petals spreading around yellow-bearded upper and lower lips. This flower is in bloom from April until June. Later in the year (August through September), the yellow fringed orchid blooms in the same place. It looks like a horde of many small, bearded yellow-to-orange flowers. Other orchids found in Louisiana bogs include the yellow-crested, the snowy, and the rose pogonia.

The first settlers in Louisiana used plants for folk remedies. The colicroot and toothache grass, for example, did what their names imply. The root was given to children with colic, and toothache grass was chewed to relieve the pain. I chewed the grass and felt a slight numbing effect.

Louisiana's rarest plant, the bog spicebush, is found in a bayhead swamp in Washington Parish. Only two male plants are known in Louisiana, thus reproduction is impossible. With some two hundred others in Mississippi and South Carolina, this is a genuinely rare plant. Botanists call it *Lindera subcoriacea,* and the Latin name is sort of like its own fingerprint. Plants and animals are given such names so that scientists won't have to contend with a confusing array of local names. The cougar, for instance, is also commonly called panther, mountain lion, puma, painter, and catamount. Scientists call it *Felis concolor.* Thus no mistakes are made, whether the student of

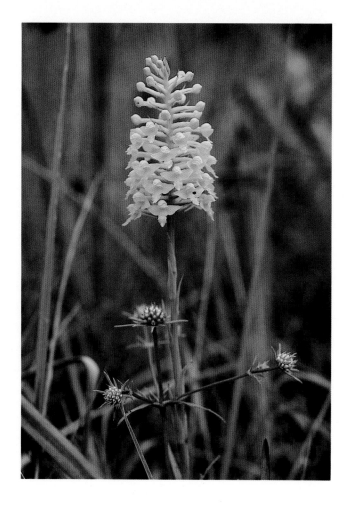

Springtime in the bog brings the colorful grass pink orchid, Calopogon pulchellus *(above left). The yellow-crested orchid,* Habenaria cristata *(below left), is a cluster of many small flowers. The candy root,* Polygala cruciata, *is so named because of a sweet-smelling root (top right). The yellow pitcher plant,* Sarracenia alata, *is an insectivorous plant (top far right).* Toothache grass, Ctenium aromaticum, *found at the edge of a bog in Vernon Parish, is a mild anesthetic when chewed (bottom right).*

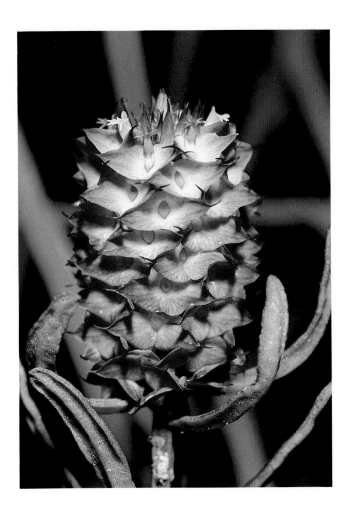

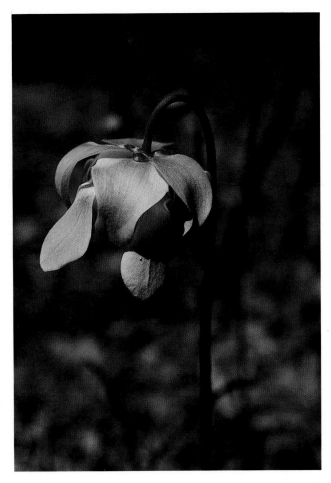

this animal is French, Dutch, or American.

The day I went to see the rare *Lindera subcoriacea*, Latin was the language, for I was with Annette Parker, Ladimore Smith, and Lowell Urbatsch, all professional botanists. They tested each other's skills all day long. At the sight of a miniscule grass, weed, or flower sprout, one would bend over, point, and say, "What's that?" They'd all lie down on their bellies and look at the specimen through magnifying glasses. Then Latin would begin to flow as they sought to identify it.

Annette was the only one who had seen the bog spicebush before, and the rest of us were anticipating a view of Louisiana's rarest plant. After driving down a dirt road, parking by a washing-machine graveyard, and penetrating a dense tangle of prickly blackberry vines, we entered a mucky bayhead swamp. As we neared the plant I wondered what drives these botanists to such extremes, to look behind a junkyard? But, excited, I kept right at Annette's heels, for I wanted to see the expressions of all these people when they first spotted *Lindera*.

Crossing behind the small shrub she pointed to, I kept my comments to myself and turned to watch Dr. Urbatsch approach, touch a leaf, and sigh dully, "Is that it?" Similar comments were made by them all as they walked around the scraggly three-foot shrub with only six branches and about twenty leaves. I suppose we were expecting the fruit of the mayhaw,

the flower of the magnolia, the form of the live oak, and the fragrance of a wild azalea.

The consistency of the muck is about the same in a bog as in a bayhead swamp, but a bog requires more open area. A few tall pines surrounding a bog wouldn't hurt, but they need fire to knock back the invading trees, such as the red bay, which can crowd and shade out the bog flowers.

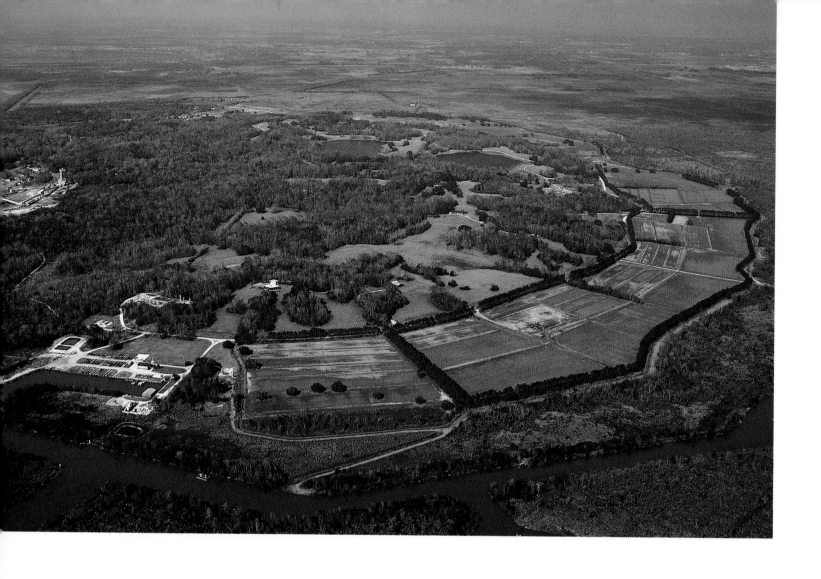

SALT DOMES

Flying over, you would have to have the eyes of an eagle to spot a bog, but from the air is the best way to get the overall effect of a salt dome. Over Avery Island, you can get a good view of the salt mine, the jungle gardens, the tabasco plant, and the pepper fields. At certain angles, you get a feeling for the dome's height, 155 feet above the rest of the marsh.

To the southeast, Weeks Island has the highest elevation compared to the surrounding land. It is 171 feet above sea level and 166 feet above the marsh. Avery, Weeks, Jefferson, Cote Blanche, and Bell are called the Five Islands. Of 204 salt domes in the state, these are the only ones with elevation; a few others have recognizable surface forms. There are about 30 salt domes in north Louisiana, 100 on the coast, and 70 offshore.

As for salt production, only three mines are still in operation—Weeks, Avery, and Cote Blanche. Louisiana leads the nation in salt output and at current rates of consumption, we'll never run out. Avery Island's salt-mine shaft is about 530 feet deep, and the plug of salt itself is more than 30,000 feet down.

Geologists believe that salt domes got their start over 150 million years ago. They speculate that while the sea was shallow, thick layers of salt accumulated. After being covered by a great deal of sediments, the salt began to rise, forming the salt domes and ridges

(above) *Avery is one of the five island salt domes along the central coast of Louisiana. Note the tabasco pepper fields.*

(right) *Many egrets and herons now use the rookery started by John McIlhenny in 1882. This cattle egret,* Bubulcus ibis, *feeds grasshoppers to its young.*

116

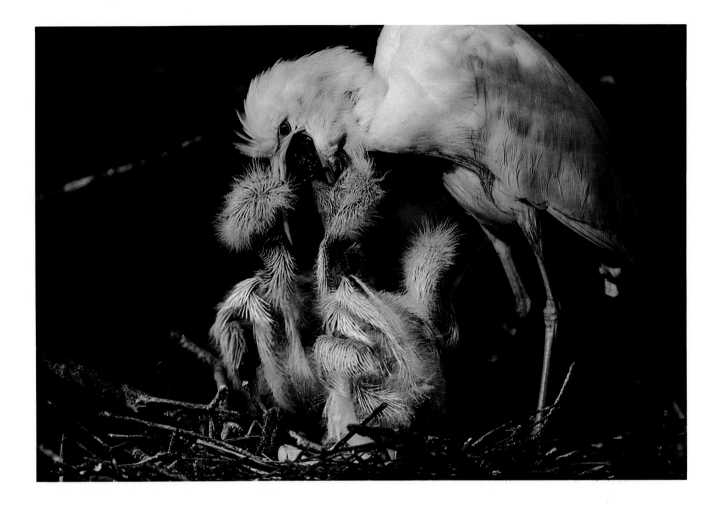

in the Gulf. A salt dome is the base of the Flower Gardens Coral Reef, the northernmost living reef in the Gulf. Much of the offshore oil exploration is on salt domes.

Jefferson and Avery islands have extensive gardens. These, along with the natural vegetation, create a higher and drier wildlife habitat similar to that of the cheniers.

In 1882, John McIlhenny started a snowy egret rookery on a small lake in the gardens on Avery Island. He captured seven egrets, fed them in a large flight cage until they finally bred, and released them after the young had fledged. These birds came back to nest on this lake year after year, drawing other species as well. I have seen anhingas, Louisiana herons, little blue herons, great egrets, and cattle egrets nesting here. This rookery is a special place for two reasons. First, the birds are used to humans watching them; second, it is easy to get to. Most bird rookeries are deep in the swamp, and getting there can sometimes be an ordeal.

One day in May, I was sitting in the observation tower near the rookery, watching the tourists pass one particular alligator. This big fellow, ten feet long, was submerged except for his nose and eyes. He was completely camouflaged in the duckweed that covered the water. More than once, a tourist leaned over the wooden rail to look at the egrets, not seeing the alligator five feet below. When the gator would sud-denly move, the tourist would let out a shriek and jump back.

All through the gardens, the flowers and vegetation are beautiful, and most of the time, you can see deer, nutria, and alligators as well as many varieties of birds.

Salt domes, though not unique to Louisiana, certainly add some spice to our seafood factory, the marsh.

5

The Coastal Louisiana

The coast of Louisiana is something we can be proud of, for we are first in most categories. With 2,625,363 acres of marshland, no other state comes close to Louisiana, because that is 41 percent of the nation's total.

Compared to other Gulf Coast states, Louisiana has more miles of coastline and shoreline. We have almost half of the protected waters (bays, ponds, etc.), which is the reason that 74 percent of the Gulf's oyster reefs are right here in the Bayou State.

Actually, the coast is the cashbox, the payoff for the rest of the state's habitats. The waters of the hills, hardwoods, and swamps blend together to melt into the marsh. If Louisiana was a slot machine, those north Louisiana habitats would strike a jackpot, and the payoff is the $239,883,000 (1982) fishery taken off Louisiana's coast.

At the foot of the Mississippi flyway, Louisiana is a crucial wintering ground for wild fowl. We get ducks and geese all over the state, but the big concentrations are in the marsh where Sabine National Wildlife Refuge has 108,000, Rockefeller Refuge has 150,000, and the Amoco private refuge has 500,000 during peak periods.

Lacassine National Wildlife Refuge, sitting at the edge of the marsh and rice belt, usually tops them all—a peak population of 750,000 ducks and geese. This refuge was established in 1937 and now contains 31,776 acres.

My first trip to Lacassine was in August, and the blue-winged teal were just beginning to arrive. Paul Yakupzack, assistant refuge manager, took me for an airboat tour of the 16,000-acre freshwater pool and pointed out where 200,000 pintails would be dabbling in December. I promised myself I'd come back.

The airboat is quite a machine. It is designed to travel in the shallow waters of the marsh and in fact can make it over mud for short distances. It does this with the powerful thrust of a 230-horsepower Lycoming aircraft engine. With no troublesome prop in the water, the airboat is an important tool to the marshland wildlife managers. In spite of the obnoxious engine noise, the ride was exciting.

The marsh is alive in all shades of green (maiden cane, bulltongue, saw grass, spike rush) and in bloom with American lotus, fragrant water lily, and banana lily. Paul pointed out a "pop-up," which he told me was a floating mass of vegetation that starts the sequence of lake to marsh.

Later, I sat quietly for three hours high up in a tower, watching a procession of ibis, egrets, and ful-

Our state bird, the brown pelican, Pelecanus occidentalis, *flies by a Grand Isle sunset.*

vous tree ducks drift by in the pastel sunset.

In the twilight, I climbed down from my tower and noticed a swamp rabbit with her young. The baby was tiny, not even one-fifth the size of the mother. As I approached the two, the seasoned adult jumped back into the vegetation. After watching the youngster nervously look about for ten minutes, I quietly moved closer. The bunny did not notice my approach. I decided to teach him a lesson. So I made a dive for him but missed on purpose. The startled rabbit leaped into the bushes. Next time when a coyote or a bobcat sneaks up on him, maybe he'll be more careful.

In December, I was back. I climbed the tower in midafternoon and glassed the freshwater pond. Just where Paul said they would be sat a multitude of pintails, and in another spot, just where Paul said they would be, rested a concentration of green-winged teal.

I watched in great anticipation of the evening, for two special events happen then. First, just before sunset, about forty thousand snow, blue, and white-fronted geese fly into the refuge. Then at sunset and for hours afterward, hundreds of thousands of ducks fly out of the refuge to feed in the rice fields.

I proceeded to the east side of the refuge and set up my cameras where a lone cypress tree in the marsh would help frame the sunset and the evening flight of waterfowl.

It was a cold day, the second clear one after a cold front. The sun warmed me a little but was dropping fast. I put on my sixth layer of clothes and watched nutria swim among the coots. One coot seemed to swim lower in the water than the rest. Must have been injured.

A sharp-eyed marsh hawk noticed this too and hovered over the hapless coot. She sized up the situation, then landed on a clump of marsh grass. Three times she hovered, then sat, each time getting closer. The coot dived two times, to no avail, for the bird of prey would be watching when it came up.

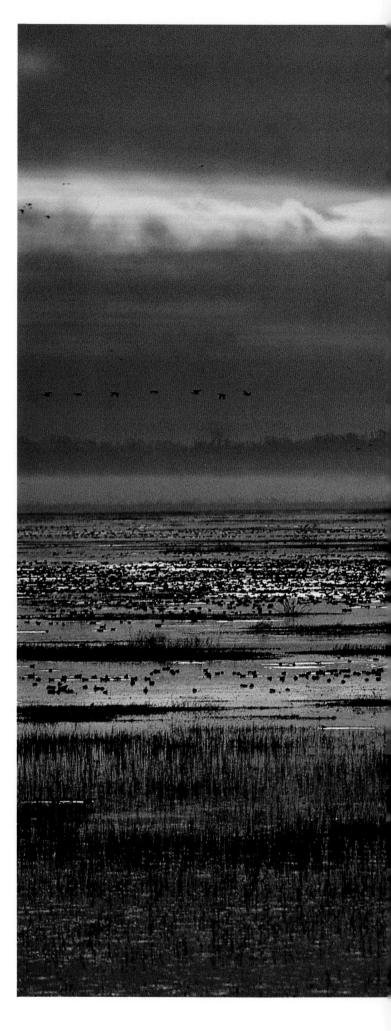

(right) *About 25,000 of the 750,000 ducks and geese that use Lacassine National Wildlife Refuge rest at sunrise.*

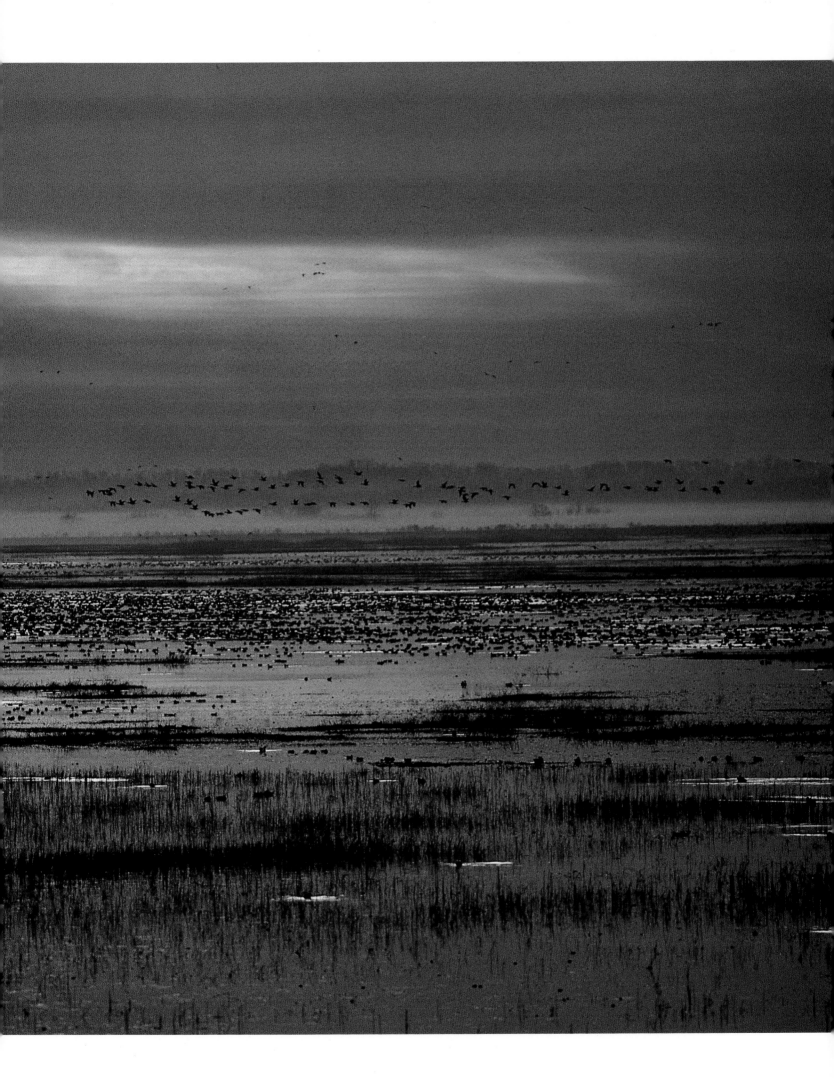

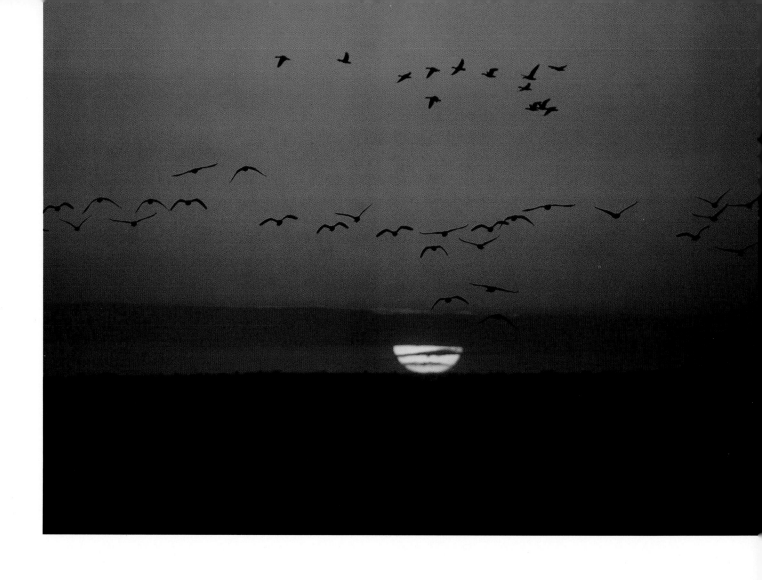

On the fourth pass, the hawk hovered and then pounced, grabbing the coot in her viselike talons. It was a struggle, but she finally got airborne and carried the flopping coot about twenty-five feet before dropping it. She left then, probably to come back later, but if she didn't, that weakened coot was on some other animal's dinner table within twenty-four hours.

Flocks of ibis and *v*'s of geese began to roll in as the sun neared my cypress tree backdrop. I became infatuated with the changing light and colors.

As that blazing yellow ball closes in on the horizon, it is much too hot to look at through my long telephoto lens. It could burn my retina, leaving me jobless. When it touches the marsh grass, somebody has put his hand on the dimmer. The light blues of daylight deepen quickly. Jupiter and the crescent moon pop out brightly. The sun turns orange, almost red, dropping out of sight. It leaves a yellow band across the western horizon. The band turns orange as the deep blues above turn purple, then black as the cypress tree and marsh grass below. The water still has a silvery glow and reflects a touch of the orange band.

Finally black meets black, and the hour-long light show is over. Night is here. It matters not to the ducks, for their parade to and from the rice fields lasts all night long.

The mass exodus starts when that yellow-to-

(above) *Snow geese,* Chen caerulescens, *leaving feeding grounds at sunset*

(top right) *A marsh hawk,* Circus cyaneus, *hovers and then attacks an American coot.*

(bottom right) *On straight black legs, a great egret,* Casmerodius albus, *stands guard above its nest.*

(bottom far right) *The productive waters of the freshwater marsh at Lacassine Wildlife Refuge*

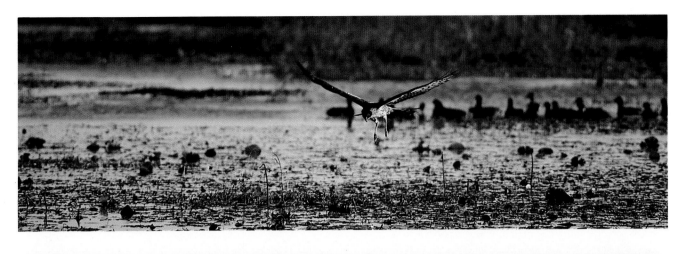

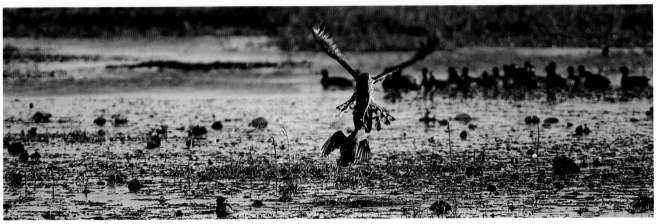

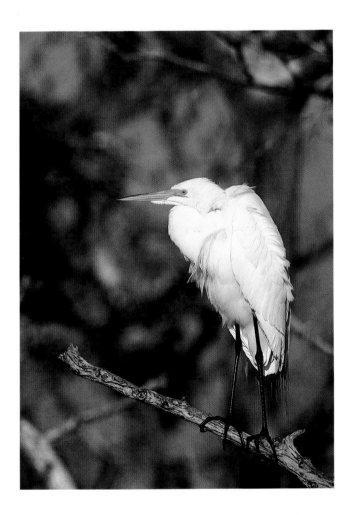

(above) *The pig frog,* Rana grylio, *is a common resident of the fresh marsh and is closely related to the bullfrog.*

(top right) *Cattails and water hyacinths line the banks of Minor's Canal in Terrebonne Parish.*

(bottom right) *American bittern,* Botaurus lentiginosus

orange band lies across the horizon. The ducks would fly right by me. Mallards and pintails up high, the teal zooming by low, like miniature spaceships with wings a-singing.

An hour before dawn, I was on the other side of the refuge, waiting for the reverse of last night to happen. The geese would get up from their night's rest with a clamor. The ducks were already back. My photographs of groups of ducks and geese flying by the rising sun reveal uncountable numbers sitting on the water. So thick they almost look like patches of marsh grass.

In another season, I was wading around a Vermilion Parish marsh one night, looking for pig frogs, which are a close relative of the bullfrog. They were thick that night. The stars were out, the frogs were croaking, and everything was going fine until I slipped while climbing a levee. It was a muddy levee, so while regaining my footing, I complained to my-self about the mud on my hands and bare legs that would surely soon be on my camera.

Ouch, ouch, *ouch*! A stinging sensation on my legs. I fumbled for my flashlight, quickly turned it on, and directed the beam toward the stings. Just mud-coated legs. I rubbed a sting spot, felt something, and plucked it up into the beam of light. Fire ant. I had fallen, knees first, into a muddy mound of fire ants. Why, it looked like a chocolate-covered ant. It re-minded me of younger days when one is so vulnera-

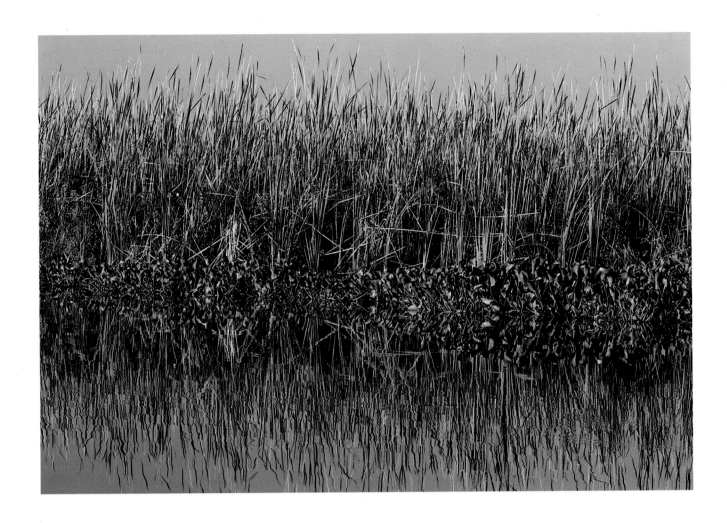

ble to teasing, and the old-timers would dare me to eat chocolate-covered ants and grasshoppers or mountain oysters. I didn't then, and I wasn't about to now. Ouch! There were still twenty of those little devils on me.

Louisiana marsh is divided into four types. It is classified by salinity. The amount of salt in the water affects the plants and animals living there.

Salt marsh is usually closest to the Gulf and is characterized by few plant varieties such as oyster grass. It is found mainly between Caillou Bay and the Mississippi River, which includes the marsh around Terrebonne, Timbalier, and Barataria bays, as well as the lower Lafourche.

Brackish marsh is less salty and is covered by wire grass, among other plants. Large patches of brackish marsh line the Cameron-Vermilion coast, behind the salt marsh.

The largest tract of intermediate marsh surrounds Sabine National Wildlife Refuge. The variety of plant life is greater and there is less salt in the water.

My favorite is fresh marsh, and it is the most varied in plant life. Species such as all the flowering lilies on Lacassine and the giant blue iris bloom in Terrebonne Parish, making it the most beautiful marsh. Terrebonne Parish and the tip of the Mississippi River delta are where you will find two of our bigger fresh marshes.

The marshes of St. Bernard Parish once gave us a

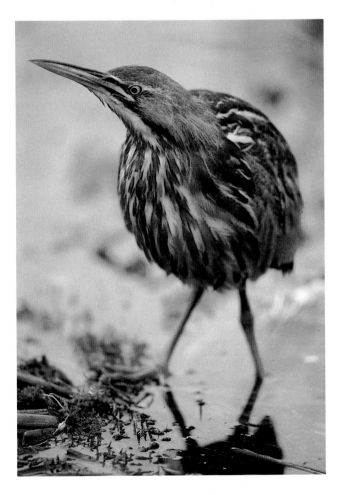

fur harvest more than that of the rest of the United States and Canada combined. Today, marshes there are disappearing.

Louisiana loses over sixty-four square miles of coastline a year, and until recently we weren't acknowledging it, much less doing anything about it. Oliver Houck, an environmental-law professor at Tulane, sums up our previous attitude. "If Texas annexed sixty-four square miles of Louisiana, we'd probably go to war. But nobody pays attention to coastal erosion from environmental causes."

With over fifteen thousand miles of oilfield canals, our once-wilderness marshes are now a checkerboard of man-made waterways. These, unlike natural bayous, allow salt water to get into the fresh marsh quicker and in greater quantities, killing plants and thus creating open water. This, along with the fact that the Mississippi River is no longer spreading out tons of silt to replenish the marsh, means that our coast is in jeopardy.

Scientists and bureaucrats are working on the problems, but should act faster, because what's gone will be very hard if not impossible to get back.

Forty-seven hundred years ago, the St. Bernard Delta pushed far out into the southeastern Louisiana Gulf. The outer rim of that delta is the Chandeleur Islands. The rest has long since subsided, leaving the St. Bernard Parish marsh and Chandeleur Sound.

Over the years, I have made quite a few trips to this arc of islands and mangrove marsh—from counting terns and seabirds with Jake Valentine to studying dune vegetation with Irv Mendelssohm.

Recently, I visited the Chandeleurs again with Joseph Killeen, an expert at catching redfish and a New Orleans advertising executive. Buzzy, as he is called by friends, is a south Louisiana aficionado. He loves the history and culture of the south Louisiana marsh Cajuns, especially their fishing, hunting, and boat-building techniques.

Perhaps that's why he is so good at landing redfish. Of the seven men on board fishing, Buzzy was the only one who caught reds. The spry fifty-nine-year-old hops into a pirogue like a teenager and poles his way along the edge of the marsh and sea-grass beds. He only casts when he sees a fish. The rest of the men caught plenty of white trout while I was put off on the beach.

(right) *Sea oats and oyster grass anchor the low dunes on the Chandeleur Islands, perhaps in vain—our islands are eroding away.*

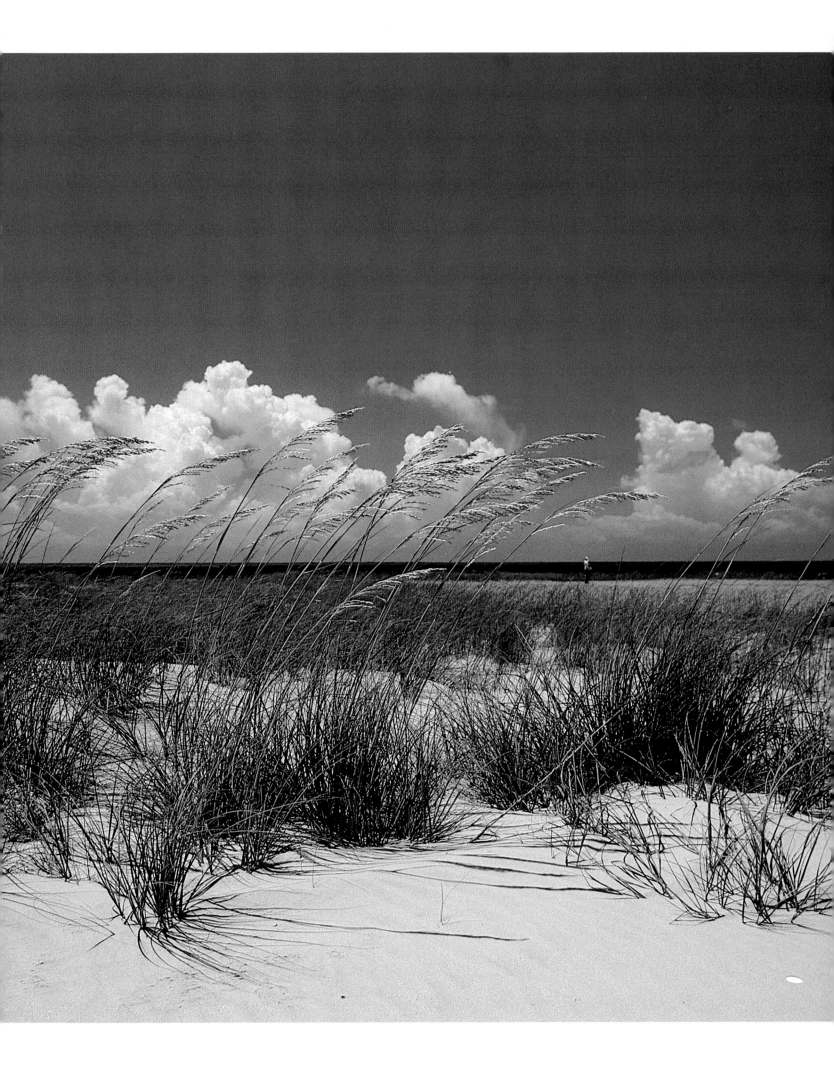

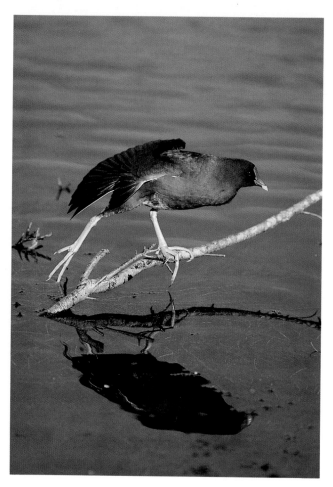

Time alone on the beach, especially this beach so far from the condos and amusement parks most people associate with sandy vacations, is my kind of relaxation. This one is covered with a layer of six inches of shells, gray, cream, some almost black. I walked for miles over these shells, passing small colonies of skimmers and least terns.

Sea ox-eye and marsh pink were in bloom among the oyster grass. Of course there was the usual flotsam along the beach, and in the surf, roots of mangrove trees. Those roots were once behind the islands that are eroding and drifting north.

A little farther, and I noticed a Wilson's plover doing its broken-wing act. The telltale sign that I was near its nest. It took me a while, but I finally spotted three black speckled eggs under the branch of a dead shrub. I made a makeshift blind and observed the pair running across the sand, their little legs moving as fast as a sewing-machine needle.

I was enjoying the plover's antics until I heard a *zooom* and a *burweek* close behind me over the sound of the surf. It startles you unless you see the whole thing. To hear those sounds and then turn to see the sharp-winged bird fly right by you brings on momentary panic.

It was a nighthawk, another island nester. The *zooom* is the sound of his wings as he goes into a dive. The *burweek* is the call he makes as he cruises by your head.

Back on the landward side of the island, I waded through the sea-grass community. There is not much of this in Louisiana—some in Pontchartrain and some on the other barrier islands, but Chandeleur is the healthiest.

With the low angle of the morning sun, the sea grass looked emerald green in the crystal-clear water. It quickly gets muddy as the water deepens, but here next to the shore it is beautiful. Fifty yards out, the surface exploded as 200 silver-dollar-looking shad burst out of the water with a bigger fish in hot pursuit.

Back on the *Rufnek II*, I listened to the fishing tales, including one about how Charles Grose caught a laughing gull that went for his fishing bait. It was released unharmed.

The next day, I photographed nesting gulls, pelicans, and the roost of magnificent frigate birds. These seabirds nest in the Yucatán and Belize and then summer in a group of five thousand on the Chandeleur Islands.

About one hour before sunset, I set up to shoot a sandspit that had a lot of birds on it. Gulls and terns settled in to roost for the evening. Those birds and that evening's sunset were a fitting end to my Chandeleur trip.

Timbalier Island is the westernmost downdrift-flanking barrier island associated with the erosion of the Caminada-Moreau headland. This means that it was once a part of the mainland. A couple of shrimp-ers I ran into told me their grandfathers drove cattle across the marsh to Timbalier Island, a marsh that is now bay.

It's an island now, though, and I enjoyed the summer of 1979 by spending a lot of time living there in a hurricane-damaged houseboat. The marsh had long since eroded, so I had to devise numerous different methods of getting across the fifteen miles of open water to my campsite. I traveled by floatplane, crew boat, shrimpboat, sport-fishing boat, and an old lugger called the *Miss J & M*. Sometimes, when no one was there to provide, I had to cross in my fourteen-foot aluminum bateau with its twenty-five-horse-power Johnson outboard.

On June 11, I was making arrangements to meet the *Miss J & M* to tow my boat to the island. At CoCo Marina, I passed a friend of mine just returning from a dive trip who reported that the bay was smooth. Later, I learned that the definition of smooth is different when you're on a sixty-five-foot boat as compared to a fourteen-footer.

I met the *Miss J & M* at 3:00, stowed my camera safely in the cabin, tied my bateau behind, and we set out. The wind was shifting to the north and picking up. About an hour out (this was a slow boat), the captain found water in his oil. He immediately shut it down and called for help. I decided to go back to the marina and see if any big boats were going out to Timbalier.

(top far left) *Sparkles of gold from the setting sun illuminate a Jefferson Parish marsh.*

(bottom far left) *A common moorhen,* Gallinula chloropus, *stretches.*

(left) *Being the winter home for many species of shorebirds such as this semipalmated sandpiper,* Calidris pusilla, *makes Cameron Parish a bird watcher's paradise.*

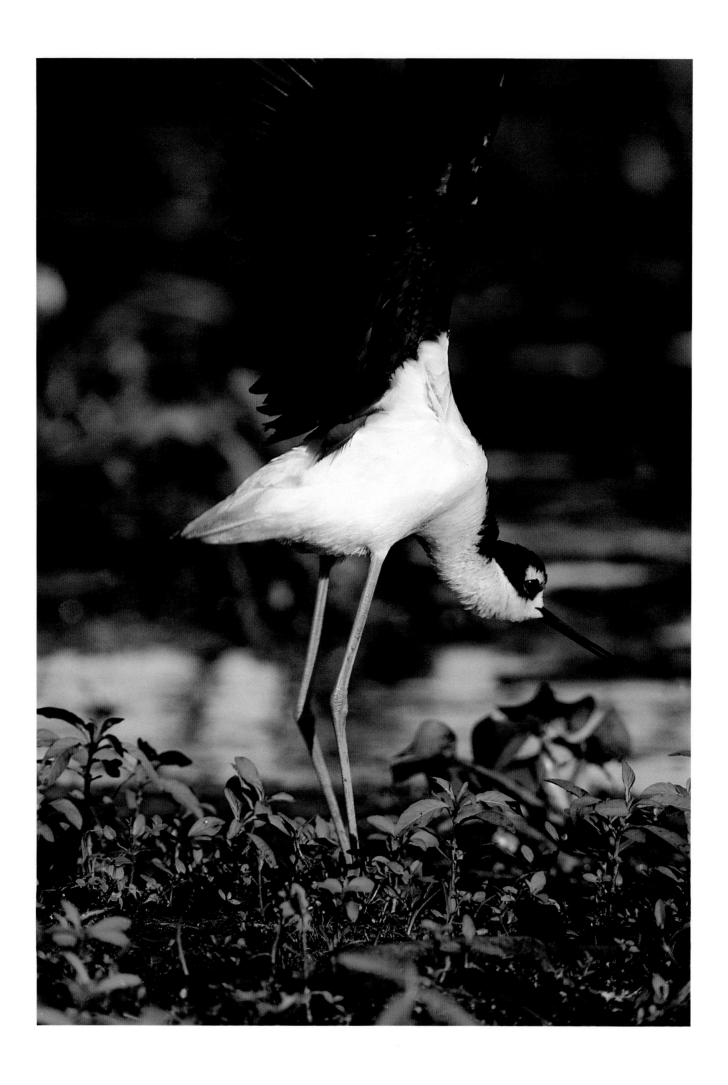

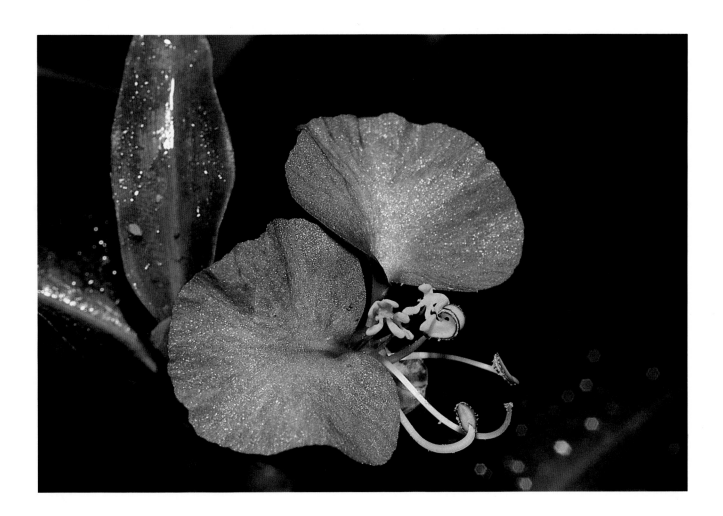

(left) *The long pink legs make the black-necked stilt,* Himantopus mexicanus, *easy to identify.*

(above) *Dayflower,* Commelina erecta

The protected waters of the marsh were deceptively smooth. I almost headed straight for the island, but thought I'd give a safe trip a try first.

Back at CoCo Marina, everyone was coming in. No luck for a ride. It was a full-moon night. The perfect night for a shot of the moon rising over the beach. The temptation got to me. I wanted to be back on Timbalier.

Some people call it dangerous. I'll just call it an adventure. I set out at 6:40 P.M., with camera cases wrapped and taped in garbage bags.

The waters in the marsh were still smooth, which is usually the case during a north wind. When I hit the edge of the bay, it was a six-inch chop that soon turned to one- to two-foot waves. The bay is shallow, so the waves are close together and it's harder to drive fast, especially in a flat-bottomed boat.

By the time I was out of sight of the big pink marker, the seas were two to three feet with five-foot swells, and my open boat was taking on a lot of water. I was soaked head to toe, and the salt spray was stinging my eyes with each bounce. With a hand-held compass and a viewing height of only three feet, navigation was tough. On a big boat, you can always see something from the bridge. I couldn't see over the next wave.

Fear entered the picture when I realized that hitting a wave wrong would capsize me. I calmed myself somewhat by thinking of my swimming ability

for my own sake and my insurance for my cameras' sake.

Finally, the tank batteries on the end of Timbalier appeared. In smooth water I could make it to the camp in ten minutes, but the seas had reached their maximum. The going was slow to near impossible. Quick, successive five-foot waves were bearing down from behind me, loading my boat with water. My boat got so heavy, it was near sinking. Going up those five-foot waves took every bit of juice I could force from my little outboard. Sometimes I thought a wave from behind would overtake and swamp me.

Cresting one big wave, my bateau took off like a world-champion surfer. Down the trough at full power, I split the next wave. A wall of water hit me squarely in the chest and knocked me back against the motor. There was water up to the gunnels in the rear of my bateau . . . camera cases floating. I was wading in my own boat. With full throttle in one hand and bailing bucket in the other, I surged part-way up the next wave. Hanging on its edge, I moved forward in pace with the wave.

Peripherally, I could see the sun setting over the island. It was a good one, and I wished I was set up behind some flowers, catching it in a photograph. Instead, the winds and the wetness caused chills to set in. My teeth were chattering so fast and hard, I thought they would break.

The shore was close, but so far away. As the water

(below) *The winter marsh is normally cold and colorless, but an occasional sunny winter day can bring a sleeping alligator,* Alligator mississipiensis *(top right), out of his den.*

(bottom right) *A great blue heron,* Ardea herodias, *displays his breeding plumage as he stands guard over his nest.*

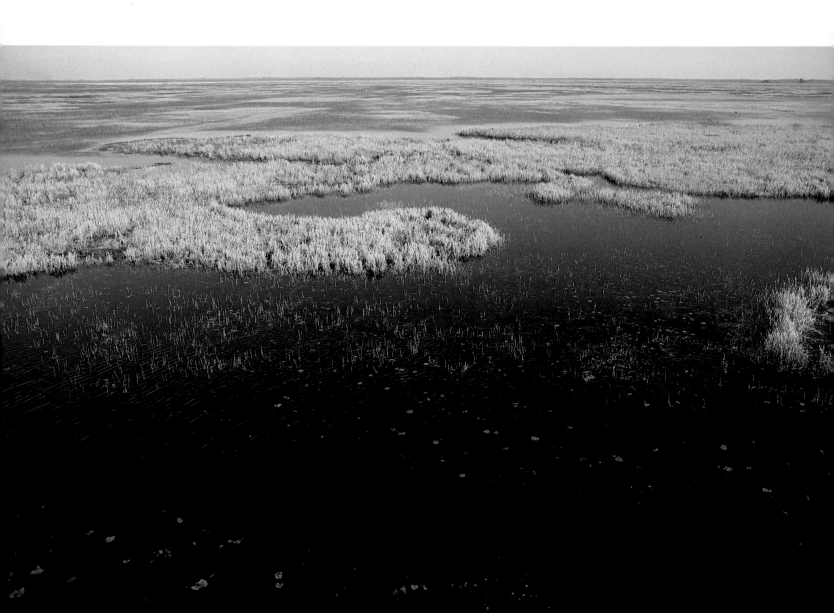

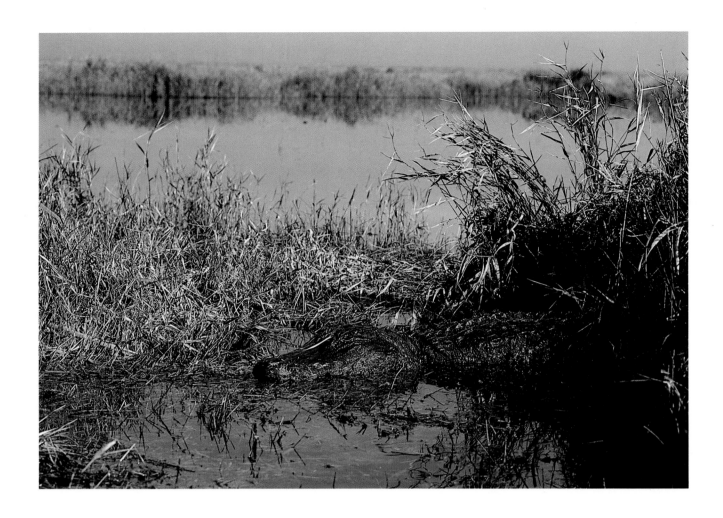

got shallower my boat would touch bottom in the waves. Then, *chunk*. I hit sand hard and my engine quit. With no power, I was being turned broadside as the strength of the wind and seas drove me toward shore.

I jumped out and, with failing muscles, guided the boat as best I could until the waves grounded it in six inches of water. The channel into the interior of the island was seventy-five yards to the east. I had to portage my gear to shore, bail the boat, and drag it to the channel. At least the exercise warmed me up. Once safely in the protected channel, I retrieved my gear and set up camp. After changing clothes, I found all my gear in perfect shape and headed out to the beach for my night shots. The adventure was over. Time to get to work.

A few weeks later, I spent my thirtieth birthday in the tern colony on a 300-yard-long sandbar between East and West Timbalier islands. According to a U.S. Fish and Wildlife Service report, there are more than eleven thousand birds here. Looking out over the noisy conglomeration of Sandwich, royal, and Caspian terns, I estimated more that year.

While watching the adult Sandwich terns carry minnows to their young, I noticed that they brought the tiniest fish to the newborn chicks. The older chicks, fully capable of running around in their nursery pod, would get larger mullet minnows. The dedicated parents worked tirelessly all day to bring a

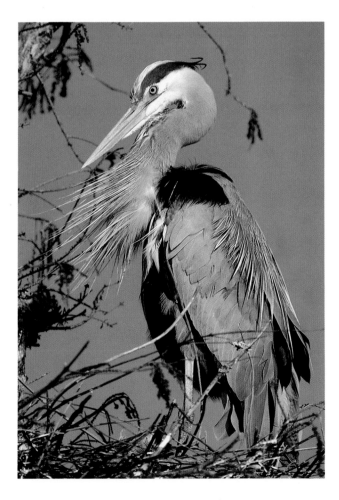

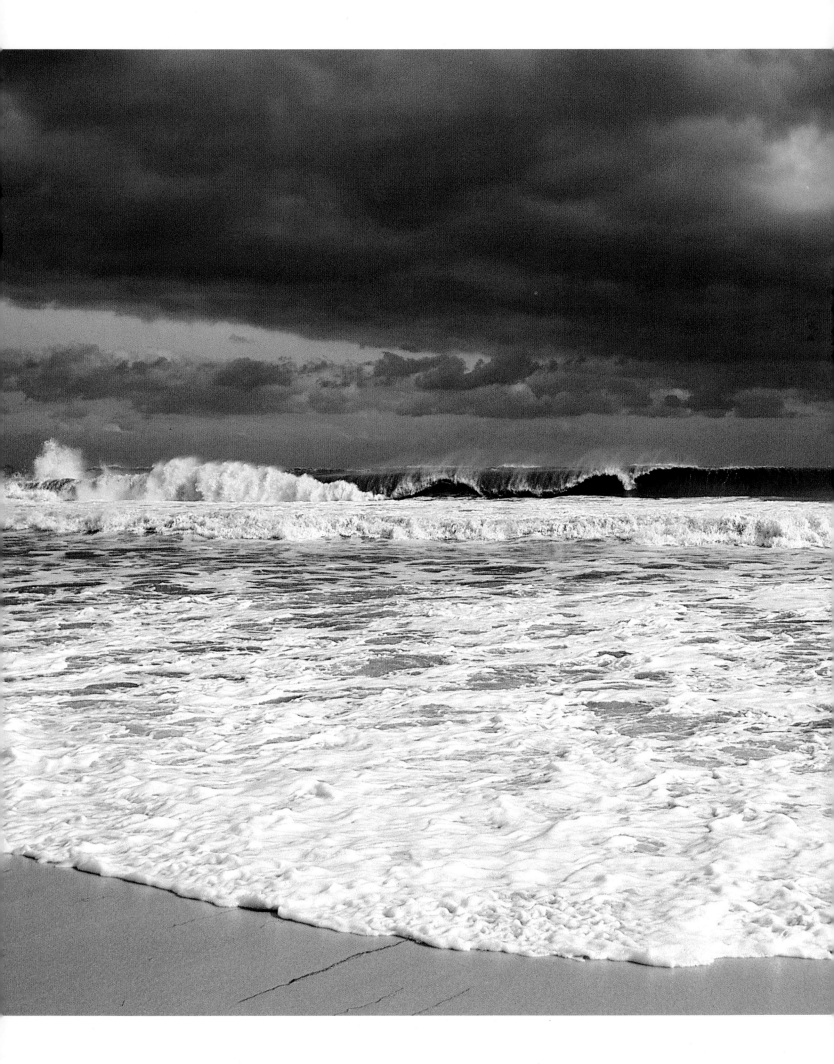

multitude of minnows to the colony from the productive estuarine system. The birds have to grow quickly because there's no telling when the next hurricane will overwash the island.

Back at the camp, I burned my Duncan Hines birthday cake. The gas oven was just too hot. My grouper steak and fresh corn cooked on an outside fire turned out much better.

In early July, I left the island to dive the rigs for a few days and to come to Baton Rouge to resupply. On July 10, I called CoCo Marina to see how the bay looked. "Flat" was the report, so I hurried down to Cocodrie.

Without a one-hour stop in Houma, I would have gotten to the boat ramp and been out on Timbalier Island with no radio to watch Hurricane Bob pass over. The storm itself would have been my only warning.

Luckily, that one hour slowed me enough—I was at the marina when I heard about the hurricane. Unluckily, I missed seeing a hurricane on a barrier island, and probably I would have experienced it safely. Bob cut a path right through the middle of the island, but didn't hurt the camp at all.

If you hate birds, despise the outdoors, don't eat seafood, and the thought of sand and salt water makes you itch, you still have to respect our barrier islands as a barricade against the powerful forces of hurricanes.

As it is, hurricanes have caused much loss of life and $3.5 billion in damage since 1901. Without the islands and the marsh, the damage could have been much worse.

Later in the week, I went back to visit the tern colony. Only the birds that could fly survived, for the little sandbar had washed away. It will pop back up in a few months as the waves and currents rearrange the storm's damage, making and moving islands as they always have. In 1985, hurricanes Danny, Elena, and Juan battered our coast, and the barrier islands took a beating. Congressman Billy Tauzin, after an aerial view of Juan's damage, commented to me that "the marsh looked like a lake; perhaps a preview of what our coast will look like in thirty years."

(left) *Storm waves from Hurricane Elena batter our fragile coast that so far is protecting our cities.*

The problem is that now the Mississippi River delta isn't moving around like it used to, spreading around sand, clay, silt, and sediment, the island building blocks. The delta is locked in place by levees and control structures. Worst of all, the majority of the silt and sand is pouring out Southwest Pass and thousands of feet down over the continental shelf. Luckily for us, we have the smaller Atchafalaya Delta in the making, but it's not solving the bigger problem.

Beyond our islands, there is quite a bit to see in the deeper waters off Louisiana. Above water, with a sharp eye or a pair of binoculars, you can see some birds that don't ever stop on Louisiana sands or soil. Wide-ranging seabirds like the northern gannet and its cousin the masked booby.

I saw the booby about fifteen miles south of the tip of the Mississippi River delta. We were following a flock of terns diving on baitfish when all of a sudden I noticed a masked booby among them just as a whale shark surfaced in the green water. This thirty-foot shark, the world's largest fish, is a harmless plankton eater and is occasionally sighted along our coast.

Other birds you might see in the Gulf are the pomarine jaeger and the tiny Wilson's storm-petrel. Add a few more birds to that list and the only other sights you can see above water are oil rigs, sunsets, and an occasional leaping fish. Underwater is where to look.

I've been diving the oil rigs for ten years and have never stopped enjoying it. Each dive offers something a bit different. The most recent trip is the freshest in my mind. It was a good dive that had some exciting moments.

I boarded the *Kennianneh*, a fifty-foot crew boat, at Grand Isle after a morning of picking up trash on the beach with "The Clean Team." Joe Howell, the owner and captain, and six others were on board for a trip to the blue waters southeast of the Mississippi River. We took the Gulf to Tiger Pass, then on to Venice, across the Mississippi into Baptiste Collette, then Breton Sound, and finally back into the Gulf.

The trip across the delta was a bird watcher's delight. I estimated seeing 8,000 white pelicans, some swimming and some flying so gracefully in formation, showing the white, then black, of their wings. I'd guess we saw over 100,000 birds all told in that one-and-a-half-hour trip through the marsh. Included in that number were egrets, herons, gulls, terns, skimmers, cormorants, and ducks.

By 4:00 P.M., we were in water deep enough to dive, and the captain's assistant eagerly took to the water. Too much Mississippi mud for pictures, so I waited for Steve to surface and report it was just as muddy down below.

Another hour of chugging, and it was blue-water ballet. Tiny flying fish burst out of the clear waters ahead of the boat. Excitedly, I suited up. After being

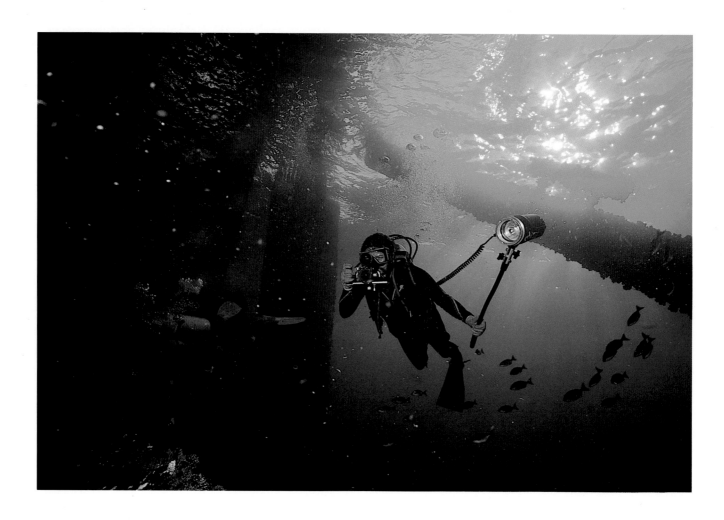

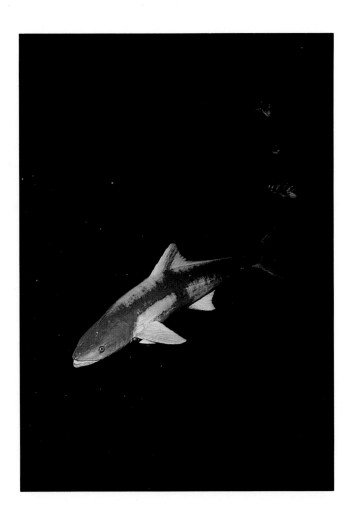

One rig had nearly thirty lobsters hiding under a conductor guide. None was much bigger than a large crawfish, but they could be if divers would leave them alone until they reached breeding age.

Under Louisiana's biggest and deepest rig, Cognac, we saw some of the most colorful coral, sponge, and gorgonia formations I've ever seen under a rig. Blending right in were the like-colored scorpion fish. You wouldn't want to step on one, for its dorsal fins are poisonous.

On the afternoon dive, I got as close to a big tarpon as I'll ever get. Many men devote years of their lives fishing for this feisty game fish, and I was lucky enough to be in the middle of a school of twenty-five trophy fish. I guess I was just as strange to them, for they circled me. Uh-oh John Wayne—I felt like a wagon train and the tarpon were the Indians.

Summing up my favorite Louisiana dives, I can narrow it down to two. The first was in the Ship Shoal rigs south of Last Island. Here I got to see three jewfish. You see, I started diving a little too late or divers tell too many tall tales. I had heard many stories from the 1960s and early 1970s of divers seeing 600-pound jewfish lined up in rows under the rigs. Afraid of nothing, they were easy to shoot and were soon rare at average diving depths.

I only saw three in a row and the biggest was only about 400 pounds, but that was enough for me. He looked like a Volkswagen.

busy in the hills of north Louisiana all season, I was behind on my usual quota of dives.

Drifting down slowly is just like being suspended in space, if you can imagine that. I grinned at passing schools of spadefish. Soon the game fish were chased away, and the spearfishermen surfaced. I had the whole Gulf of Mexico to myself. The sight was so beautiful that I felt music in the stillness. Declining to use my camera, I hovered at sixty feet, letting the curious fish check me out.

When the clear water began to darken with the coming night, I kicked slowly toward the boat. As my head broke the Gulf's surface I watched the sun, millions of miles away, disappear into the water.

On day two, we saw sharks. Sharks are strange. Five years back, I went through all sorts of trouble to build a shark cage and chummed for sharks, but I never really was successful at getting any sharks to come by my cameras.

When I finally gave up on it, I started seeing sharks on every other dive. On one of the dives, I noticed six little sharks right under the ladder. After jumping in, I counted thirty of them. Then after swimming over to the rig and sitting down on a piling thirty-five feet deep to adjust my camera, I glanced toward the boat and counted sixty-two sharks watching us under the rig. They soon lost interest and swam out of sight, and I went to work photographing lemonfish, blennies, and lobsters.

(above) *Cobia,* Rachycentron canadum, *sometimes called lemonfish, is one of the best food fish in the Gulf.*

(left) *In search of tropical fish living among the 1,000-foot-tall stanchions of the Cognac oil rig, a diver prepares his camera.*

(right) *Queen angelfish,* Holacathus ciliaris, *are some of the most colorful tropical fish that inhabit the barnacle-encrusted oil rigs.*

The other memorable dive was south of Grand Isle and involved sharks again. This time some decent-sized sharks.

At first I couldn't believe my eyes, for hovering in the current below me were five sharks. All were over seven feet long and had the fat bellies of the well-fed. Still I was cautious, hugging the piling to get closer. A better view proved them to be sand tigers, the shark of sharks. Tall caudal fin and protruding teeth. This is the fellow that artists copy when they want to put fear into your heart. But this shark is actually the complete opposite in nature. It is one of the most docile sharks and is responsible for no known fatal attacks on man.

By the end of the day, men, women, and even a fourteen-year-old boy swam within four feet of these sharks. Maybe the next man who drags one of these docile creatures to the scales at a spearfishing rodeo won't be called macho unless he eats the whole thing.

When diving, you can see the part of the ecosystem the commercial fishermen draw from to make Louisiana one of the leading seafood producers in the world. But sailing when the weather is right is a much more relaxed voyage.

From Mexico to Mandeville, I was viewing the entire Gulf with Nigel Calder and Terri Frisbie on their thirty-seven-foot ketch *Nada*. The Mexicans were bemused by the name, which means "nothing," and

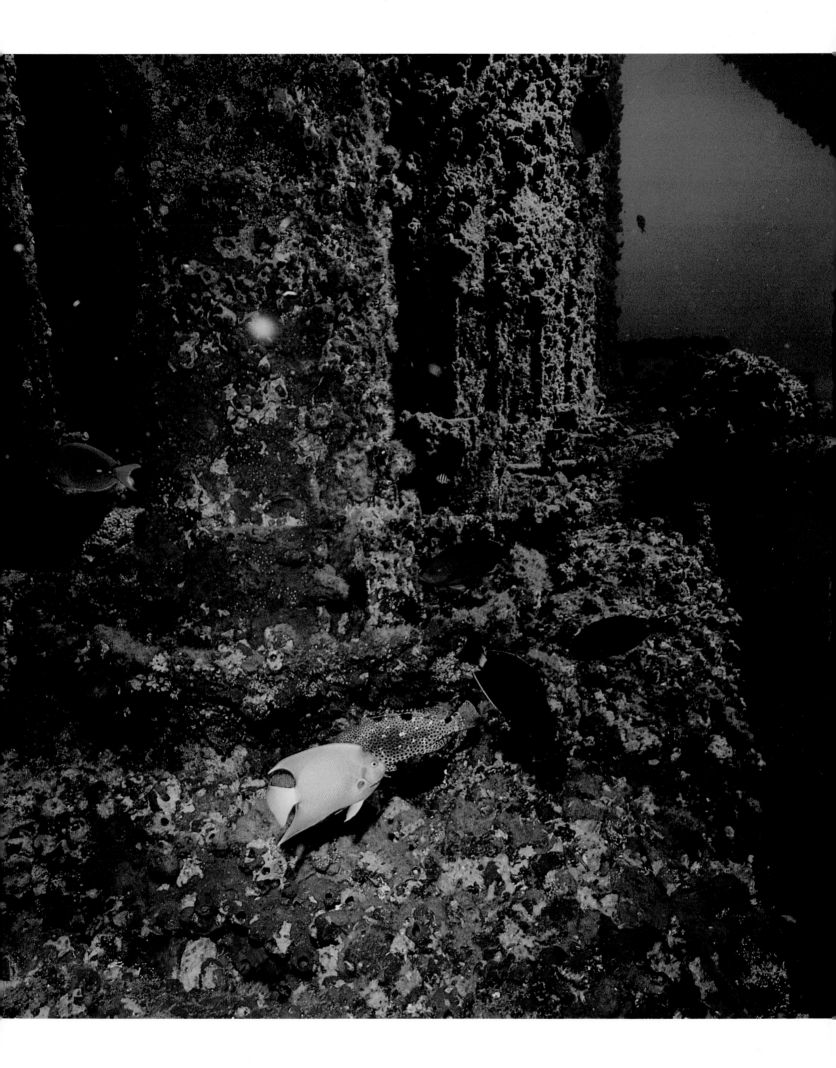

probably wondered why these crazy gringos would name their boat this way. Simply, Terri and Nigel, who built the boat from the hull up, couldn't agree on a name, thus nothing.

As we plowed through the seas northward, common dolphins would play in our bow wave as barn swallows flew by in migration. About a dozen stopped on the boat every day, and on two nights we had a barn swallow that flew into the cabin and slept on a small hammock hanging from the ceiling. Cattle egrets also hitched a ride. One weak-looking bird rode for two days.

About a hundred miles from Louisiana, the wind stopped dead, the sails drooped, and the sea became flat and shiny as a basketball court. After swimming and snorkeling in the five thousand feet of water, we decided to crank up the motor til the wind picked up.

It didn't, so we broke out the Trivial Pursuit game and chugged toward Chandeleur Sound. I was at the tiller, trying to resist helping my neighbor with a natural-science question, when I glimpsed a squirt out of the corner of my eye. I know they're here, but is it really what I think it is?

I rubbed my eyes and saw it again. It wasn't a squirt . . . it was a spout. "Moby Dick," I yelled.

Nigel took the helm. I dashed for my camera as Terri ran for her sketch pad. Closer we chugged, and I leaned out over the bowsprit. Finally Nigel cut the engine, and our momentum carried us to within

(below) *Sperm whales,* Physeter catodon, *bask in the calm waters of the Gulf 100 miles southwest of the Mississippi River delta.*

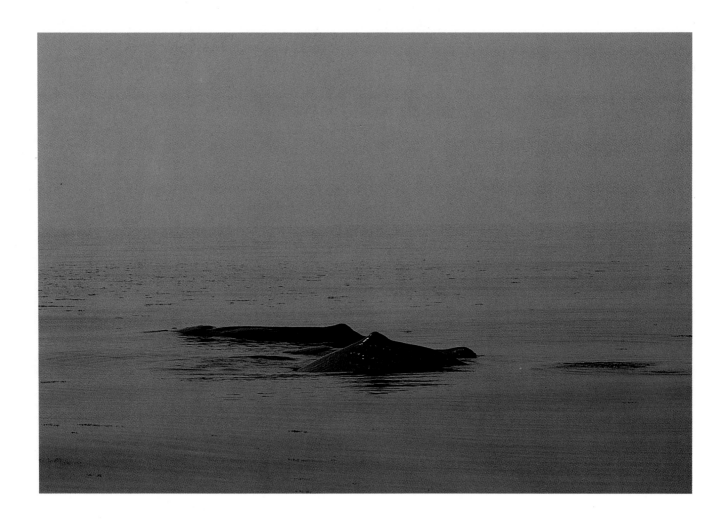

thirty-five feet of four sperm whales and a calf. What a lucky find.

After watching the whales for several minutes, I decided to slip into the water with my camera. Slip I did, for a spoonful of honey poured down the side of the boat couldn't have gone in any quieter. But it must not have been quiet enough, because all I saw was one big tail fluke disappearing into Davy Jones's locker.

Back in the boat, we watched the whales surface again about a half-mile away. We approached, and they didn't mind the boat at all. The calf seemed just as curious about us as we were about him.

Finally we had to motor on—happy, though, that we got to see one of the Louisiana coast's rarest mammals.

The grass is greener nowhere else in the world, for Louisiana is a special place. From the tiniest shrew to the massive whale and from the top of Driskill Mountain to the deepest canyon in the Gulf, Louisiana has a diversity of geology, geography, and natural history that makes it a bountiful land.

(above) *The magical orange glow of a cold-front sunset over Louisiana's vast marshland*

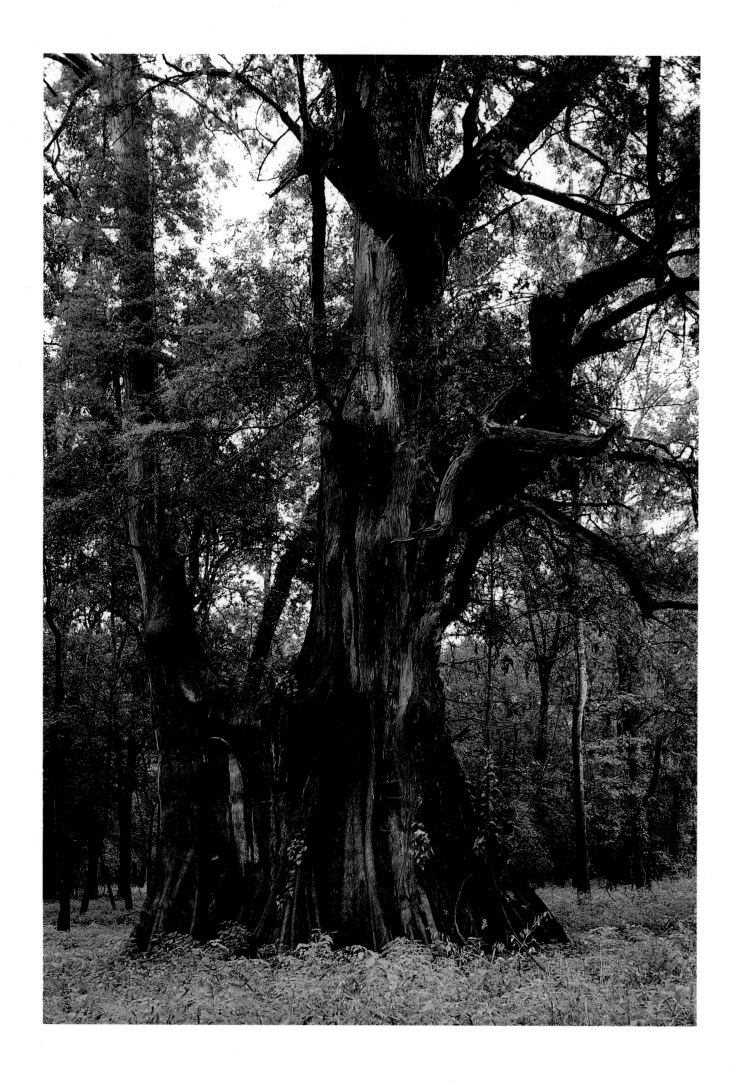

Appendices

Louisiana Facts

Population	4,206,000 (1980) (19th in U.S.)
Highest point	535 feet (Driskill Mountain)
Lowest point	-5 feet (New Orleans)
Largest lake	621 square miles (Pontchartrain)
Largest reservoir	284 square miles (Toledo Bend)
Area	48,523 square miles (31st in U.S.)
Shoreline*	7,721 miles
Coastline**	397 miles
Marshes	2,625,363 acres
Bays	3,378,924 acres
Offshore oil rigs	3,342
Salt domes	204
State tree	Baldcypress
State flower	Southern magnolia
State bird	Brown pelican
State insect	Honeybee

* Length of the coast, including islands, bays, rivers, and bayous up to the head of tidewater.

** General length of the coast.

National Champion Trees in Louisiana

Species	Circumference	Height	Location
Baldcypress *Taxodium distichum**	53'8"	83'	West Feliciana
Water-tupelo *Nyssa aquatica*	27'1"	105'	Allen
Live oak *Quercus virginiana*	36'7"	55'	St. Tammany
Shumard oak *Quercus shumardii*	21'9"	97'	East Carroll
Spruce pine *Pinus glabra*	13'2"	123'	St. Helena
Nuttall oak *Quercus nuttallii***	21'6"	115'	Morehouse

* Of all the champion trees nationwide, this baldcypress is ranked sixth. Only the giant sequoia and four others are bigger.

** Not officially recorded yet, but bigger than the tree that is currently listed as the largest.

The national champion baldcypress tree

Louisiana's Scenic Rivers

These forty-nine streams are protected by Louisiana Legislative Act 398 from channelization, clearing and snagging, channel realignment, and reservoir construction.

1. Pushepatapa Creek
2. Bogue Chitto River
3. Tchefuncte River
4. Tangipahoa River
5. Chappepeela Creek
6. Tickfaw River
7. Amite River
8. Comite River
9. Blind River
10. Bayou des Allemands
11. Whiskey Chitto Creek
12. Six Mile Creek

13. Ten Mile Creek
14. Little River
15. Big Creek
16. Fish Creek
17. Trout Creek
18. Bayou Bartholomew
19. Bayou L'Outre
20. Bayou D'Arbonne
21. Corney Bayou
22. Middle Fork of Bayou D'Arbonne
23. Saline Bayou

24. Black Lake Bayou
25. Bayou Kisatchie
26. Spring Creek
27. Saline Bayou
28. Bayou Penchant
29. Bayou Cocodrie
30. Bayou Cocodrie
31. West Pearl River
32. Bayou Dorcheat
33. Bayou Trepagnier
34. Bayou La Branche
35. Calcasieu River

36. Bayou Dupre
37. Lake Borgne Canal
38. Bashman Bayou
39. Terre Beau Bayou
40. Pirogue Bayou
41. Bayou Bienvenue
42. Bayou Chaperon
43. Holmes Bayou
44. Wilson Bayou
45. Bradley Slough
46. Morgan River
47. Bayou St. John
48. Bayou Lacombe
49. Bayou Cane

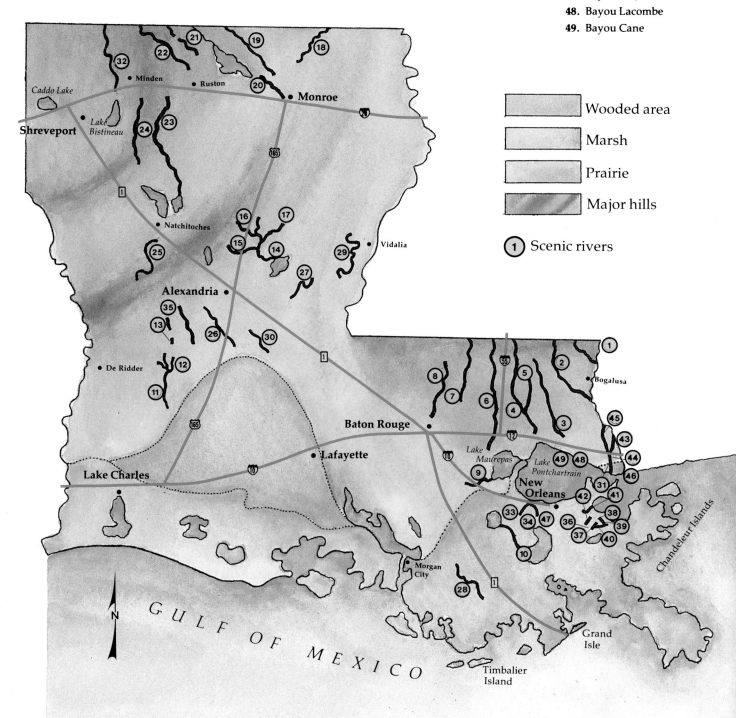

�____	Wooded area
▢	Marsh
▢	Prairie
▢	Major hills
①	Scenic rivers

Further Reading

Comeaux, Malcolm Louis. *Atchafalaya Swamp Life: Settlement and Folk Occupations*. Baton Rouge: School of Geoscience, Louisiana State University, 1972.

Davis, Edwin Adams. *The Rivers and Bayous of Louisiana*. Baton Rouge: Louisiana Education Research Association, 1968.

Kniffen, Fred B. *Louisiana: Its Land and People*. Baton Rouge: Louisiana State University Press, 1968.

Lockett, Samuel H. *Louisiana as It Is*. Edited by Lauren C. Post. Baton Rouge: Louisiana State University Press, 1970.

Lockwood, C. C. *Atchafalaya: America's Largest River Basin Swamp*. Baton Rouge: Beauregard Press, 1981.

————. *The Gulf Coast: Where Land Meets Sea*. Baton Rouge: Louisiana State University Press, 1984.

Lowery, George H., Jr. *Louisiana Birds*. 3rd ed. Baton Rouge: Louisiana State University Press, 1974.

————. *The Mammals of Louisiana and Its Adjacent Waters*. Baton Rouge: Louisiana State University Press, 1974.

Newton, Milton Birchard. *Atlas of Louisiana: A Guide for Students*. Baton Rouge: School of Geoscience, Louisiana State University, 1972.

Sevenair, John P., ed. *Trail Guide to the Delta Country*. New Orleans: New Orleans Group of the Sierra Club, 1980.

Louisiana Life. 1981–.

Louisiana Conservationist. September, 1948–.

Notes on Photographs

Custom prints of all photographs used in this book are available. A limited quantity are printed in sizes 16 × 20 and 11 × 14. For information, contact:
The Lockwood Gallery
P.O. Box 14876
Baton Rouge, Louisiana 70898

All photographs were taken with Nikon F, F2, F2A, FE, or F3 35mm cameras. The name of each photograph, along with lens, exposure, and film, is listed below.

pages ii–iii Takeoff. 200mm f/4 Nikkor. f/5.6 @ 1/250. KR64.
page vi Home to Nest. 200mm f/4 Nikkor. f/8 @ 1/250. KR64.
page viii Blackbird Explosion. 300mm f/2.8 Nikkor. f/11 @ 1/60. KR64. Tripod.
page x Eastern Chipmunk. 200mm f/4 Nikkor. f/8 @ 1/125. KR64. Tripod.
page 4 Dogwood and Pines. 35mm f/2.8 PC Nikkor. f/16 @ 1/30. KR64. Tripod.
page 6 Driskill Mountain. 200mm f/4 Nikkor. f/5.6 @ 1/250. KR64.
page 7 Day Late, Dollar Short. 55mm f/2.8 Micro-Nikkor. f/8 @ 1/30. KR64. Tripod.
page 7 Red Dirt Sunrise. 105mm f/2.5 Nikkor. f/8 @ 1/250. KR64.
page 8 Whitetail A-Running. 600mm f/5.6 Nikkor. f/5.6 @ 1/250. CF1000. Tripod.
page 8 Huckleberry. 55mm f/2.8 Micro-Nikkor. f/8 @ 1/60. KR64.
page 9 Marchive Bluff. 55mm f/2.8 Micro-Nikkor. f/2.8 @ 1/1000. KR64. From airplane.
pages 10–11 Harvest Moon. 105mm f/2.5 Nikkor. f/2.8 @ 1 second. KR64. Tripod.
page 12 Stormy #2. 24mm f/2.8 Nikkor. f/5.6 @ 1/15. KR64. Tripod.
page 13 Alert Armadillo. 105mm f/2.5 Nikkor. f/4 @ 1/15. KR64.
pages 14–15 Springtime Creek. 35mm f/2.8 PC Nikkor. f/16 @ 1 second. KR64. Tripod.
page 16 Tunica Hills, Fall. 35mm f/2.8 PC Nikkor. f/11 @ 1/4. KR64. Tripod.
page 17 Seven-Hooter. 300mm f/4.5 Nikkor. f/4 @ 1/25. KR64. Tripod.
page 17 Tunica Hills Fern. 55mm f/2.8 Micro-Nikkor. f/11 @ 1/4. KR64.
pages 18–19 Clark Creek Falls. 35mm f/2.8 PC Nikkor. f/11 @ 1/15. KR64. Tripod.
page 19 Emerging Mushroom. 55mm f/2.8 Micro-Nikkor. f/11 @ 1/4. KR64.
page 20 Red Fruit. 200mm f/4 Nikkor. f/11 @ 1/4. KR64. Tripod.
page 21 Spotty. 105mm f/2.5 Nikkor. f/5.6 @ 1/125. KR64.
page 22 Sicily Island Rapids. 35mm f/2.8 PC Nikkor. f/8 @ 1/30. KR64.
page 23 Sicily Island Falls. 35mm f/2.8 PC Nikkor. f/11 @ 1/8. KR64. Tripod.
page 24 Stinger. 55mm f/2.8 Micro-Nikkor. f/8 @ 1/60. KR64.
pages 24–25 View from Bates Mountain, Fall. 55mm f/2.8 Micro-Nikkor. f/11 @ 1/60. KR64. Tripod.
page 26 Loblolly Pine Bark. 55mm f/2.8 Micro-Nikkor. f/16 @ 1/30. KR64. Tripod.
page 26 Virginia Creeper. 200mm f/4 Nikkor. f/11 @ 1/30. KR64. Tripod.

page 27 Pine Beetle. 55mm f/2.8 Micro-Nikkor. f/2.8 @ 1/500. KR64.
page 27 Controlled Burn, Kisatchie. 105mm f/2.5 Nikkor. f/5.6 @ 1/125. KR64.
page 28 Longleaf and Sunflowers. 35mm f/2.8 PC Nikkor. f/11 @ 1/60. KR64. Tripod.
page 29 French Mulberry. 55mm f/2.8 Micro-Nikkor. f/8 @ 1/125. KR64. Tripod.
page 30 Longleaf Vista Trail. 35mm f/2.8 PC Nikkor. f/11 @ 1/4. KR64. Tripod.
page 31 Almost Grown Up. 24mm f/2.8 Nikkor. f/11 @ 1/8. KR64.
page 32 Longleaf Flowers. 200mm f/4 Nikkor. f/8 @ 1/60. KR64. Tripod.
page 32 Cinnamon Fern. 55mm f/2.8 Micro-Nikkor. f/11 @ 1/15. KR64.
page 33 A Touch of Gold. 600mm f/5.6 Nikkor. f/5.6 @ 1/250. KR64. Tripod.
page 33 Fire Pink. 55mm f/2.8 Micro-Nikkor. f/11 @ 1/30. KR64. Tripod.
pages 34–35 Longleaf Butte. 35mm f/2.8 PC Nikkor. f/11 @ 1/60. KR64. Tripod.
page 36 Wild Azalea. 55mm f/2.8 Micro-Nikkor. f/11 @ 1/125. KR64. Tripod.
page 37 Green and Gold. 55mm f/2.8 Micro-Nikkor. f/11 @ 1/30. KR64.
page 37 Street Lights. 55mm f/2.8 Micro-Nikkor. f/16 @ 1/15. KR64.
page 38 Margaritifera. 55mm f/2.8 Micro-Nikkor. f/11 @ 1/8. KR64. Tripod.
page 39 Gummy. 24mm f/2.8 Nikkor. f/8 @ 1/125. KR64.
page 39 Grasshopper for the Babies. 600mm f/5.6 Nikkor. f/5.6 @ 1/125. KR64. Tripod.
page 40 Bogue Chitto Reflections. 55mm f/2.8 Micro-Nikkor. f/11 @ 1/30. KR64. Tripod.
page 42 Foggy Morning. 35mm f/2.8 PC Nikkor. f/8 @ 1/15. KR64. Tripod.
page 43 Bogue Chitto Bend. 16mm f/3.5 Nikkor. f/11 @ 1/125. KR64.
page 44 Pushepatapa and Mountain Laurel. 24mm f/2.8 Nikkor. f/8 @ 1/60. KR64.
page 45 Canopy. 24mm f/2.8 Nikkor. f/11 @ 1/15. KR64. Tripod.
page 45 Tiger Swallowtail and Mountain Laurel. 55mm f/2.8 Micro-Nikkor. f/11 @ 1/30. KR64.
page 46 Ancient Stumps. 105mm f/2.5 Nikkor. f/11 @ 1/125. KR64.
page 46 Ferns. 55mm f/2.8 Micro-Nikkor. f/11 @ 1/30. KR64. Tripod.
page 47 Springtime. 600mm f/5.6 Nikkor. f/8 @ 1/125. KR64. Tripod.
pages 48–49 Bayou Kisatchie Rapids. 55mm f/2.8 Micro-Nikkor. f/11 @ 1/30. KR64. Tripod.
page 50 Logjam. 24mm f/2.8 Nikkor. f/8 @ 1/30. KR64.
page 50 Swamp Red Maple. 105mm f/2.5 Nikkor. f/11 @ 1/15. KR64.
page 51 Obstacle. 55mm f/2.8 Micro-Nikkor. f/8 @ 1/30. KR64.
page 52 Castor Creek. 35mm f/2.8 PC Nikkor. f/11 @ 1/15. KR64. Tripod.
page 53 Fast Water. 35mm f/2.8 PC Nikkor. f/16 @ 1/8. KR64. Tripod.
page 54 L'Outre. 24mm f/2.8 Nikkor. f/11 @ 1/60. KR64.
page 55 Riding the Duckweed. 105mm f/4 Novaflex with bellows. f/16 @ 1/60. KR64. Flash.
page 55 Loggy Bayou Tributary. 35mm f/2.8 PC Nikkor. f/16 @ 1/4. KR64. Tripod.
page 56 Pope Lake Tupelo. 35mm f/2.8 PC Nikkor. f/11 @ 1/15. KR64.
page 57 Moon and Cormorants. 105mm f/2.5 Nikkor. f/8 @ 1/30. KR64.
page 57 Clear Lake. 55mm f/2.8 Micro-Nikkor. f/4 @ 1/1000. KR64. From airplane.
page 58 Lake Iatt Sunrise. 24mm f/2.8 Nikkor. f/11 @ 1/60. KR64.
page 59 American Lotus. 55mm f/2.8 Micro-Nikkor. f/11 @ 1/60. KR64.

Index